THE **Better**Photo Guide to
Digital Photography

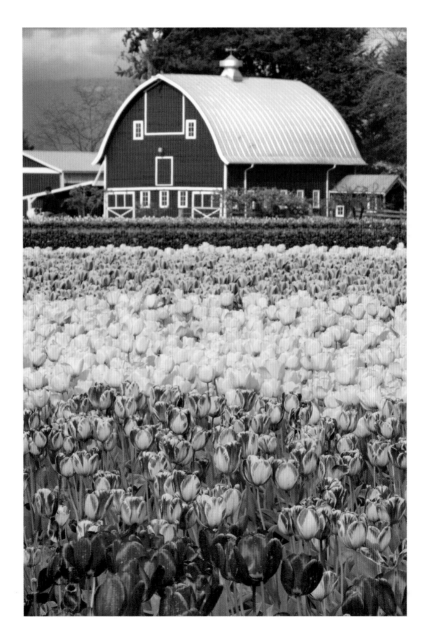

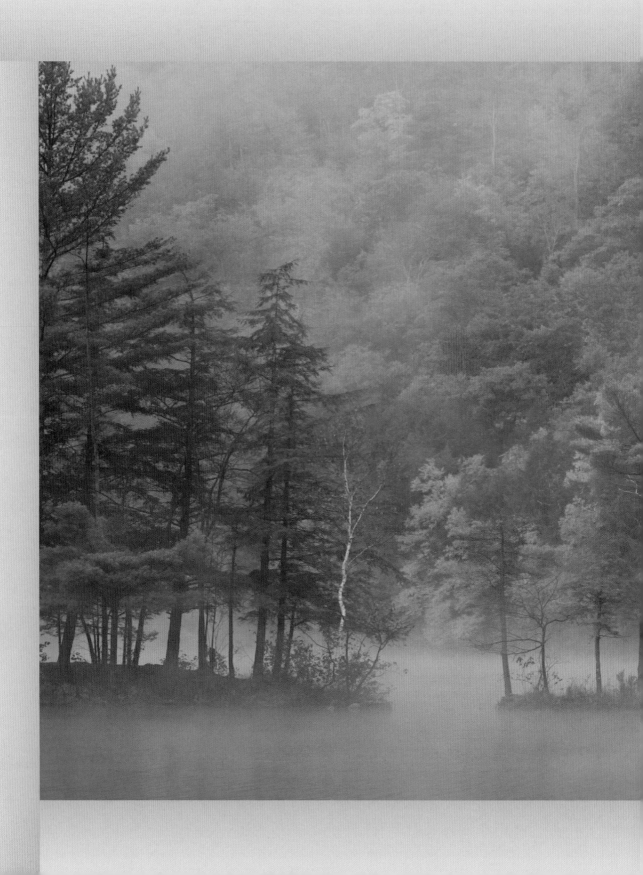

THE **Better**Photo Guide to
Digital
Photography

JIM MIOTKE

AMPHOTO BOOKS

**AN IMPRINT OF WATSON-GUPTILL PUBLICATIONS
NEW YORK**

ACKNOWLEDGMENTS

I'd like to express my gratitude to the dedicated BetterPhoto.com members; to Victoria Craven, Alisa Palazzo, and Areta Buk at Amphoto—and to Bryan F. Peterson for introducing me to these fine individuals. I would also like to thank Melody Hauf for her fun drawings, and Brian and Marti Hauf for their thoughtful proofreading and prayerful support. Heather Young and her family—as well as the Conner, Adams, Smith-Dahl, Parsons, and Ramsey families—played a big role, as did Jay and Amy Wadley, Triple "D," the 7L Ranch, Kerry Drager, Jim Zuckerman, Maggi Foerster, and my mom and dad.

PAGE 1: 1/30 SEC. AT f/22, ISO 100, 100–400MM LENS AT 130MM

PAGES 2–3: 1/4 SEC. AT f/4.5, ISO 100, 28–135MM LENS AT 53MM

PAGE 5: 1/30 SEC. AT f/4.5, ISO 400, 28–135MM LENS

Senior Acquisitions Editor: Victoria Craven
Senior Development Editor: Alisa Palazzo
Designer: Areta Buk / Thumb Print
Senior Production Manager: Ellen Greene

Text set in 10.25-pt. Berkeley Book

First published in 2005 by Amphoto Books
an imprint of Watson-Guptill Publications
Crown Publishing Group, a division of Random House Inc., New York
www.crownpublishing.com
www.watsonguptill.com

Drawings by Melody Hauf

Library of Congress Cataloging-in-Publication Data
Miotke, Jim.
 The BetterPhoto guide to digital photography / Jim Miotke.
 p. cm.
 Includes index.
 ISBN 0-8174-3552-2 (pbk.)
 1. Photography—Digital techniques. 2. Digital cameras. I. Title.
 TR267.M85 2005
 775—dc22

 2005010989

Printed in China

To my lovely wife, Denise,
without whom this book would not have seen the light of day,
and my beautiful boy, Julian,
who surprises and delights us every day

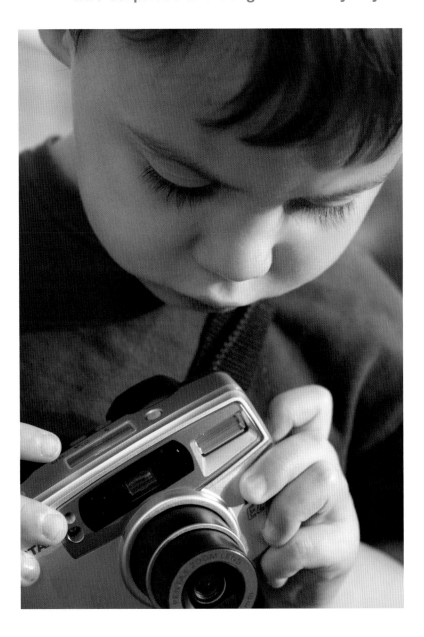

Contents

Introduction

IN THE PIONEER DAYS of photography, photographers had to be part-time chemists. They mixed potions and caustic powders together themselves to make images appear on paper, glass, and metal. Then Kodak introduced the Brownie, with the slogan "You press the button—we do the rest." Kodak was betting on the general shopper's reluctance to become an at-home chemist. And, as history has shown us, the bet paid off.

We see the same pattern repeating itself today. When digital cameras first became popular, people filled them up with pictures and then struggled to figure out how to get these images off of the camera and printed on home printers. This required learning a lot more than just photography. So, many companies now provide services to help digital photographers turn their digital images into beautiful prints. For instance, they can insert their memory card into a kiosk at a local photo lab, order prints from stores like Costco or Wal-Mart, or upload their photos to online companies for print ordering via the Web.

This means that anyone who wants to put off learning about computers, software, and printers can leave these lessons for a future time, focusing instead on photographic techniques. For this reason, this book focuses on shooting techniques, rather than software techniques. We're going to take things one step at a time and concentrate first on the art of taking great pictures.

This book is entirely about making great photos with your digital camera. It is not about altering images on your computer, and it is not about scanning your old film pictures into your computer. We are here to focus on what you need to know in order to make great photos. It's true that you can do a lot to improve your photos by tweaking them on the computer. However, since most of us only have so much time in the day, this book avoids lengthy discussions of Photoshop and cuts right to the chase. I will discuss only those software techniques that you really need to know.

Likewise, this book will not discuss how to set up your computer, printer, or e-mail account; I fully understand that these are important concepts for most digital photographers, but they are beyond the scope of this book. I've kept the focus here on technique—on how to make better photos with a digital camera while out in the field.

If you are converting from film photography, you may recognize many of the topics that we explore. That's because many aspects of exposure, composition, and lighting apply equally to both film and digital photography. All the same, digital photography introduces a few new quirks that we'll discuss in detail. By presenting both the traditional principles of photography and these digital aspects, this book is the perfect starting point for any photographer, whether you've been shooting film for a while or you are just now getting into photography for the first time.

A QUICK LOOK AT EQUIPMENT

I'm assuming that you already own a digital camera. The real question is, What kind of digital camera do you own? There are a few major types:

COMPACT DIGITAL CAMERAS. I refer to these as *digicams* from time to time throughout the book, and less frequently as *point-and-shoots*. These cameras are very small and usually feature a zoom lens, the ability to creatively control aperture and shutter speed, as well as a few other fun features. However, what you see through the viewfinder of this type of camera often is not exactly what you will get in the final composition.

DIGITAL SINGLE-LENS-REFLEX (SLR) CAMERAS. These are bigger and bulkier than the compact cameras but much more flexible and powerful

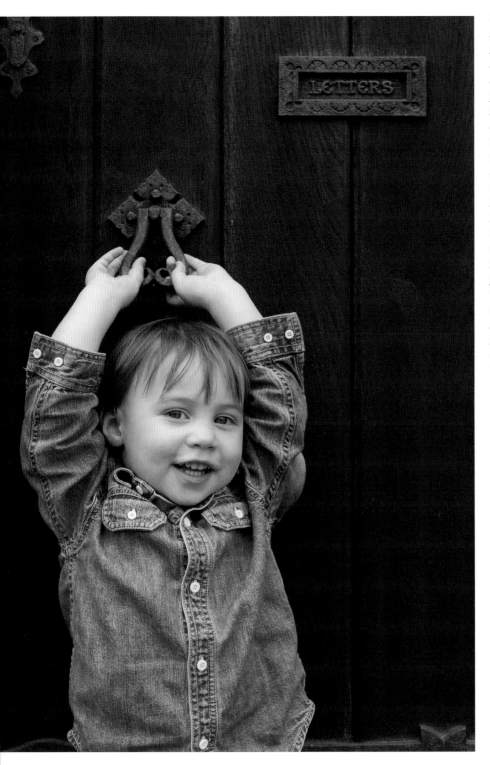

One of the great advantages of shooting digital is that, because there's no expense on film and developing, you can shoot almost as much as you like. All you need to do is come prepared with plenty of memory-card storage. This freedom is truly one of the great benefits of shooting digitally. For example, as we walked down a village lane in the Cotswolds in England, my son discovered this interesting doorknocker. I was free to make countless images of him as he approached and played spontaneously with it. The entire time, I didn't have to worry about wasting film and spending a fortune having my pictures developed.

1/125 SEC. AT f/5.6, ISO 100, 16–35MM LENS AT 35MM

when it comes to getting creative with your photography. What you see through the viewfinder is what you get in the final image. This makes it easier for you to clearly see when the subject is in focus and when the scene is composed exactly the way you want it to be composed. These cameras are designed so that you can use a variety of lenses, giving you ultimate flexibility when it comes to image magnification. The fact that you can get extremely close to distant subjects with a particular lens is just one of the many benefits of an SLR. Furthermore, they do not suffer from shutter lag—the delay that some compact digi-cams have when the shutter button is pressed.

CELLULAR CAMERA PHONES AND LOW-END POINT-AND-SHOOT CAMERAS. Although these fun kinds of digital cameras have been limited and low quality in the past, many manufacturers are beginning to add interesting features, such as zoom lenses and higher pixel resolutions. You may not be able to control some important settings when using these cameras, but you can, at the very least, apply my guidelines on composition, lighting, and subject selection.

Regardless of which kind of digital camera you use, this book will help you take better pictures. If you want to get especially creative, the camera should feature the ability to easily change aperture and shutter speed.

For most of my photographic work, I use a digital SLR—and I highly recommend it. With this kind of camera, you can take amazing photos with great ease and convenience. If I ever were to steer someone toward a compact digicam, the reason would be that the size of such a compact camera makes it much easier to carry around than a SLR. If the bulkiness factor keeps you from taking the camera with you everywhere you go, then by all means, get a smaller camera.

If you already have a compact digicam, don't worry about it being too limited. Simply try the guidelines and techniques presented in this book and see how it goes. If you find that your camera does a great job, run with it. If you decide that you'd like more "power" and don't mind the additional bulk, upgrade to a digital SLR. Today's market offers several SLRs and price ranges to fit your budget.

We'll discuss features that are nice to have in your camera in the first chapter, but for now, the most important functions are the ability to control aperture and shutter speed. This particular kind of creative control will take you a long way when it comes to capturing unique and beautiful images.

If you don't already have a digital camera and are turning to this book for guidance in that arena, no problem. I can help you. Simply turn to the Digital Camera Buyer's Guide at the back of this book.

Other than a good camera, all you need is a memory card and a tripod. With printing kiosks

A Note about the Images

I made all of the images in this book with a digital camera. I resisted the temptation to include scanned versions of my older slides because I wanted you to see firsthand that you can create excellent images digitally. And, to drive home that point, most of the images reflect the original in-camera composition; in other words, I didn't crop them after I made them to improve the composition. Only a few images in the chapter on composition, and a few others that I designate as cropped in the caption, were trimmed after the fact.

What's more, I made all of these images with an *affordable* digital camera. While most of the photos were created with a digital SLR, it was not an especially expensive camera. My point is that you too can create these kinds of images. Don't allow yourself to think, "Oh sure, he can do it because he has such an awesome camera. I can't do that!" While equipment is important, how you use the equipment you have is more important.

practically on every corner, you don't even really need your own computer or software. As I mentioned earlier, you can simply take your camera or memory card to one of these kiosks to have your favorite photos printed.

I SEE, I HEAR, I DO: LEARNING BY EXPERIENCE

The guidelines presented in this book come from practical experience. If I haven't tested it out myself, I'll tell you. Having said that, these guidelines are just my personal thoughts and opinions. To really learn these concepts and make up your own mind about each technique, I encourage readers to go out shooting. That's why you'll find, at the end of each section, an exciting photography assignment. For each principle that we explore, the corresponding assignment will help you make it your own.

There's an old saying by Confucius that I just love:

I hear and I forget. I see and
I remember. I do and I understand.

Let this be our mantra while we learn digital photography. Take each assignment as an opportunity to overcome—once and for all—the fears, doubts, and confusions that you have about digital picture-taking. After you've completed each assignment, share the photos with your friends and family, and feel free to upload them to the BetterPhoto online discussions or contest (go to www.betterphoto.com). I look forward to seeing what you yourself create when you put these guidelines into practice.

I'm thrilled that you've decided to take up digital photography. There's a reason why digital photography is quickly becoming America's #1 hobby—taking digital pictures is fun! The new technology makes it easier to get more satisfying photos and to learn more efficiently from your mistakes. Two of the best features—that digital cameras give immediate feedback after every shot (via the LCD screen) and that they automatically record camera settings (via EXIF data, see page 27)—are alone

worth their weight in gold. These two features help the beginning digital photographer learn quickly and make many stunning photos in the process. And, as far as camera features are concerned, that's just the tip of the iceberg. So, let's get to know your camera better and explore a few things that you'll come to love more and more as you grow into an expert digital photographer.

A Dozen Quick Tips to Get You Going

❏ Take the camera with you everywhere you go (see page 42)

❏ Get *and use* a tripod (see page 76)

❏ Get as much memory-card storage as you can afford (see page 55)

❏ Use the LCD screen to proof your images immediately after you capture them (see page 24)

❏ Learn how to view EXIF data and use it to improve (see page 27)

❏ Use the raw format if you have the memory space and prefer full control over each image, though this may cause greater complication when processing your images on the computer (see page 52)

❏ Use JPEG as your file format if you are limited on memory or feel overwhelmed enough as it is (see page 47)

❏ Set your camera to a mode that gives you some degree of control and doesn't make all the decisions for you (see page 102)

❏ Move in close to fill the frame with your subject (see page 138)

❏ Use the Rule of Thirds and turn to the vertical orientation from time to time (see page 156)

❏ Shoot from unique points of view (see page174)

❏ Take note of the light illuminating your scene, and be sure to take advantage of the special light at the beginning and ending of each day (see page 116)

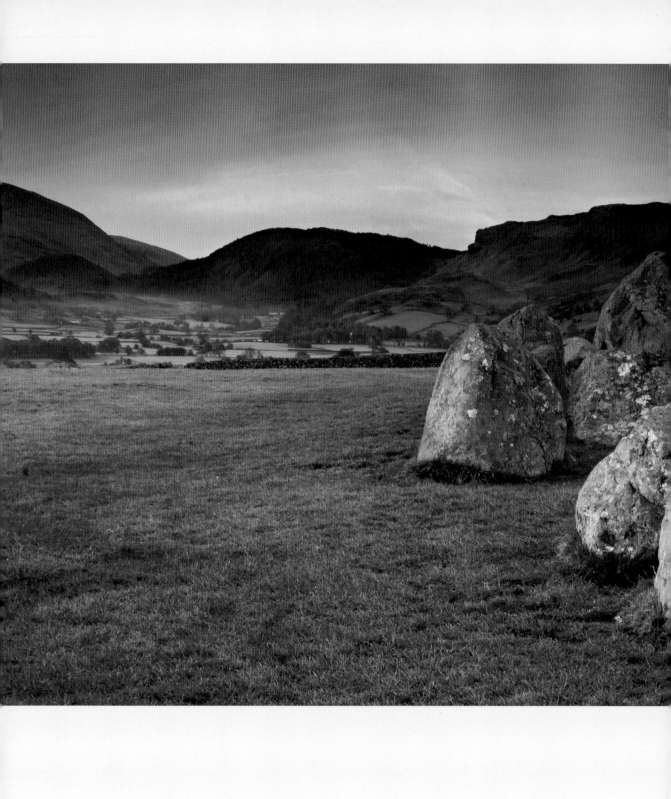

Getting to Know Your Digital Camera

AS DIGITAL CAMERAS become more affordable and of higher quality, countless people are turning to the thrilling hobby of photography. And, with so many people expressing an interest by investing their hard-earned dollars in a new digital camera, camera manufacturers are coming out with more and more models and an ever-expanding array of features. The sheer number of digital cameras on the market might make you feel so overwhelmed that you forget to learn what your particular digital camera can and cannot do. That's why it's important to get to know your digital camera features inside and out—without further delay. Don't worry if you don't understand what all of these camera features do or how they function. The first step is to understand what you have to work with.

To get some morning shots of Castlerigg, a stone circle in England's beautiful Lake District, I woke up before dawn. My goal was to have both evening and morning photos for comparison and a study of the light. After making several images with a wide-angle lens that encompassed the entire scene, I noticed the mystical, low-lying tulle fog in the distant valley. I focused on just a few of the standing stones so that I could include more of the background, and used a graduated filter to add some color to the pale early-morning sky. The LCD screen helped me place the filter in exactly the right position.
1/2 SEC. AT f/19, ISO 100, 28–105MM LENS AT 30MM

Your Particular Kind of Camera

THE ODDS ARE very likely that you either use a digital single-lens-reflex (SLR) camera, a compact digicam, or a cellular camera phone. As these are three very different kinds of cameras, it's important for you understand the limitations and advantages of each type.

Digital SLR cameras tend to be big and bulky. The three digital SLR features that I most enjoy are: (1) the ability to use a variety of lens; (2) the advantage of a viewfinder that shows exactly what the camera sensor sees; and (3) the ease with which I can change aperture and shutter speed.

This is not to impugn those of you with *compact digicams*. In addition to usually being less expensive than SLRs, digicams are extremely easy to carry with you—fitting into your shirt pocket or purse. They streamline the picture-taking process by giving you everything you need in one small package and by offering a variety of automatic features. The highest quality digicams can create pictures that are just as good or better than images from some digital SLRs. Most importantly, because they're much more compact, digicams tend to travel with their owners more often. That's key—you need to bring your camera everywhere you go because . . . well . . . it tends to come in handy when taking pictures.

Cellular camera phones are extremely convenient and are great for those who simply want to have fun and share photos with friends and family. Instead of carrying around two items—a camera and a phone—you get to combine them into one ultracompact accessory. Camera phones have been limited in the past, but as the technology advances, the better models will feature more creative controls and functions.

Whichever digital camera you own, you need to become familiar with its features. So let's take a look at the controls and functions that will most help you create the best digital photographs you can. To begin, first take the Camera Capabilities Questionnaire on pages 16–17; it will give you a sense of how familiar (or unfamiliar) you are with your camera, while showing you what your camera can do.

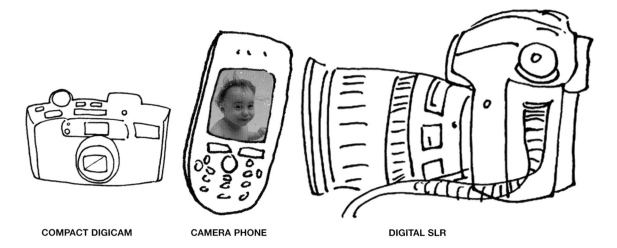

COMPACT DIGICAM CAMERA PHONE DIGITAL SLR

This is a good example of the kind of image you can conceivably make with just about any camera. This photo is not as much about aperture, shutter speed, and other creative controls as it is about composition. When used in combination with the classic principles of composition, any camera can create eye-catching images.
1/60 SEC. AT f/4.5, ISO 100, 100–400MM LENS AT 100MM

Camera Capabilities Questionnaire

Before you get to the art of taking digital photos, you need to learn about what your camera can and cannot do. Scan the following list and try to first answer each question from memory. Once you're done, review your list and see how many you knew. This will give you an idea of your current product knowledge.

For the questions you can't answer, it's time for a little research. Look in the owner's manual that came with your camera. If you don't find the answers you are seeking, I recommend visiting the manufacturer's Web site and looking at their sales and marketing information. If your camera is fairly new, you might also find brochures and sales literature at a local camera store. The idea here is that if the technical folks who write the manuals are difficult to understand, turn to the people on the marketing team. They often do the best job explaining the features and benefits to the customer. After all, their jobs depend on it.

If you still are uncertain about your camera's features, check out BetterPhoto.com's equipment reviews section. It's full of camera comparisons, explanations of camera features, and technical specs to help you understand which camera does what.

Don't let yourself feel overwhelmed if some of the terms on this checklist are new to you. After all, that's why you're reading this book—to learn what these terms mean and how to use the features in your future photographic endeavors. The intention of this exercise is not to make you feel intimidated. Rather, the idea here is to make you more aware of your camera's abilities and your own picture-taking interests.

1 First, what *type* of camera do you use? A digicam (point-and-shoot), a digital SLR, a cellular camera phone, or some other kind of digital camera?

2 Which features does your camera offer?

_____ Color LCD screen

_____ Playback zoom (the ability to use the LCD screen for zooming in for enlargement/detail views)

_____ The ability to display and change camera settings on the LCD screen

_____ The ability to display histograms on the LCD screen

_____ Tripod mount (to attach the camera to a tripod)

_____ Focus lock (for recomposing scenes after locking focus on a subject)

_____ Aperture priority (the ability to set an aperture of your choosing)

_____ Shutter priority (the ability to set shutter speed of your choosing)

_____ The ability to control ISO *

_____ Spot-meter mode and exposure lock

_____ Exposure compensation

_____ Bulb setting and self-timer or remote control

_____ The ability to shoot in JPEG, TIFF, or raw formats

_____ Compact flash card, SmartMedia, xD-Picture Card, Memory Stick, or another storage format

TIP: SHOOT IN COLOR

If your camera features the option of taking black-and-white pictures, shoot in the color mode instead of this black-and-white mode. It's relatively easy to remove color later using software, but you have to be an artist to add color back into a black-and-white image.

_____ Zoom lens (or interchangeable lenses for SLR users)

_____ Digital zoom as well as optical zoom (for non-SLR users)

_____ Macro mode or macro lens

_____ Lens threads to allow the use of filters

_____ The ability to control white-balance settings

_____ EXIF data recording

_____ The ability to view EXIF data via the camera

_____ Black-and-white, sepia, and/or infrared modes

_____ Hot shoe for external flash

_____ PC port for studio lighting sync cord

_____ Mirror lock-up (for SLR users) **

3 What is the maximum resolution (pixel dimension), and what, if any, are your pixel resolution options (e.g., Large, Medium, Small)?

4 What are the quality-setting options for JPEG capture (e.g., SHQ, HQ, S1, S2, Fine, Normal, Standard)?

* Digital SLRs usually have higher ISO options than compact digital cameras, and they generally produce less noise in the upper ISOs. (See page 66 for more on noise.) However, compact digital cameras often can create cool, surrealistic infrared images, whereas many digital SLRs cannot.

** Mirror lock-up is found only on SLR digital cameras. Photographers who want maximum depth of field use it from time to time to help keep their camera especially still and, thus, their images tack sharp.

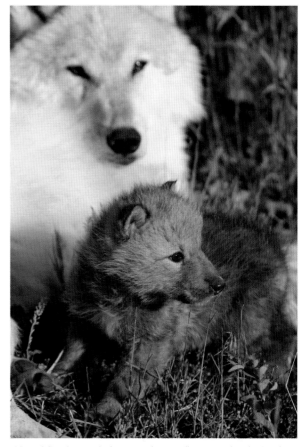

When I first learned photography, reading great books by the likes of John Shaw and Bryan Peterson, I often wondered how they remembered the exposure settings that they noted in the captions under each picture. Later, I learned that they usually carried a notebook and jotted down these settings after creating each photograph. Still, that seemed to me to require a great deal of organization and mindfulness. Without noting the data in this way, I would never have remembered the exposure settings and lenses used for these images if not for the EXIF data recording feature found in my digital cameras. In each situation, I was working too fast to stop and take notes. Thanks to the EXIF recording feature, this task was automated and made easy for me. In fact, I retrieved all the camera settings listed in this book from the EXIF data. (See page 27 for more on EXIF data.)
1/350 SEC. AT f/5.6, ISO 100, 100–400MM LENS AT 250MM

Lens Options

NOW THAT YOU'VE FINISHED the Questionnaire and familiarized yourself with your camera, let's start in earnest by examining three features in detail: the lens, the LCD screen, and EXIF data recording and viewing. We'll start with lenses.

Lens selection is discussed more thoroughly in chapter 6, and you can also learn more about this in the Digital Camera Buyer's Guide on page 206. For now, it's important to know where you stand with the lens on your current digital camera. Once you have this knowledge tucked away, along with the other features from the Camera Capabilities Questionnaire, you can begin taking pictures with more and more success.

Depending on which kind of camera you use, you may or may not have options when it comes to your lens. In traditional 35mm terms, lenses with a focal length of around 28–35mm are considered *wide-angle* lenses. Lenses in the 50–80mm range are *normal* or *standard.* When you get into the 100mm and above range, you're talking about a *telephoto* lens.

In addition, there are three different kinds of lenses: *fixed focal length* lenses, *in-camera zoom* lenses, and *interchangeable* lenses. Cameras with more limited features often only have a *fixed focal length* lens. This means that you have no choice when it comes to lens focal length. All you can do is walk closer to or further from the subject when composing a picture. Due to space limitations, most cellular camera phones feature a fixed lens. Due to cost restrictions, less expensive digital point-and-shoot cameras usually have no more than a fixed lens.

The images on the next three pages show what you can do with various focal lengths on your digital camera lens. With a wide-angle lens, you can capture expansive vistas, as in this image of the sky and a line of cowboys.
1/125 SEC. AT f/4.5, ISO 100, 16–35MM LENS AT 35MM

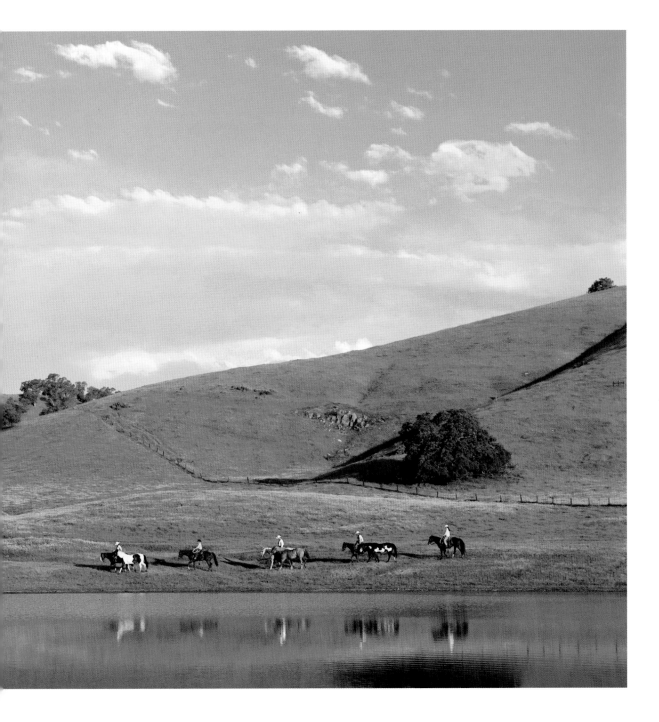

If you bought a digital point-and-shoot that has a zoom lens (*in-camera zoom*), you can get closer to your subject at the touch of a button. Most of these cameras allow you to get fairly wide-angle pictures but are still somewhat limited on the telephoto end of their range. Zooming in as far as you can go may still not bring you close enough to your subject. If you have both an optical and a digital zoom option, it is generally safest to avoid using the digital zoom; but, having said that, there are times when the digital zoom feature can be useful (see pages 144–147 for more about this).

Interchangeable lenses are found on most digital SLR cameras. These are lenses that you attach to and remove from the camera, exchanging one lens for another instead of just zooming in or out. As each lens can be expensive, this option can end up costing more in the long run but can give you the most flexibility and power when it comes to lens selection.

This is the option that I use and recommend to most people. If you greatly enjoy photography and continue to learn and improve, you'll most likely appreciate a camera with this kind of flexibility.

A Note about Focal Lengths

Many digital point-and-shoot cameras refer to focal length with very small numbers, such as 9mm or 14mm. If you've been shooting with a film camera for some time and are used to thinking of 14mm as a super wide angle, you'll need to learn to translate the focal lengths on your new digital camera. When you see such small numbers, it means that you have a camera with a different focal length scale. Refer to your owner's manual or to sales information on the manufacturer's Web site to learn the 35mm focal length equivalents.

I used a telephoto lens here and got fairly close to the subject.
1/750 SEC. AT f/10, ISO 400, 100–300MM LENS AT 300MM

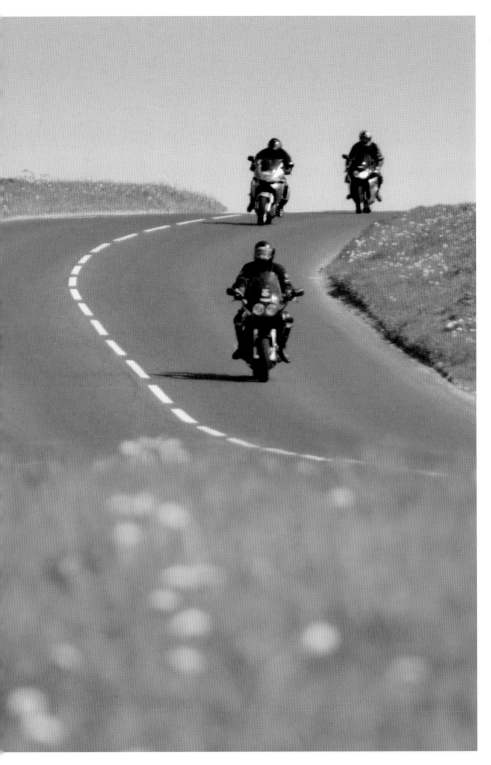

Thanks to a powerful tele-photo lens combination and the lens magnification factor found in most digital SLR cameras, I was able to fill the frame with these three motor-cyclists, even though they were very far off in the dis-tance. Using a 100–400mm lens at 210mm, with a 2X teleconverter, I was looking through the equivalent of a 700mm lens (in 35mm terms). This extreme magnifi-cation allowed me to create a tight composition of the three riders and the road.

Also, telephoto lenses and focal lengths tend to compress the foreground and background elements together. In this case, this compression makes the motorcyclists appear all that much closer to the foreground grasses and the viewer.

Just remember one thing if you shoot at such extreme focal lengths: always use your tripod. Camera shake (moving the camera during exposure) is, by far, the number one reason why beginners walk away with many blurry photos. Shooting at extremely tele-photo focal lengths requires a particularly fast shutter speed, a sturdy tripod, or both. Even if your lens features image-stabilization technology, it's difficult to get crisp photos at telephoto lengths while handholding the camera.

1/180 SEC. AT f/10, ISO 100, 100–400MM LENS AT 210MM, 2X TELECONVERTER

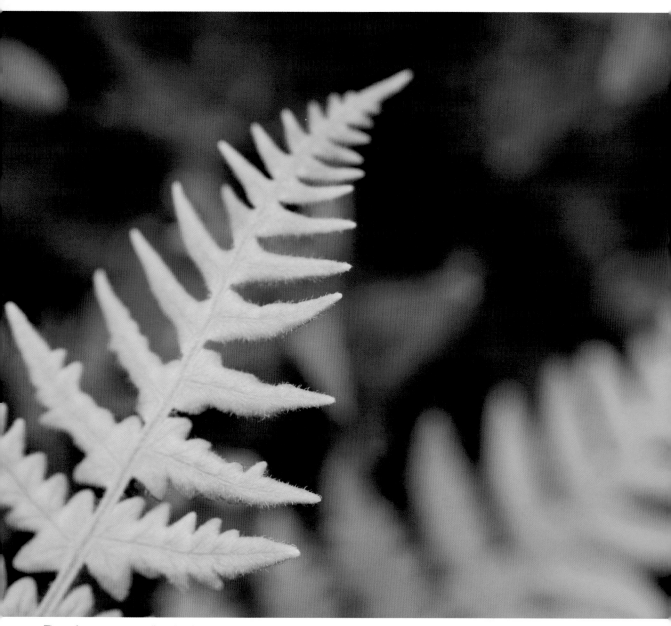

These ferns were actually quite tiny. Using a 100mm macro lens, I placed the camera on a tripod and set it about a foot and a half away from the plant. With the goal of having the distant frond softly echo the foreground one, I selected a small f-stop for shallow depth of field (see chapter 4 for more on exposure and depth of field).

1/90 SEC. AT f/2.8, ISO 100, 100MM MACRO LENS

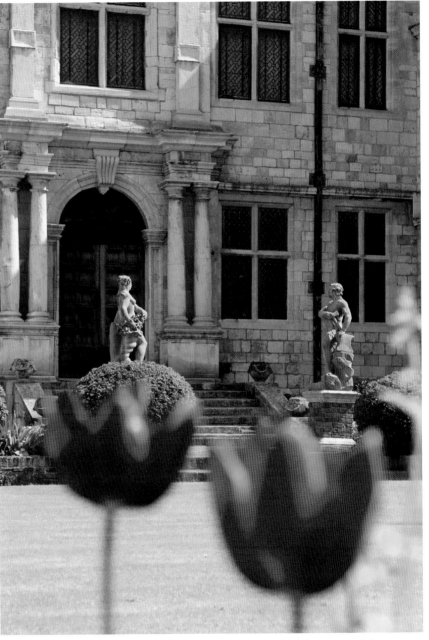

For this photo, I used what many photographers refer to as their "street zoom" lens, a mid-range 28–105mm zoom. I chose a "normal" focal length of 58mm, got on the ground to take advantage of a low point of view, and took the picture. My goal was to include the tulips as an out-of-focus splash of color.

1/180 SEC. AT f/6.7, ISO 100, 28–105MM LENS AT 58MM

The LCD Screen

HOW DO YOU KNOW when you've captured a successful photo? One way is to make good use of the LCD (liquid crystal display) screen on the back of your camera. Everyone who has seen or used a digital camera knows how exciting it is to be able to view your images right on the spot. In fact, this is one of the greatest things about shooting digitally. Much more than simply giving you the joy of immediate gratification, the LCD screen actually helps you learn how to become a better photographer.

The LCD screen is the little one- to two-inch color monitor usually located on the back of the camera. Some people refer to this as an *LCD viewfinder*, but I prefer to call it an *LCD screen* for reasons I'll discuss in a moment. The LCD screen is the most important feature of shooting digitally. In the old days of film photography, serious students interested in learning photography had to carry little notebooks with them everywhere they photographed, carefully jotting down aperture, shutter speed, frame number, and other notes each

This is what the LCD screen looks like on the back of a digital SLR. If you're using a digicam, things may look a little different, but the general idea is the same.

Keeping Your LCD Screens Straight

Don't confuse the LCD screen with the monochrome LCD panel that displays things like shutter speed, aperture, and images remaining on your storage card. On my digital SLR, the monochrome LCD panel sits on the top right side of the camera body, near the shutter button. On some cameras (digital point-and-shoots), the LCD screen also functions as the LCD panel described here. A separate LCD is more common on digital SLRs.

time they took a picture. After getting the slides or prints back from the photo lab, photographers would sit down and compare those notes with the results. They went through this tedious process to learn which settings created which effects.

What a cumbersome learning process! Now, with the immediate feedback of the LCD screen, you can get a fair idea of what is happening with your settings—while you're still on location. So, you get two important advantages when using the LCD screen: (1) you get to learn by immediately seeing the results, and (2) you then have the opportunity to reshoot to correct what wasn't successful (providing your subject is still cooperating).

As much as I love the LCD screen, I don't use it as a viewfinder. This eats up battery power like there's no tomorrow. Also, it can increase the likelihood of taking blurry pictures, since holding the camera away from your face tends to make it less stable. I know what you're thinking . . . squinting through the tiny viewfinder can be a pain. But using the optical viewfinder will keep you shooting a lot longer before you need to recharge and will increase your chances of getting tack-sharp photos.

If you're using a digicam, however, there are two exceptions to this. First, when the lens is zoomed out, part of the lens may interfere with the view in the optical viewfinder, necessitating use of the LCD screen as the viewfinder. And second, when doing macro (close-up) photography, you may encounter the parallax problem. *Parallax* is when you see one thing and your lens sees another (so what you see in your viewfinder does not match the final image exactly). This problem becomes worse the closer you get to your subject. To help you get the composition you want, many cameras will automatically force the LCD to come on when you turn the macro mode on. In these two instances, digicam users might opt to use the LCD screen as the viewfinder.

For those of you with digital SLR cameras, on the other hand, what you see through the viewfinder is what you get. You look though the picture-taking lens and see exactly what the sensor "sees." With these types of cameras, you never need to use the LCD screen as a viewfinder, even when doing macro photography.

TIP: LCD SETUP

Set up your camera so that your LCD screen immediately displays each photo after you take it so that, when you have the time, you can review each image just after shooting it. As mentioned before, there's no better way to learn the effects of your various camera settings. When you make adjustments to your camera settings, make a mental note of which settings you changed and what kinds of photos those settings helped create. Then, if necessary, shoot again to create an even better photo.

When the day is done, use your LCD screen again to review your work. You may want to erase the duds, but be careful! The screen only gives you a rough idea of the image, so only erase those images that are really, really bad—i.e., the totally blurry or totally black ones. If you're unsure, keep the image until you have a chance to view it at 100 percent magnification on your computer monitor or a large TV screen.

Having a Hard Time Seeing the Screen in Sunlight?

If you have difficulty seeing the LCD screen when you're shooting outdoors, try moving to a spot in the shade. If you still find yourself straining to see your images, try one of the following:

❑ Purchase special accessories designed to block out sunlight so that you can see the LCD screen better.

❑ Use a 4x loupe. Loupes are handheld magnifiers used by film photographers to review slides on a light box. Get a 4x rectangular loupe with a neck strap, cover any clear sides with black tape if you need to, and position it over your LCD screen when reviewing images. You'll find it both magnifies the image and makes the screen darker—and, thus, easier to view.

WHAT TO WATCH FOR IN THE LCD

When you're viewing an image in the LCD screen, you need to know what to look for. Here is a brief checklist of things I pay attention to when reviewing my work on the screen:

- **Brightness.** I want to know as soon as possible if I'm exposing the scene too dark or too bright.

- **Composition.** I quickly scan the edges to see if any part of my subject is being cut off. I also look for slanting horizons, an overabundance of negative space, distracting elements, and other compositional faux pas.

- **Major blur.** If I see major, unintentional blur, I know to immediately try the shot again. The second time around, I work harder to ensure that the camera is as stable as it can possibly be.

- **Minor blur.** Many cameras let you zoom in to view one portion of the image. If you're unsure about the sharpness of a photo—and you have a camera with this zooming LCD feature and have sufficient time between shots to look more closely—use this feature to zoom in on one particular part of the photo and view it on the LCD screen. This will help you get a better idea of overall focus.

The one thing you have to watch out for when viewing images on your screen is what I call *LCD distraction*. This is when you are so busy reviewing the images you just took that you miss an even better shot. If you decide to review your photos while there's still a chance for a subsequent photo op, keep one eye on your subject at all times. If you have a friend nearby, you might also ask him or her to watch the subject for you, alerting you when anything interesting begins to happen. This comes in handy when photographing kids, whose attention can drift from time to time, only to return to the camera when you least expect it. Better yet, refrain from closely reviewing your images until later.

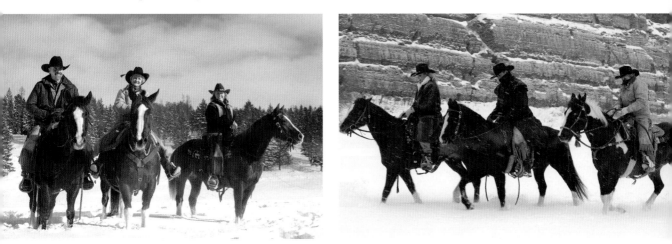

In addition to watching my LCD screen for problems with exposure, composition, and sharpness, I also keep an eye out for other kinds of problems. After photographing these three ranchers, I viewed the image in the LCD, and something just seemed wrong. I finally realized that everyone looked too posed. There was no dramatic energy or "story." The next day, determined to get more involved, I asked the ranchers to act cold, unhappy, and frustrated as they rode in the snow. They ended up having a lot of fun, and the result was much more engaging.

LEFT: 1/180 SEC. AT f/8, ISO 100, 28–135MM LENS AT 28MM; RIGHT: 1/125 SEC. AT f/6.7, ISO 400, 28–135MM LENS AT 47MM

EXIF: A Confusing Acronym for a Very Cool Feature

THE MOST INTIMIDATING thing about EXIF data is the name—Exchangeable Image File Format—and like many computer acronyms, it leaves something to be desired. It's not as user-friendly as it could be. Once you get around this poor name though, the topic is more understandable.

EXIF, also called *metadata*, refers to technical information that is embedded along with an image. On most digital cameras, EXIF automatically records details such as shutter speed, *f*-stop, ISO, flash mode, file dimensions, file format, camera type (in case you use several different cameras), and more tidbits about how each image was created. You can even see the camera-to-subject distance and the focal length used. It's a pretty cool feature. In fact, without it, I would not have been able to tell you the technical details of all the images in this book.

The great thing about EXIF is that you don't ever have to remember things like what shutter speed and aperture you used. Remember the poor film photographer who had to schlep a notepad around and write the image specs in it after every shot? For digital photographers, that is thankfully a thing of the past. With these details being automatically recorded for digital photographers, it becomes that much easier to learn how certain creative choices help, or hinder, when it comes to achieving particular photographic goals.

HOW TO VIEW EXIF DATA

Now, all you need is to figure out how to view this information. As automatic as the recording of EXIF data may be, viewing it can be slightly tricky. There are a few ways you can get at this stored information. With many digital cameras, EXIF data can be viewed in the LCD screen. Check your owner's manual to see if you can do this. Or, if you own the most recent version of Photoshop, EXIF data is displayed in the program's File Browser feature. Or, you can use EXIF Image Viewer, which is a simple image-viewer program that you can download off the Internet for free; there are actually several image-viewer programs, so do a search to find the one you like best.

ASSIGNMENT Familiarize Yourself with Your Camera and Learn How to View EXIF Data

1 If you haven't already done so, complete the Camera Capabilities Questionnaire on pages 16–17. When you're done, go to the BetterPhoto.com Reviews section, find your camera model, and list your favorite features along with some of your own comments about the camera. The benefits will be twofold: you will reinforce your understanding of how your camera works and you'll be sharing that knowledge with others.

2 Then, make sure you know how to view EXIF data. Check your owner's manual, and if you can view the data on your LCD screen, familiarize yourself with how to do it. If you can't access the data with the LCD, spend a little time investigating image-viewer programs or Photoshop. Develop the habit of viewing this data frequently to learn which setting creates which particular effect.

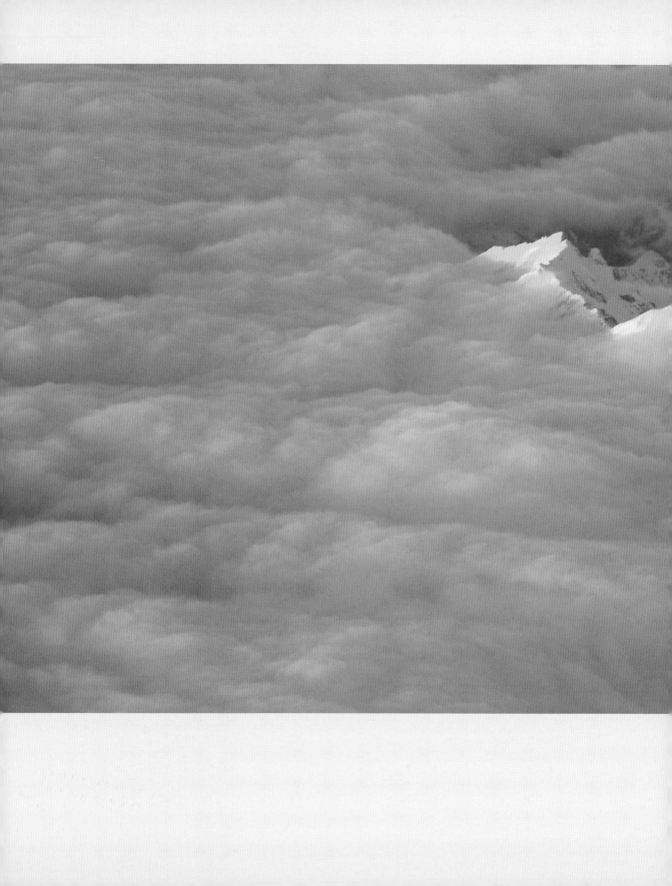

Figuring Out What to Shoot

"Would you tell me, please, which way I ought to go from here?"

"That depends a good deal on where you want to get to," said the Cat.

"I don't much care where . . . ," said Alice.

"Then it doesn't matter which way you go," said the Cat.

—from *Alice's Adventures in Wonderland* by Lewis Carroll

Have you ever felt frustrated because you didn't know what to photograph? Or perhaps you have an overall subject in mind but can't figure out what "spin" to put on it. Deciding what subjects to approach—and how to approach them— is a huge part of being a great photographer. After all, the first step in creating successful photographs is determining what you're trying to capture. Like Alice, until you define a vision, or even a small inkling of a goal, you won't know which way to go—and you'll have a difficult time making all the creative decisions regarding exposure, focus, lighting, and composition. Over the years, I've discovered a host of tricks to get my creative juices flowing. Whenever you feel stuck in the mud, read this chapter.

I took this photo when I was flying home from a photography field trip. I prefer to carry my camera gear with me rather than check it, and therefore, I had my camera on hand to capture this heavenly scene just before the sun set. Here's a tip: When photographing through a window, move as close as you can to it; this will minimize any distortions caused by dirt, scratches, and debris on the glass (or plastic). It also helps to use a longer lens and, if you're shooting with a digital SLR, to use a lens with image-stabilizing technology.
1/125 SEC. AT f/4.5, ISO 100, 100MM MACRO LENS

Previsualizing and Planning

I FIRST LEARNED the term *previsualizing* from studying the writings of Ansel Adams, and it has certainly paid off over the years. Adams used the term to describe the act of allowing yourself to imagine, ahead of time, what kind of photograph you are most interested in capturing. Instead of simply responding to events or scenes as they present themselves, the idea is to think ahead about what visual goals most inspire you.

This previsualizing challenges you to anticipate what could happen and how you might control your camera to create new, unique, and satisfying images. Even though something different might (and probably will) happen, and you could likely end up with a completely different photo than you had envisioned, this process opens up hidden wellsprings of inspiration. By simply putting thought into what you would like to capture, you make it that much easier to achieve your photographic goals.

This creative visualization is both fun and rewarding. Allow yourself to get playful and excited, thinking "outside of the box." Sit down and brainstorm about potential photographic subjects, as well as about how to capture these subjects in unique and attention-grabbing ways. And, trust that you will be provided with everything you need to achieve your photographic goals. All you have to do to realize those goals is to sit down and define them.

As soon as you have a rough idea of what you would like to photograph, go somewhere. Simply head out the door for the day, or take a long trip. Either way, get out to a new and exciting place. The idea here is to go places in order to find subjects that inspire you to photograph. You may not need to go far. In some cases, taking your kids to the park will be all you need to get the creative juices flowing. At other times, in order to feel totally inspired and stimulated, you'll need to go somewhere you've never gone before.

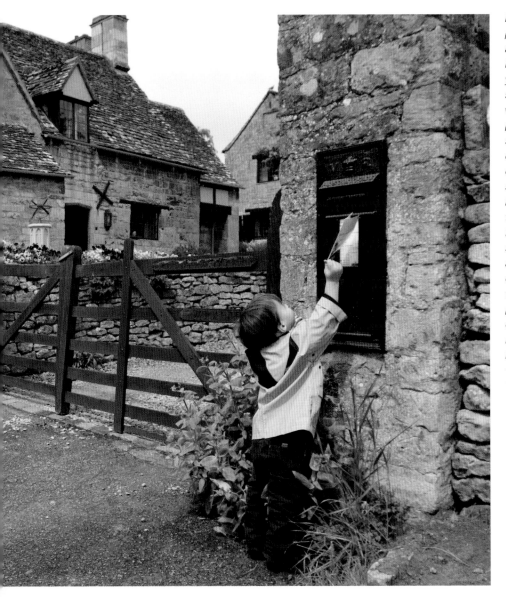

Don't hesitate to help a photo along if it needs a little something extra. No one's going to judge you if you take proactive steps to get exactly what you want. For this photo, I put a yellow rain slicker (that we had been carrying with us throughout England) on my son, gave him a tourist brochure, and asked him to "mail it." As he tried, I quickly backed up and shot several images using a fairly wide-angle setting on my lens. I placed him in the lower right of the composition to get as much of the charming Cotswold neighborhood in the background as I could.

1/250 SEC. AT f/8, ISO 100, 16–35MM LENS AT 16MM

Getting away also helps by minimizing distractions. Especially when taking a long trip, you quickly forget about the laundry, your duties at work, sifting through e-mail, or answering the phone. You leave the "To Do" list behind, which allows you to think only about taking great photos. This simplicity can give you the kind of clarity you need to feel creative. However, it is important that your mission is *to get great photos*, rather than to get away from it all. Going on a vacation on which you do nothing but relax by the beach and take an occasional picture does not qualify. You have to be a bit dedicated to photography.

It's important to fully understand that such trips are "work." In order to get the great pictures, you'll need to be "on" all the time, constantly thinking about what you can photograph and how you can make it look interesting. You'll often be required to wake up early, and skip breakfast (and sometimes dinner, too), settling for the occasional snack instead. That doesn't mean you can't have fun, though. After all, photography *is* fun! When the photography gets especially laborious, I remind myself that you can't have play without work. You can't have one without the other. And I know of no work more fun than photography.

Keeping a Visual Notebook

One excellent way to define your goals is to keep a collection of images that inspire you. You could simply write down a list of photo ideas, but as photographers are generally visual people, it's usually more effective to collect pictures.

Subscribe to magazines or visit the library. Look though catalogs, books, and Web sites like BetterPhoto.com—anything with the kind of photographs you enjoy. Examine these photos and pay attention to how they make you feel. Whenever an image causes an emotional response in you, make a note to remind you of that photo. Better yet, print the photo off the Web site, make a copy, or cut it out so that you can place it into a protective sleeve and keep it in a binder. This will provide you with a running book of photo ideas to which you can turn whenever you need inspiration. The images below—by Bill Neill and Nick Kelsh—have certainly inspired me.

Although it takes time and effort to plan ahead in this way, making a photo idea binder is fun to do, and it plays a powerful part in helping you make great photos. It helps you clarify, in your mind's eye, the subjects you most love.

TIP: PLAN—BUT BE FLEXIBLE

As I've just explained, planning is good—and necessary to the photographic process. But having said that, don't be so inflexible that you overlook and miss unplanned photographic opportunities. Sometimes, what you've planned doesn't materialize, but that doesn't mean other—possibly better—subjects won't present themselves. You need to be ready for, and open to, anything.

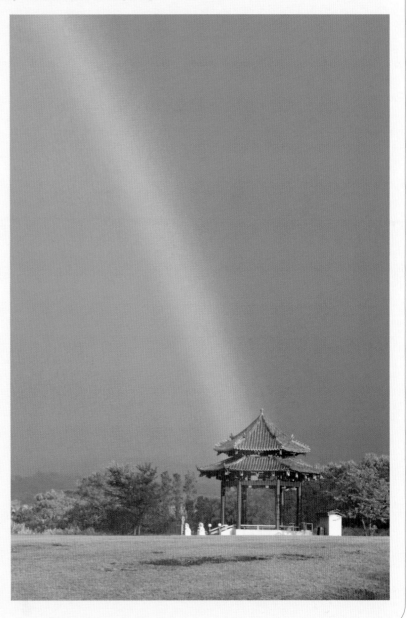

On a recent trip to Kauai, Hawaii, I woke up one morning before dawn and drove down the island to go scuba diving. I was specifically interested in photographing the beautiful underwater sea turtles. On the way down, I passed the community college and noticed a rainbow near an outdoor gazebo. I immediately pulled the car over and ran back to the exact spot at which the lower end of the rainbow appeared to touch the gazebo. I mounted my camera securely on a tripod and made several exposures, experimenting with both horizontal and vertical compositions.

Once I felt satisfied that I had captured the shot, I continued to the scuba diving site. The actual dive turned out to be a photographic disaster: After only one underwater exposure, my camera malfunctioned, and I was forced to drag along a nonworking camera for the remainder of the dive. What's more, I encountered many sea turtles and I couldn't make a single picture of them! However, the trip was not a total loss, because although I didn't get the shot that I was specifically seeking, I did come home with a beautiful image of this rainbow and gazebo.

1/250 SEC. AT f/6.7, ISO 100,
28–105MM LENS AT 105MM

Photographing What You Love

TO CONTINUALLY ENJOY the work of photography, it's essential that you photograph *what you love*. Resist the temptation to photograph things just because the pros do it. Photographing nudes in black and white with expensive equipment, for example, won't necessarily play a big part in getting others to take you seriously as a photographer. What matters most is the vision you bring to the table—and your persistence.

Photographing subjects you love—whether they happen to be nature scenes, your kids, your pets, or local wildlife—will help you develop your own ideas and will help you persevere when the going gets tough. Focus on what you love and the great photos will eventually follow.

PEOPLE

For success with photographing people, one of the best and easiest things to do to is to move in closer. Simply focusing on your subject's face or eyes will eliminate any distracting surrounding details. You can also move in closer on an object that means something to your subject, such as a child's favorite toy. Or, if there's a favorite outfit of your child's that you'd especially like to remember, have your child wear it when it comes time to take pictures. These tips, in addition to the tried-and-true rules and ideas about composition, will help you make successful portraits. (See chapter 6 for more on composition.)

TIP: PUT YOUR SUBJECT AT EASE

When photographing people, the key is to interact with them in a lighthearted and friendly manner. To do this, learn to work your camera without thinking about it, and more importantly, treat people with a positive, respectful attitude—just how you would like to be treated if someone were taking your picture.

NATURE

Beholding the beauty of a natural vista is truly a multimedia experience. We see with three-dimensional depth and flexibility, our eyes adjusting instantly so that we can subconsciously enjoy the subtle differences in tone, distance, and definition. Without even thinking about it, we turn effortlessly to take in the entire 360-degree scene. We take a cool breath of air and let the fragrant smells trigger memories, as our ears are treated to bird calls, crickets chirping, and the sounds of nature.

Why are we surprised, then, when we have trouble capturing a beautiful nature scene in a flat, two-dimensional 4 × 6-inch photo? After all, a picture is only an abstraction; we abstract—or pull out—a thin slice of visual reality. But although you cannot record the visual depth and contrast of a scene—let alone the sounds, smells, and feelings of being there—you can choose which elements to include and how to render the image in a way that evokes memories of experiencing the scene in person.

The first step is to become conscious of light and how it helps, or hinders, an accurate and thought-provoking capture of a scene. (See chapters 4 and 5 for a discussion of the nature of light and how cameras record light.) The second step is to learn the rules of composition. These guidelines (see chapter 6) apply regardless of camera type, and they offer the quickest route to satisfying, enjoyable picture-taking. If you've been frustrated in the past, looking at disappointing pictures that failed to do justice to a beautiful vista, hang in there. Even if you cannot capture all of the three-dimensional sights and sounds of a scene, you can certainly come home with photos that successfully represent these awe-inspiring views simply by learning these few tricks of the trade.

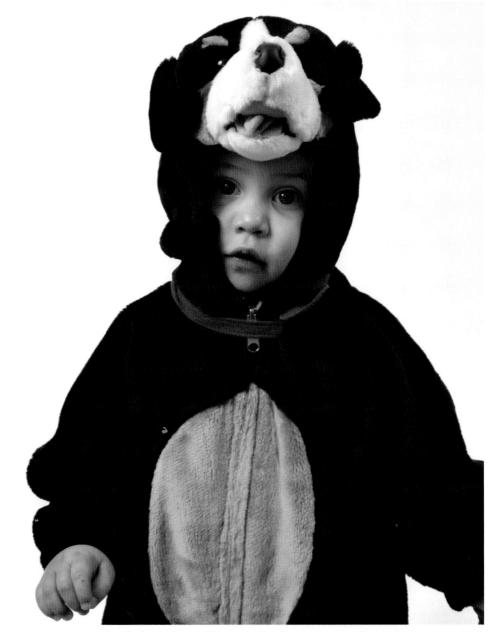

If there's one universal truth about raising children, it's that they grow up too fast. Before you know it, they no longer fit into their cutest little outfits. That's one reason why I'm thrilled to have this photo. My son loved this doggy Halloween costume. He would ask to wear it at least once a day. Noticing this, I made a note to photograph him in it in my garage studio. So one evening, we had fun doing a mini fashion show. This kind of project reaps double rewards: You not only get great photos and good practice, but you also build a collection of fantastic mementos for you and your children.

1/90 SEC. AT f/11, ISO 100, 28–105MM LENS AT 28MM

THEMES AND EXPLORATION

When you feel uninspired or photographically frustrated, sit down with pen and paper and write down ideas for potential photographic themes. A photographic theme is a unified, cohesive idea that runs throughout a series of photographs. It could be anything from a particular color to a certain subject or prop . . . whatever you can imagine! As you write your ideas down, don't allow yourself to judge, edit, or erase. You don't want to get into "editor mode." Just stay in "creative mode." Let yourself brainstorm.

Another good exercise is to stay with one subject and explore it from as many angles as possible, discovering all its details. Experiment with different exposures, focal lengths, and viewpoints. Sometimes your first interpretation of a subject is the best one, but other times, your images may benefit from the further exploration that comes from sticking with your subject.

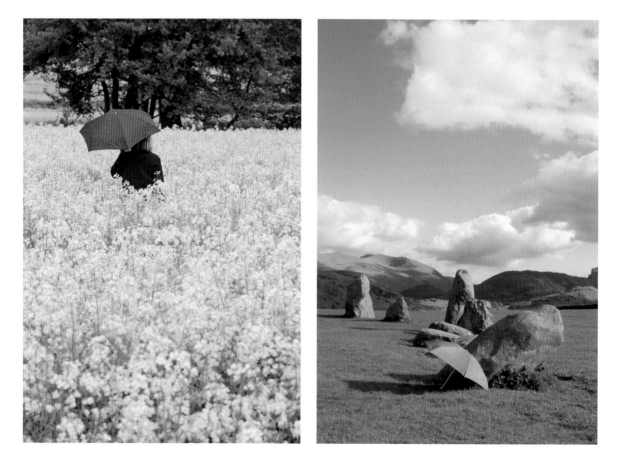

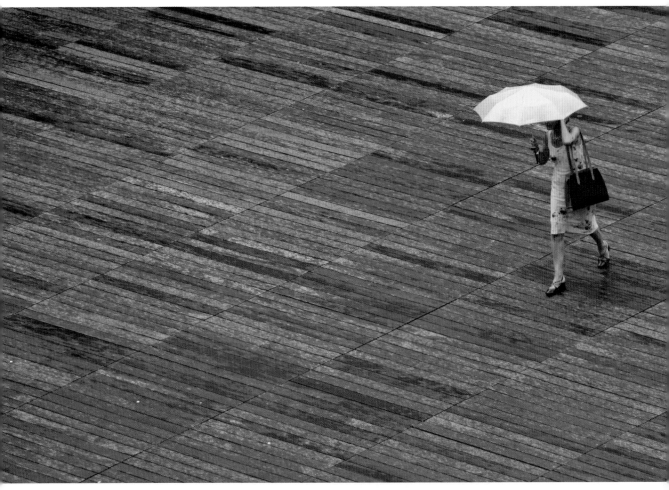

Since I often enjoy photos with colorful umbrellas, I decided to make them a theme. My wife liked the idea and purchased a couple of umbrellas for me to take when I went out shooting. Photographing these props enabled me to produce the kinds of images I was after in a semicontrolled way. More importantly, the theme gave my creativity something to focus on.

For the left-hand image opposite, my wife graciously stood on one of our suitcases for several minutes while I made a variety of images. For the right-hand image opposite, I simply placed an umbrella among some standing stones in England to give the scene an added splash of color. The image above was a more spontaneous composition. As I was leaning out of my hotel window in Lyon, France, it began to rain, and I noticed this woman walking across the square as she started to unfurl her umbrella. Placing her in the upper right corner of the composition, according to the Rule of Thirds (see page 156), and using the lines on the ground to create an interesting texture and pattern, I captured what has become one of my favorite photographs.

OPPOSITE, LEFT: 1/250 SEC. AT f/10, ISO 100, 28–105MM LENS AT 28MM; OPPOSITE, RIGHT: 1/1000 SEC. AT f/10, ISO 800, 100MM MACRO LENS; ABOVE: 1/250 SEC. AT f/5.6, ISO 200, 100–300MM LENS AT 185MM

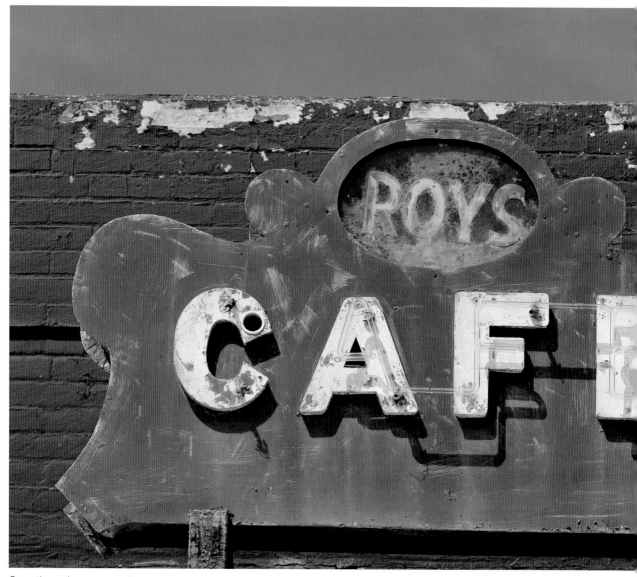

Sometimes the process of identifying your subject is progressive. You don't know exactly what you're attempting to capture until after you've tried a variety of compositions. So relax and let yourself have fun. Experiment and try a bunch of different things, knowing that you cannot really make a wrong decision, just different decisions. If something catches your eye, ask yourself what attracts you to the scene and then begin shooting various compositions.

Intrigued by the colors and textures in this aging café sign in Hornitos, California, I took a few pictures and then decided to keep "working it." As I zoomed in closer with my telephoto lens, I tried a variety of horizontal and vertical compositions, experimenting with different settings. I didn't worry too much about which one was the best. Instead, I just let myself enjoy taking pictures, knowing that I'd have plenty of time to figure out which one I liked best later.

ABOVE: 1/500 SEC. AT f/10, ISO 100, 100–400MM LENS AT 100MM; OPPOSITE, TOP: 1/500 SEC. AT f/8, ISO 100, 100–400MM LENS AT 300MM; OPPOSITE, BOTTOM: 1/500 SEC. AT f/8, ISO 100, 100–400MM LENS AT 400MM

DETAILS

If you're still unsure of exactly what to photograph, another option is to go out looking for details. When I don't know what to photograph, I reach for a telephoto or macro (close-up) lens and go out searching for any small, attractive details that catch my eye, and when I find them, I move in very close. (See pages 148–155 for more on macro, or close-up, photography.)

The image below shows detail in a cowboy's boot that I found visually interesting. When captured with proximity and simplicity, a close-up image invites the viewer to wonder about the nature of the overall scene. What's more, moving in close on a detail can give you ideas and a sense of direction when photographing a scene or event.

FLEXIBILITY IS THE KEY

Regardless of what you intend to photograph, be willing to switch gears. Sometimes your original idea just isn't working out. The weather may have gone south. Your child may suddenly be unwilling to cooperate. You might discover that the famous monument you were looking forward to photographing is closed until 10:00 a.m., long after the good light has come and gone.

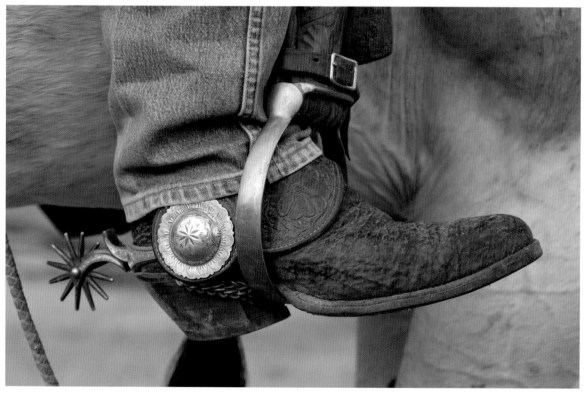

When you're stuck in a rut, one great trick is to search for details, using a telephoto lens to move in especially close to your subject (we'll talk more about lenses in the chapter on composition). This image was actually inspired by a photo that won First Prize in our monthly photo contest at BetterPhoto.com over a year ago. Don't be afraid to attempt to duplicate photos that inspire you. Odds are likely that you'll end up creating your own unique vision—and learning a lot about photography in the process.
1/180 SEC. AT f/6.7, ISO 100, 100–400MM LENS AT 100MM

However, you don't want to toss in the towel and call it quits at the first problem. If you're thrown a curve ball, first try to work with the situation as best as you can. You might find that you get the great shots when you continually "work" your subject, trying different angles and points of view, different exposure settings, and different compositions for your photographs.

If continued attempts fail to succeed, don't hesitate to go in an entirely different direction. For example, if your two-year-old simply won't cooperate as planned, turn your attention to the flowers in your yard or making a beautiful portrait of a favorite pet. Simply being flexible opens up many inspirational photographic opportunities.

Also try to be flexible in how you actually take the picture. Try doing something new, like lying down on the ground. Bring wacky and colorful props around with you when you go out shooting. Ask strangers if you can take their picture, striking up conversations and making new friends. When photographing kids, talk in strange voices and make funny faces. Encourage yourself to step out of character so that you can both get exceptional images and have a fun time in the process!

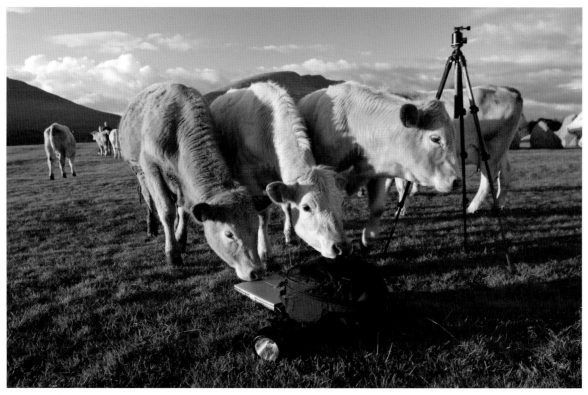

I had been looking forward to photographing a set of ancient standing stones in England (see pages 118–119), but when I arrived at the location, I was surprised to find local livestock sharing the land. The cattle were allowed to roam around the monument. As I set up my camera and waited for the sun to get low on the horizon, the cows became more and more accustomed to me. After photographing one particularly friendly and inquisitive cow with a 16mm wide-angle lens, I looked up and realized that I was surrounded by curious cattle. These are extremely large animals, and I'll be the first to admit I was a little intimidated. However, when they began nosing my backpack and slobbering all over my laptop, I drew the line and I shooed them away.
1/60 SEC. AT f/4, ISO 100, 16–35MM LENS AT 16MM

Take the Camera Everywhere

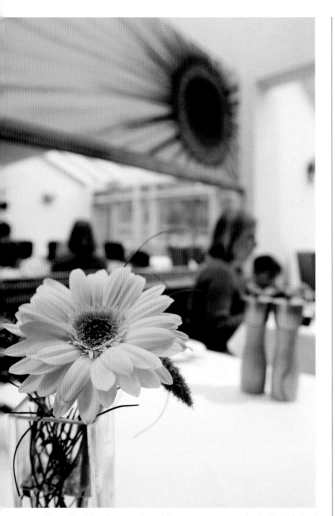

I made this photo at breakfast on a recent trip to the United Kingdom. The restaurant was decorated with flowers on every table and gorgeous huge paintings that resembled macro photographs of flowers. After eating a bit of breakfast, I took my camera to a nearby table and crouched low enough to include both an actual flower in the foreground and one of the large paintings in the background. I then chose a large enough aperture opening to get a shallow depth of field that would render the background out of focus. This aperture, in combination with the composition, created the "echo" effect I was after. (See pages 82–91 for more on aperture.)
1/60 SEC. AT f/4, ISO 100, 16–35MM LENS AT 16MM

IF THERE'S ONE simple thing that sets apart the picture-takers who get great shots from those who don't, it's whether or not they take the camera with them—everywhere they go. Take the camera when you go to the store, to work, onto the airplane, to a party, out for a drive . . . *everywhere*! Don't limit your camera-carrying to when you go on vacation or when you feel specifically motivated to go out and take pictures.

If you don't already take your camera with you everywhere you go, think about what's holding you back. Is it that your camera is too big and bulky? Is it that you feel embarrassed when taking pictures of people or particular situations? Or, do you simply forget to take it with you? Whatever the reason, find a solution. Your photographic future depends on you having your camera on hand when the inspirational photo op occurs. If you frequently forget it, keep it next to the front door by your car keys. If your camera is bulky, by all means consider purchasing a more compact one. Do whatever it takes to have that camera at your side at all times.

Don't be afraid to have your camera hanging from your neck regardless of where you'll be going or whom you'll be meeting. It's crucial that you get into the habit of taking the camera with you everywhere you go, every time you head out the door.

WHAT'S YOUR MOTIVATION AND STYLE?

Both when you're in the field and prior to heading out, it's helpful to ask yourself a few questions about your goals and the way in which you approach things. For example:

1 What's your motive for picture-taking? (Do you want to share experiences with friends and family, to simply have fun, to preserve memories,

to fill scrapbooks, to tell a story, to get a job as a photographer, or to become rich and famous? What drives you to make photos?)

2 Do you have any particular interests that lend themselves to inspired photography? (If you like to travel, your digital photography subjects will be very different from someone who is primarily interested in photographing children at home.)

3 What's your style? (Would you consider your-self organized and punctual? Are you a pack rat or someone who likes to clear things out? Do you like to shoot just one shot every so often, or do you like to "shoot first, and ask questions later"?) Figure out your own personal shooting style.

I, personally, am motivated to preserve memories and teach. My interests are in people, wildlife, and travel. I prefer to take as many images as possible, and then severely edit my work later. This causes me to work long after the actual shooting, spending countless hours in front of the computer sorting through the results, editing the keepers, and examining any unsuccessful shots. This work, however, pays off. It is the method that I've found works best for me.

Thinking about the answers to these questions, will go a long way to helping you improve your photography.

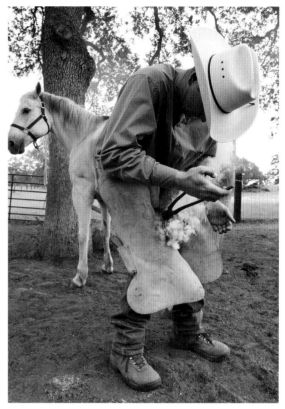

One motivation for picture-taking might be to tell a story. It was with this motive in mind that I photographed this farrier doing a variety of tasks while preparing to "hot shoe" a horse. I particularly enjoy this photo because of the interesting perspective I got by moving in close with a wide-angle lens, as well as the way the horse is looking back as if to ask, What are you doing with my hoof?
1/250 SEC. AT f/8, ISO 200, 16–35MM LENS AT 16MM

ASSIGNMENT **Begin Gathering Ideas**

This assignment has two parts:

1 First, start a visual idea file or notebook. Spend at least an hour going through your favorite magazines and cutting out pictures that you love. If you don't want to ruin the magazines, make copies or use Post-It notes to mark the pages to which you want to refer back.

2 Then, think of something or somebody you love, and make a weekend project out of photographing this subject. If possible, include objects that have sentimental value to give the photo extra meaning. Photograph your subject in as many unusual and creative ways as you can imagine.

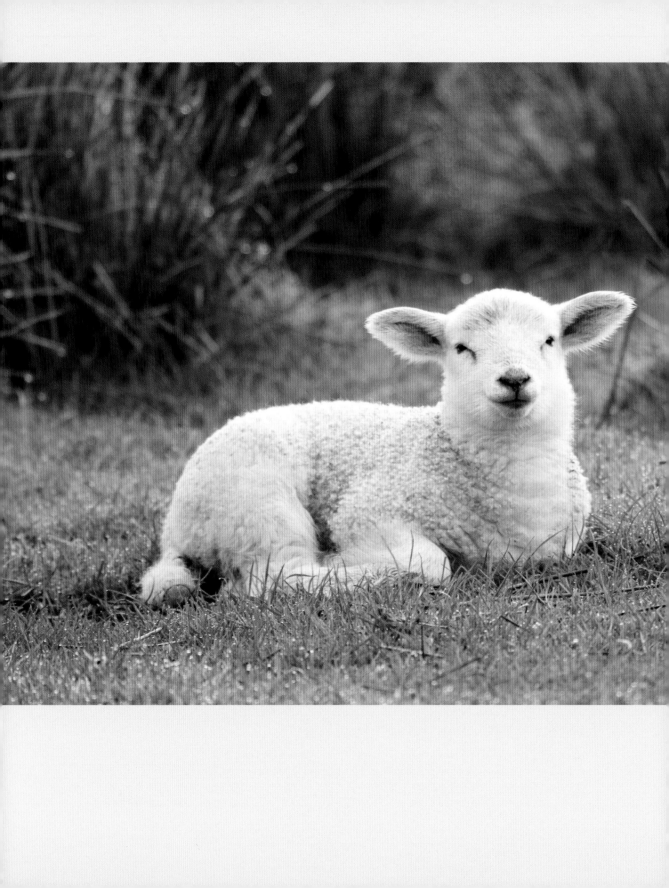

File Formats, Quality Settings & Resolution

WHEN I STARTED BetterPhoto.com in 1996, I saved all the photos displayed on the site as GIF files. At the time, I didn't know that the GIF format wasn't the best way to save photos. Since it's limited in how many colors it captures, the GIF format is better for flat color graphics, such as cartoons and drawings. For displaying all the color gradations in photographs, the JPEG format is much better. Once I learned this, I began replacing GIFs with JPEGs. For several years, I used JPEGs almost exclusively. Recently, though, I've changed my methods again. After learning what I could do with raw files, I now use them for almost all of my photography. Learning about the various file formats, along with all the quality settings and resolution options, will go a long way toward giving you as much control over your camera and your photographic results as possible.

1/60 SEC. AT f/5.6, ISO 100, 100–400MM LENS AT 400MM

Art as Ones and Zeros

IT'S HARD FOR US artistic types to accept the fact that each digital image is nothing more than a neatly arranged series of ones and zeros—a string of technical information that, when interpreted and displayed by certain programs, looks like a picture. These strings of information can be configured in different ways, each being a different picture file format. The three types of formats we'll examine in this chapter are TIFF, JPEG, and raw.

Many digital cameras give you a choice when it comes to file format. And since you select the format before you take the picture, it's very important that you choose wisely. As with any choice in digital photography, each format has its advantages and disadvantages. Each is best suited to a particular photographic application. These advantages and disadvantages involve a choice between image quality and image quantity. Capturing images in a large, high-quality format, for example, can cause problems when it comes to space limitations on your memory card, while working with smaller, lower-quality formats can cause problems when it comes to image quality, especially when you print your images.

Some cameras only capture images in the JPEG format and don't offer a format choice. If you have a camera that doesn't give you a choice (check your owner's manual), you can jump ahead to the next chapter for now. If you have a camera that offers more than one file format, this chapter will help you make an informed decision before you begin taking pictures. The two most prevalent file format options are JPEG and raw. In a nutshell, the JPEG format is much simpler to use and more economical on space. Raw, also known as "camera raw," is more flexible, but uses more space. In addition, we'll also look at one other high-quality option, the TIFF file format.

A Quick Guide to File Format Selection

❑ If you like to travel, cannot afford to buy a lot of memory card storage, and/or fear another layer of complication when it comes to working with your images on the computer, shoot in the highest quality JPEG mode you can. If you choose this option, as soon as you get your image onto your computer, save it as a TIFF file or PSD (Photoshop Document).

❑ If you have a way to easily offload images (i.e., onto your laptop or a portable storage device), have a need for ultimate control over the quality of your images, and/or don't mind adding another layer of complexity onto your digital workflow process, choose the raw file format.

JPEG

JPEG (Joint Photographic Experts Group) is by far the most popular image file format. Most people like it because the results from JPEGs are acceptably good and the amount of images you can pack onto a memory card is far greater than when using TIFF or raw files.

The JPEG file format lets you save big image files in tiny packages. For example, if your original digital image is 18 MB (megabytes), a JPEG version of this might be as little as 2 MB, whereas another file format might take up several megabytes of storage space. By discarding information that's not visible to the human eye, the JPEG format makes files extraordinarily small. Also, JPEGs are easy to use and view. The format is universal, viewable by Web browsers and e-mail programs around the world. If your primary interests are uploading photos to a Web site or sharing photos via e-mail, JPEG format is great.

There's one problem with JPEGs though. When information is discarded in order to squeeze more images into limited memory card space, this process of compressing the image can have negative side effects.

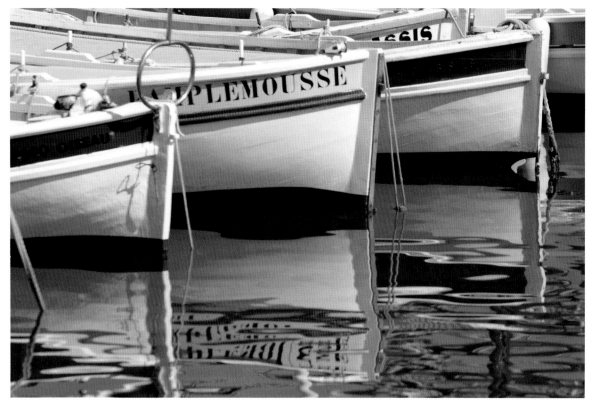

On a trip through France, I saw this attractive scene of three boats in the Cassis harbor. Because I had a limited amount of memory card space available, I opted to shoot this as a high-quality JPEG.

1/500 SEC. AT f/6.7, ISO 100, 100–300MM LENS AT 260MM, JPEG FORMAT

JPEG COMPRESSION

JPEG compression occurs when the camera saves a JPEG image to the digital media and also when you save a file on your computer. When compressed to the maximum, a JPEG image will usually display defects, called *artifacts*. The more you compress a JPEG, the more these artifacts will mar the quality of your photo. You control how much your images are compressed with a quality setting (which we'll get to in a minute). With JPEG, the goal is to minimize these artifacts while keeping the file as small as possible.

Some photographic images show artifacts more readily than others. In my experience, scenes with a polarized blue sky illustrate the negative effects of overcompressing (or over-JPEGing) more clearly than images with details and varied texture, such as a picture of green grass or a forest of trees.

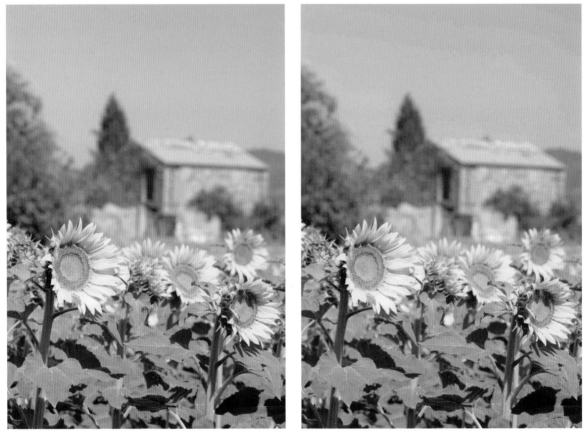

If you look closely at the blue sky in these two images, you can see the negative effects of artifacts. In the right-hand image, the blue tones of the sky begin to band and look blocky or jagged. I shot both of these images as JPEGs. The only difference was how I saved them once I had transferred them to the computer. I saved the first image as a TIFF file (see page 50) and the second at the lowest-quality JPEG setting possible for comparison—in practice, you would rarely, if ever, save at such a low setting. Usually, when I save JPEGs, I keep the quality setting around 7 or 8, unless I absolutely must save the image as a smaller file. So, the lesson here is this: Shooting in a high-quality JPEG format can be safe; just be careful about compressing the image so much that it does noticeable damage to your photo.

LEFT: 1/250 SEC. AT f/5.6, ISO 100, 100–400MM LENS AT 400MM; RIGHT: 1/250 SEC. AT f/4.5, ISO 100, 100MM MACRO LENS

JPEG QUALITY SETTINGS

Whenever you shoot or save an image as a JPEG, you can save it at any of a variety of different levels of compression. These compression levels are quality settings. There's a scale from high compression (lowest image quality) to low compression (highest image quality). When you save your photo as a JPEG, select the highest quality you can. You can make this setting both in your camera and also later on your computer if you resave the file after making modifications to it. Make sure that you're in the driver's seat in either option: If you're taking pictures as JPEGs, learn from your owner's manual how to set the quality or compression level. If you need to save an image as a JPEG in a software program, again, aim for keeping the quality level as high as you can while making the file as small as you need it to be.

For example, if you have a slow Internet connection, you may opt to compromise the quality a bit to reduce your file size. But avoid the lower quality settings if you want your images to remain sharp, crisp, and clear.

As someone who loves to travel, I've found that the JPEG format works extremely well. I've taken 3-MB JPEG images and enlarged them to beautiful 13 × 19-inch prints. I've also enjoyed how easy JPEGs are to upload to the Web or to e-mail to friends and family. However, knowing what I have now learned about the raw file format, I now prefer to shoot raw files most of the time. More on raw in just a moment, but first, let's look at the TIFF file format.

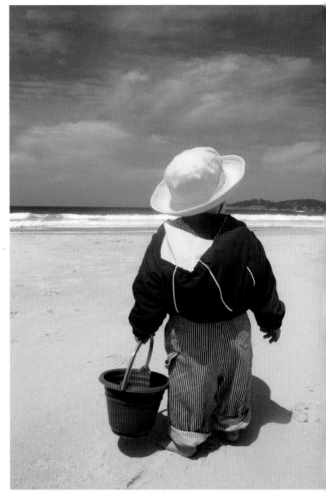

While exploring the beach in Carmel, CA, I photographed this little boy watching the waves. I shot this image as a JPEG because, honestly, I hadn't yet learned the virtues of using the uncompressed file formats, such as camera raw.
1/250 SEC. AT f/11, ISO 100, 16–35MM LENS AT 16MM, JPEG FORMAT

TIP: FILE FORMATS AREN'T EVERYTHING

Don't be afraid of experimenting with file formats, but don't overvalue them either. Don't let yourself get stuck. If file formats are totally confusing to you, simply move on to the next topic and come back to this later. When it comes to overall photo quality, these technical issues are far less important than things like composition, lighting, shutter speed, aperture, and ISO. The creative controls are much more influential when it comes to making powerful, eye-catching images.

TIFF

TIFF (Tagged Image File Format) stores the image in a high-quality file. TIFF may be a good choice for you if your camera offers it as an option, and:

a you cannot or do not want to save the image as a raw file

b you have a lot of space available on memory cards AND

c you are seriously interested in assuring the highest image quality, especially when printing

Many photographers prefer the TIFF format to JPEG, because TIFFs capture images without the compression that would degrade image quality (compression to which JPEGs are susceptible). We've been told that TIFFs produce better color and detail, and that they are the ideal format for printing images. We've been told to shoot TIFF files whenever we think we might want to print our images. And, most of us fancy ourselves printing our images someday; very few of us won't even consider entertaining the idea of turning our favorite photos into big, beautiful prints. So, if we were to follow this thinking, we would choose TIFF or raw format over JPEG.

The problem with uncompressed file formats, such as TIFF, are that they take up huge amounts of memory card and computer storage space. If you were to shoot only TIFFs when using a small memory card, you would quickly run out of room and have to think of creative ways to free up storage space or have to stop taking pictures until you could transfer your images to your computer.

It is far worse to be out in the middle of nowhere, trying to decide which images to delete to free up more memory than it is to have images that suffer from JPEG compression. I have often agonized over which images to delete in order to get enough storage space so that I could shoot a few more pictures. I've rarely agonized over artifacts from JPEG compression.

Presently, it seems that the TIFF format is being replaced by raw. Some cameras don't even bother offering the TIFF format anymore. By my count at press time, out of 274 current cameras 47 have the TIFF option and 31 use raw. I no longer use TIFF, but rather raw and then PSD.

Although I rarely shoot in TIFF, I use this file format from time to time when saving images on my computer. By saving an image as a TIFF, I'm assured that I will not continually degrade the quality of the image as I save and resave it. Also, many editors ask me for TIFF files rather than JPEGs. So, I only use TIFFs when reworking with an image in a program like Photoshop, or when my editor has asked for TIFF format. When setting up my digital camera for a shoot, I choose either raw or JPEG.

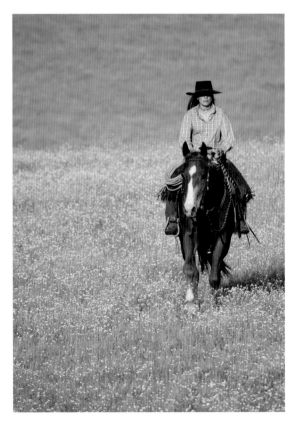

Lossy vs. Lossless

An important difference to consider when selecting your file format is whether the format is *lossy* or *lossless*. JPEG is a lossy file format, meaning that it suffers from a reduction in image quality each time the file is resaved after being opened. TIFF and raw files, on the other hand, are *lossless* files, meaning that they do not suffer a reduction in image quality. JPEG files are smaller and take up less storage space, however, than TIFFs and raw files, which are much larger. So, you must decide which is most important in your particular situation: file size and maximum storage space, or image quality.

I reworked both these images in Photoshop. For the cowgirl, I made only minor enhancements mostly having to do with sharpness and color correction. The wall with yellow flowers needed some serious work, as the foreground flowers were noticeably out of focus. By making some in-depth Photoshop adjustments, I was able to sharpen the foreground flowers.

When doing this kind of work, one of the first things I do is save the image in a lossless file format, such as PSD or TIFF. This assures me that the quality level of the image will not degrade (due to compression) as I continue to work on it. If you use Photoshop, saving in the PSD (Photoshop document) file format will save space on your computer; but if you don't have Photoshop, or you want to send the image to someone who doesn't have Photoshop, then save your file in the TIFF format.

OPPOSITE: 1/250 SEC. AT f/5.6, ISO 100, 100–400MM LENS AT 400MM, TIFF FORMAT; LEFT: 1/250 SEC. AT f/10, ISO 100, 28–105MM LENS AT 28MM, TIFF FORMAT

Raw

RAW IS A TERM used to describe the proprietary file format that your camera uses. In other words, this is the camera manufacturer's file format. Nikon has a raw format. Canon has one. And so do other manufacturers.

One manufacturer's raw file is no better or worse than another's. The format is simply a proprietary way to save images. Raw captures a pure file without any image processing occurring in the camera.

The raw file format is comparable to a film negative. Negatives, unlike slide film, involve an additional step of printing, and during this step, many adjustments can be made to the image. Similarly, the raw format offers substantial flexibility when processing images in a software program, like Photoshop. For example, when opening up a raw file, you can adjust the color, brightness, shadow details, tint, and the white balance of the image. (See pages 126–133 for more on white balance.) Instead of these settings being decided upon capture, you get to choose what you would like to see in the image as you open it.

You can change these and other settings long after you've captured the image, as these settings are adjustable if you don't get them perfectly right in the first place. Many photographers prefer shooting in the raw mode because it captures the image without processing the image in the camera. They want to retain full control over what gets changed and what does not. That is the real power of raw—full control. Most people think that the main advantage of shooting raw files is that they can produce large, high-quality image files. This is truly a big advantage, but the best thing about raw is the total control it gives to those digital photographers who want it.

However, this doesn't necessarily mean that you should always shoot raw files. There are several disadvantages. One is that raw files require special software to open on your computer; you have to use the most recent full version of Photoshop (which has this software in it), or another specialized software program, to transfer your raw images to your computer. This can be a hassle.

If you don't own this expensive software, you'll need to find another way to get the images from your camera onto your computer. You may be able to use the software that came with your camera, but this often involves hooking up a cable and using slow transfer rates. Either way, opening up raw files involves one more step in the digital image processing workflow. This can be either a good thing or a bad thing, depending on how you look at it. As previously mentioned, this extra step gives you more control over the final product, but it also adds another layer of complication.

So, working with raw files is generally more tedious, time-consuming, and difficult. Also, shooting in the raw format requires substantially more memory space than shooting JPEGs. You can fit a lot more images onto your memory card if you shoot JPEGs. Like the TIFF format, the raw format produces larger files than JPEG in its effort to capture all those little details that make up the photo. TIFFs are usually larger than raw files, but both are considered major memory hogs. In practice, selecting your file format is very dependent on how many images your memory cards can hold.

> **TIP:** ARCHIVE YOUR IMAGES
>
> If you shoot in either the TIFF or raw formats, be sure you have a large amount of free hard drive space on your computer. Also, I highly recommend using a CD-ROM or DVD burner to periodically archive your images. This process of burning your images onto a CD or DVD will allow you to delete those images from your hard drive and free up space.

This pair of photos illustrates how powerful the raw format can be. The first photo shows the image as I shot it— underexposed, muddy, and cloudy. In Photoshop's raw converter, I increased the exposure to brighten the image. I also made the blacks richer and darker. This resulted in the second photo, which is clearly much better. Whereas the first photo is obscure and barely visible, the second one looks much better, more accurate and pleasing.

UNCORRECTED

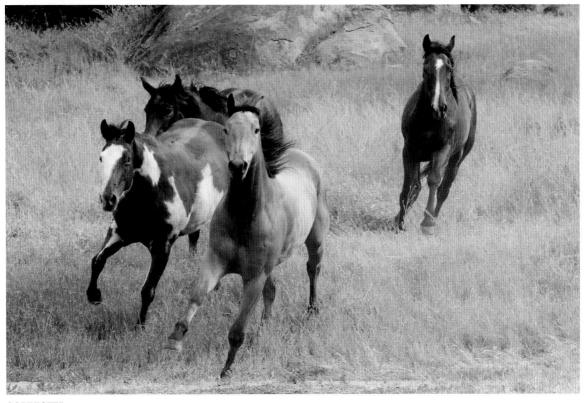

CORRECTED

1/350 SEC. AT f/10, ISO 200, 100–400MM LENS AT 100MM, RAW FORMAT

UNALTERED

ALTERED

1/90 SEC. AT f/5.6,
ISO 100, 28–135MM
LENS AT 122MM,
RAW FORMAT

This example illustrates one big advantage of shooting in the camera raw file format. Like a film photographer printing a variety of different images from one negative in the darkroom, a digital photographer using the raw file format can produce different images from one "digital negative." Since this image of a bear cub was a raw file, I could open it up twice, each time with different exposure settings.

First (top left), I aimed to get most of the picture looking properly exposed—not too dark and not too bright. When I did this, the wildflowers had no detail in them. So, in the second version, I made sure that the wildflowers were darker. Then, in Photoshop, I combined the two images to produce one image that featured good exposure throughout (bottom left). Had I shot this as a JPEG, I would have been limited as to how much overexposure I could correct; the raw format gave me more control.

While this additional control can be liberating for some people, the complexities it involves can be frustrating for others. Those not yet ready to take on another layer of complexity may be happier shooting JPEGs. Those who already enjoy tweaking images on the computer will likely find the raw file format more satisfying.

Storage and Memory Card Options

THE CHOICES when it comes to memory cards include compact flash, SmartMedia, Memory Stick, xD-Picture Card, and more. Some digital cameras only accept one kind of memory card, though, so actually, you might not have much of a choice. If that's the case, all you need to do is purchase the largest amount of memory storage you can afford.

Some digital cameras, however, do allow you to use more than one type of memory card. If your camera has this feature, simply choose the card that works best for you. Go with whatever option is least expensive, holds the most images, and works with your current computer setup.

The most important thing is the number of megabytes (MBs) in the card. Regardless of which format your camera requires, you want to get the largest cards possible (i.e., ones with the most MBs). This can be a painful decision to make because the larger the card, the greater the cost. But, this is one area in which you don't want to skimp. On your next road trip, you'll be glad you got the most you could afford.

If you see yourself doing a great deal of digital photography on the road, invest in a memory card that's 2 gigabyte (GB) or larger. This will allow you to capture a large number of high-quality images before having to off-load them from your camera to your computer. Big memory cards come in very handy when you're shooting raw or TIFF files.

TIP: DON'T ERASE AS YOU GO

Never delete images while viewing them on your camera's LCD screen unless you are absolutely sure that they're absolutely awful. Try to be objective about the quality of your photos, but before you hit the delete button, entertain the notion that you may be wrong. I only consider deleting a photo in the LCD monitor when it is incorrectly exposed—clearly too dark or too bright—or blurry. And even then, I often refrain from erasing the image until I view it on my computer.

Microdrives vs. Solid State Memory Cards

When purchasing Compact Flash memory cards, you may be tempted to get a device called a *microdrive*, rather than the more typical *solid state* memory cards. Microdrives usually cost less, and most of the time, they work fine. In my experience, though, they process images more slowly, sometimes causing me to miss a shot. They are also more fragile than the solid state cards. These days, I use solid state memory cards for most of my shooting and carry around my microdrive as back up for when my other cards become completely filled up.

Pixel Resolution

THE WORD *pixel* comes from *picture* and *element*. A pixel is basically one tiny dot of your overall photo. In the same way each tile makes up the overall picture in a mosaic, all the pixels together make up the digital image. Pixel resolution is the count of pixels on the horizontal (the width) and the vertical (the height) axis of your image. Examples would be 3072 × 2048 or 640 × 480.

Different pixel resolutions result in different print sizes. So, there's an advantage to shooting with as many pixels as you can. Larger images—with higher pixel dimensions—allow you to make larger prints. Images that have smaller pixel dimensions are more limited when it comes to printing. It's as simple as that. You can still get high-quality images with cameras that only offer low pixel resolutions; you just can't make these images as large as the images made with cameras that offer high pixel resolution options.

RIGHT: 1/250 SEC. AT f/5.6, ISO 400, 100–400MM LENS AT 285MM;
BELOW: 1/250 SEC. AT f/4.5, ISO 100, 100MM MACRO LENS;
OPPOSITE: 1/125 SEC. AT f/4.5, ISO 100, 16–35MM LENS AT 16MM

If you're interested in producing artistic prints, shoot in the highest pixel resolution available. It's as simple as that. The only time you might want to reduce pixel resolution is if you're sure you'll only need low resolution—if you're e-mailing the photo, uploading a picture to eBay, or using the photo for job-related stuff. In all other cases, go for as much as your camera can handle.

RESOLUTION: 1536 × 1024

RESOLUTION: 2250 × 1500

RESOLUTION: 2048 × 3072

ASSIGNMENT Shoot JPEG, TIFF, and Raw

There's nothing better than personal experience when it comes to choosing file formats, quality settings, and pixel resolutions. Try them all out so that you can decide for yourself what works and what doesn't for you. Shoot a scene in as many different file formats as your camera offers. (Your owner's manual will tell you which formats you have and how to select them.) If all options are available, do one JPEG, one TIFF, and one raw file.

As you switch between modes, note how many photos you can capture on your memory card in that particular format. You'll see the number of available images increase greatly when you choose the JPEG format. (You can usually see this number in the LED display on the top of your camera or on the LCD screen on the back. Again, check your owner's manual if you cannot find this number.)

Once you've transferred the images to your computer, open them up in a software program such as Photoshop Elements or the software that came with your camera. If you're shooting JPEGs, you can also view them in a Web browser like Internet Explorer. Next, compare the actual file sizes as well as the image quality of each format. Do you see a difference in quality? Did you find one format more intuitive and easier to use than the others? If you have a hard time seeing the artifacts in your JPEG file, zoom in on shadows or even-toned areas, such as a blue sky. Magnifying these areas can sometimes make it easier to see the jagged artifacts.

Then, using your firsthand experience and comparing each image side by side, make your decision as to which file format you will use for each application.

Exposure

WHEN I LEARNED photography—on a 35mm film camera—I had far too many unnecessary things to think about: potential subjects, appropriate film and film speed for the subject, ISO setting, aperture, and shutter speed. After changing rolls of film, all too often I would forget to change the ISO setting, causing entire rolls of film to be shot at incorrect exposures.

Thanks to the digital revolution, the science of exposure has dramatically changed. The process of getting good exposure is now both easier and more flexible. But before you learn about this digital difference, you need to learn what the terms *aperture*, *shutter speed*, and *ISO* mean.

My goal when capturing these dramatic castle ruins on the northeast coast of England was to take a time-lapse photo in which the crashing waves blended together and looked like low fog. To do this, I set my f-stop as high as it would go—f/22—to allow the slowest possible shutter speed. However, f/22 didn't get me a slow enough shutter speed for the desired effect. So, I placed three neutral-density filters on my lens. These are, basically, sunglasses for your camera—they block out light, enabling you to get slower shutter speeds even in bright conditions. I also used a graduated pink filter and a magenta FL-W filter to give the image some added color.
26 SECONDS AT f/22, ISO 100, 16–35MM LENS AT 30MM

The Exposure Triangle

IN HIS CLASSIC BOOK, *Understanding Exposure*, Bryan Peterson refers to the triangular relationship between aperture, shutter speed, and ISO, which he calls *the photographic triangle*. Looking at all three of these components together—instead of just considering aperture and shutter speed alone—comes in even handier for digital photographers than it does for film photographers. So let's take a look at how this *exposure triangle* works, starting with the three elements that comprise it, and work together to determine the exposure for any given scene.

APERTURE. Also referred to as *f*-stop, this is the size of the opening of the lens. The size of this opening plays a major role in determining how much light reaches the sensor inside the camera. A larger aperture opening allows more light to get into the camera; a smaller opening allows less light in. Larger aperture openings have smaller numbers, while smaller apertures have larger numbers; for example, *f/22* is a small aperture, while *f/4* is a larger aperture.

SHUTTER SPEED. This refers to how long the aperture remains open. The longer the shutter speed (i.e., the longer the aperture is open), the more light gets into the camera and to the sensor. The shorter shutter speed (i.e., the shorter the aperture is open), the less light gets to the camera's sensor.

ISO. On digital cameras, this is the measurement of the sensor's sensitivity to light. (For film camera's, it is the measurement of the film's sensitivity to light.) A less sensitive (lower) ISO number means that more light is required (either with a larger aperture opening, a longer shutter speed, or both) to get the same effect that a highly sensitive (higher number) ISO would yield with less light.

Different combinations of aperture (or *f*-stop), shutter speed, and ISO can all add up to the same overall exposure.

Visualize the camera's shutter as shutters on a window. Think of aperture as the size of the window. If one window (aperture opening) is bigger than another, more light will enter the house (given that the shutters remain open for the same amount of time— i.e., have the same shutter speed). When the shutters of one window open and close more quickly than those of another window, less light enters the house (given that the windows are equal in size).

Given that the shutters are open for the same amount of time (the shutter speeds are equal), a larger window (larger aperture) will allow more light to pass into the house.

Given that the shutters are open for the same amount of time (the shutter speeds are equal), a smaller window (smaller aperture) will allow less light to pass into the house.

How Things Interrelate

Examining these charts will give you an idea of how the three components—aperture, shutter speed, and ISO—interrelate. Take a few minutes to look them over.

		APERTURE					
		f/4	f/5.6	f/8	f/11	f/16	f/22
ISO	100	1/2 sec.	1 second	2 seconds	4 seconds	8 seconds	16 seconds
	200		1/2 sec.	1 second	2 seconds	4 seconds	8 seconds
	400			1/2 sec.	1 second	2 seconds	4 seconds
	800				1/2 sec.	1 second	2 seconds
	1600					1/2 sec.	1 second

		SHUTTER SPEED					
		1/2 sec.	1 second	2 seconds	4 seconds	8 seconds	16 seconds
ISO	100	f/4	f/5.6	f/8	f/11	f/16	f/22
	200	f/5.6	f/8	f/11	f/16	f/22	
	400	f/8	f/11	f/16	f/22		
	800	f/11	f/16	f/22			
	1600	f/16	f/22				

		SHUTTER SPEED					
		1/2 sec.	1 second	2 seconds	4 seconds	8 seconds	16 seconds
APERTURE	f/4	ISO 100					
	f/5.6	ISO 200	ISO 100				
	f/8	ISO 400	ISO 200	ISO 100			
	f/11	ISO 800	ISO 400	ISO 200	ISO 100		
	f/16	ISO 1600	ISO 800	ISO 400	ISO 200	ISO 100	
	f/22		ISO 1600	ISO 800	ISO 400	ISO 200	ISO 100

The first chart shows the effect of ISO and aperture, or f-stop, on shutter speed. For example, if the camera's light meter indicates that a proper exposure would be made with an aperture of f/11 for 4 seconds at ISO 100, then shifting the f-stop to f/22 at the same ISO would require the shutter speed to double to 8 seconds. Since the aperture size decreased, more time is needed to allow the light to properly expose the subject.

The second chart shows the effect of ISO and shutter speed on aperture, or f-stop. For example, if the camera's light meter indicates that a proper exposure would be f/8 for 2 seconds at ISO 100, then slowing the shutter speed down to 4 seconds would require the aperture to be f/11, given the ISO remains the same. Since the shutter speed is now longer, to get the proper exposure the aperture needs to be smaller to let less light into the camera.

The third chart shows the effect of aperture and shutter speed on ISO. For example, if the camera's light meter indicates that a proper exposure would be f/22 for 16 seconds at ISO 100, then shortening the shutter speed to 8 seconds with the same f-stop would require an increase in ISO to 200. Since the aperture stays the same but the shutter speed is shorter, or faster, less light reaches the camera sensors and so greater light sensitivity (higher ISO number) is needed.

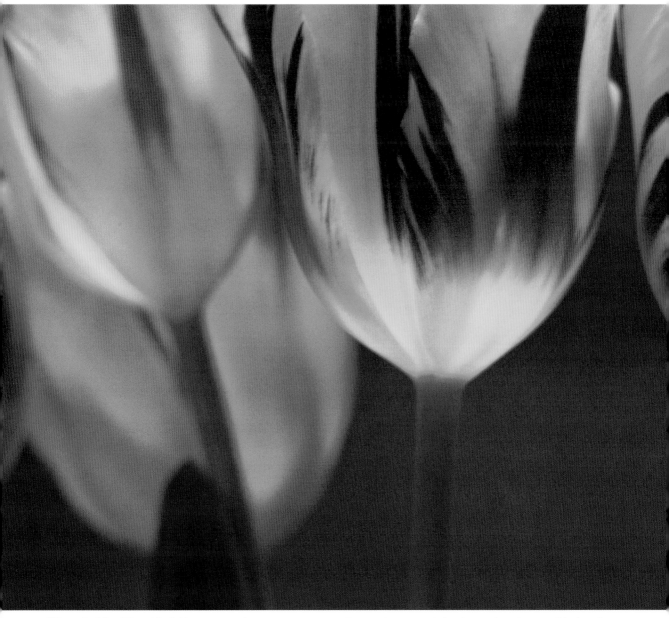

When studying this subject, I knew my main concerns were aperture and camera shake. I was close to my subject and, generally, the closer you get to your subject, the shallower your depth of field will be (see page 82 for more on depth of field). I wanted a high f-stop number to keep depth of field as deep as possible. As I was photographing this subject in dim lighting, without a tripod, I needed to keep the shutter speed as fast as possible. All these needs made it necessary for me to choose a high ISO. ISO 800 allowed me to use a high f-stop number and still keep the shutter speed acceptably fast.

1/20 SEC. AT f/10, ISO 800, 100–300MM LENS AT 300MM

An Analogy for Sun Worshippers

A different way to think about how aperture, shutter speed, and ISO work together is to think about getting a suntan. As I live in Seattle, this doesn't really apply to me, but hopefully it will help you better understand how exposure works.

Sensitivity to light (ISO) can be likened to how much you tend to burn when out in the sun. If you burn easily, you can think of yourself as a high ISO kind of person (film with a high ISO number is more sensitive to light). If you tend to tan without burning, perhaps you are a low ISO person.

Shutter speed can be likened to how long you expose yourself to the sun. Stay out for too many minutes and you will likely get overexposed, or sunburned. Stay out for just a few minutes and you might not get tan at all, depending on your sensitivity to the sun.

Aperture can be likened to the strength of the sunscreen you apply. Using sunscreen with a high rating—SPF 50, for example—is like choosing a large *f*-stop number, which indicates a smaller aperture opening and, therefore, restricts the amount of light entering the camera. Using a low-rated sunscreen—SPF 15, for example—is equivalent to shooting with a small *f*-stop number, which indicates a larger aperture opening and, therefore, allows more light to enter the camera. (See page 82 for more on *f*-stops.)

Remember that, regardless of which example helps clarify things for you, aperture, shutter speed, and ISO are all equally affected by the intensity or brightness of the sun. Sunbathing in a different location where the sun is hidden in clouds would be just like photographing a subject in dimmer light.

ASSIGNMENT Create Your Own Exposure Charts

You need to understand the three exposure components—aperture (or *f*-stop), shutter speed, and ISO—in order to get bright, sharp images each and every time. So, the best way to really understand how the Exposure Triangle works is to sit down with your camera and experiment with manipulating the three elements, filling in your own charts as you change each setting.

Get out a piece of paper or open an Excel document on your computer. If you have the option, set your camera to the semiautomatic program mode, usually indicated by a P. (See page 102 for more on the various modes.) Throughout this experiment, point the camera at the same scene and keep the lighting consistent. Start with any aperture, shutter speed, and ISO you like. Then begin by changing one and noting how the others change in order to compensate (you can usually see these numbers in the top LED screen or the back LCD monitor). Continue changing one aperture or shutter speed or ISO at a time until you've gotten through them all. This simple assignment will help you out more than you can imagine.

ISO

DON'T WORRY if the exposure charts seem confusing at the moment. As we dig deeper into the three elements of exposure, things will become clearer. The first component we'll look at is ISO. Out of habit, most photographers set the ISO before beginning to photograph and then promptly forget about it. There is, however, much to be gained by breaking this habit. Before I show you how to use ISO to your advantage, I need to explain exactly what ISO is and talk a little bit about its place in the history of photography. It might sound boring, but bear with me; it's actually an important and liberating thing to learn.

THE ORIGIN OF ISO

Back when I was a kid, you had to insert these rolled-up strips of celluloid into your camera—they called it "film." You had to decide ahead of time which kind of film you thought you might need, often before you knew what your subject would be. If you selected the wrong type of film, you'd have to tough it out or rewind the film before you had completely used it up. You would have to carry around a small device that would enable you to pull the film leader out of the film canister so that you could try to use any remaining frames of a rewound, partially exposed roll of film. What a hassle!

And it gets worse. This was before a camera could even identify which kind of film had been placed in it. You had to tell the camera what kind of film was inserted by changing what was called the *ISO setting*. If you got this wrong or forgot to update the ISO when you inserted a new type of film (which happened a lot more than anyone cared to admit), you wouldn't realize until you got the pictures back from the photo lab. And by then, it was far too late.

So, what is ISO? It stands for International Standards Organization. The term refers to a film's sensitivity to light. Manufacturers produce a variety of films with varying degrees of sensitivity to light. This light sensitivity is referred to as film speed. Common film speeds include ISO 100, ISO 200, ISO 400, and ISO 800. Smaller ISO numbers indicate a lower sensitivity to light, while larger ISO numbers indicate a higher sensitivity to light. So, film with a smaller ISO number is less sensitive to light (or *slower*) and, therefore, requires more light for successful exposure, while film with a larger ISO number is more sensitive to light (or *faster*) and, therefore, requires less light for successful exposure. Most digital cameras use these same ISO numbers. Since there's no film, though, these ISO equivalents now refer to the effect of light on the camera sensors.

In order to understand how ISO affects digital exposure, we need to take one last look at how ISO relates to film. Films that are less sensitive to light (or slower) require exposure to a greater amount of light or more time to be affected by that light. These less sensitive films generally result in sharper, more colorful images. Films that are more sensitive to light (or faster) work better in low-light situations, but often result in photos with more visible *grain*—the tiny particles that make up the sensitive part of the film.

So, there's a choice to be made between speed (how sensitive the film is and how well it will work in low-light situations) and quality (how finely detailed the images will be). Films with less sensitivity (lower ISO numbers) take longer to expose than films with more sensitivity (higher ISO numbers) but generally result in higher-quality images. Understanding these options, film photographers choose the ISO that is most appropriate for the occasion. However, as I mention above, once the choice is made, there is little the film photographer can do to change it until the film is removed from the camera.

THE BEAUTY OF CHANGING ISO ON THE FLY

Thanks to digital technology, photographers no longer have to manually set the ISO at the beginning of each roll of film. With most digital cameras, you can set—and switch—the ISO whenever you want.

Let's say you've spent the afternoon photographing your friends and family at a barbecue. As it transitions to evening and the party moves indoors, you want to continue photographing the event. However, the lighting is now too dim. At your current ISO of 100, the best shutter speed your camera can give is 1/10 sec. Without resorting to using flash, 1/10 sec. is far too slow and will result in blurry images. If you were using film, the only thing to do would be to rewind your current roll and replace it with a faster film (one with a larger ISO number). This is possible, but it's a time-consuming hassle.

Fortunately, digital shooters can change ISO in one simple step! All you have to do is change your ISO equivalent to a higher number, such as 400, 800, or even 1600. This makes the camera more sensitive to the light coming into it, and provides a little more breathing room when it comes to selecting a fast-enough shutter speed.

ISO and Different Kinds of Digital Cameras

Most digital cameras will automatically adjust aperture and shutter speed to compensate for a changed ISO. If you increase your ISO (resulting in greater light sensitivity and, therefore, less exposure time), your shutter speed should automatically get faster (allowing less light into the camera).

With some digital cameras, though, changing your ISO seems to put the camera into a manual exposure mode. If you notice that increasing your ISO always results in overexposed pictures (pictures that are too bright), you probably have this kind of camera. If so, you'll need to manually adjust the shutter speed or aperture when changing the ISO.

Some digital cameras don't let you manually change the ISO at all. This is unfortunate, and the only thing to do in such situations is resort to using your flash or a tripod (if the subject is stationary). Other cameras by default use an Auto ISO setting. I recommend turning this automatic function off—so that you retain control over ISO.

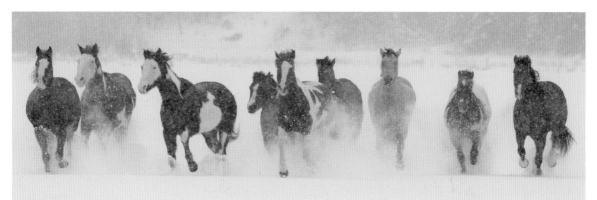

I initially photographed this herd as it was running away from me at ISO 100. After reviewing the LCD, I noticed that many images were slightly blurry. The EXIF data indicated that the shutter speed was too slow. So, I increased the ISO to 400. This allowed me to shoot at 1/500 sec., which resulted in a sharp photo of my fast-moving subject. (I later cropped the photo to a panoramic format.)

1/500 SEC. AT f/8, ISO 400, 100–400MM LENS AT 400MM

NOISE POLLUTION

As with images exposed on film, digital images also involve a choice between speed (light sensitivity) and quality. In film photography, the result of this choice is often a pronounced graininess, as mentioned previously. In digital photography, the equivalent of grain is something called *noise*, and it looks much like the grainy texture of high-speed films. The amount of noise increases as the ISO increases.

Most people find photos with a large degree of noise unappealing. The colors in these photos do not appear rich, and the images have a distracting texture. Noise becomes more noticeable when you enlarge an image. Since images displayed on your computer require a smaller resolution than printed images, noise may not be as evident in a Web or e-mailed image. It will be much more of a problem in printed photos.

For this reason, it's usually best to keep the camera on ISO 100 and only adjust it to a higher ISO when you need a faster shutter speed. This will ensure that you consistently get the best quality image with the least amount of noise. You would only increase the ISO when ISO 100 would result in a blurry photo. Blurry images are usually much more noticeable to the eye than images with noise.

Take a look at this series of images, each showing the same subject shot with a variety of ISOs. Before peeking at the captions, see if you can determine which images were shot with a high ISO and which were shot with a low ISO.

In such a low-light situation as this—a rancher illuminated solely by campfire light, I knew I would have to either use my tripod or a high ISO. I tried both. I used a tripod and my 16–35mm lens at 35mm for all five of these images, and afterward I adjusted the exposure in each in Photoshop's raw converter to make the brightness consistent throughout. The image with the highest ISO (opposite, bottom right) displays the most noise. My favorite is the version shot at ISO 100. It took one full second to expose and would have been impossible without my sturdy tripod.

1 SECOND AT f/2.8, ISO 100

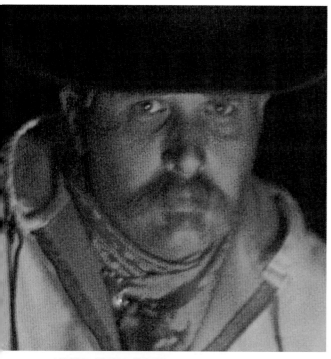

1/4 SEC. AT f/2.8, ISO 400

1/3 SEC. AT f/2.8, ISO 800

1/10 SEC. AT f/2.8, ISO 1600

1/10 SEC. AT f/2.8, ISO 3200

WHEN NOISE IS OKAY

Noise and grain are not necessarily bad. Photographers sometimes intentionally generate this texture for interesting, creative effects. For one thing, it can add to the mood of a photograph. Think of the kind of images you often see on jazz or rock album covers. The photographers who create these images often go for as much noise and distortion as they can, because it seems to best suit the subject matter and environment.

Generally, though, most people want photos with rich colors and sharp, smooth details. This means choosing a low ISO number. So again, it's a good idea to generally keep your ISO as low as possible, only increasing it when you intentionally want noise or when low-light conditions would make a sharp picture impossible without a high ISO.

This image would not have been possible without turning to a high ISO. I didn't have my tripod available, and the room was actually much darker in person. So, I increased my ISO and made a few photos, each with a slightly different composition. This first one turned out the best. Sure, there's noise in the shadows, but the noise isn't a problem with this particular subject.

1/45 SEC. AT f/3.5, ISO 1600, 16–35MM LENS AT 16MM

All the same, if you are in a tight spot, it's nice that digital cameras allow us to change the ISO on the fly so that we can accurately and creatively capture the moment before it disappears. And, if you happen to capture an image that you like but that has more noise than you want, don't hastily hit the delete button. You might be able to salvage your photo using special software. Those with Photoshop can try a plug-in called Dfine by nik multimedia, inc. Others can use a software program called Noise Ninja by PictureCode. Both of these options provide excellent help when it comes to reducing unwanted noise in your images.

BLUR: THE BIGGER PROBLEM

It is far better to resort to higher ISO numbers whenever you need them than to avoid them for fear of noise and ending up with unintentionally blurry photos. I would much rather capture a noisy image than a totally blurry one. What's better, after all? A noisy photo that is in focus or a noiseless, blurry image? Most of the time, I take the former over the latter. The only exception to this is when I'm trying to create an intentionally blurry, special effects photo.

ANOTHER OPTION: USING A LOW ISO AND YOUR TRIPOD

If your subject is stationary or you're okay with blurred movement, you have an option other than increasing your ISO number. Consider using a tripod and keeping your camera set to a lower ISO, such as 100. This will likely necessitate a long shutter speed. If your subject is moving, this long exposure gives you a blurred, special effects kind of image. If the subject is static, you'll end up with more clarity and richer colors. In either case, you will have more options if you end up deciding to print enlargements of your images, because a low ISO affords you better quality than a high ISO. When problems like subject movement make long exposure with a tripod impossible or impractical, turn to a higher ISO number. At all other times, keep your options open by using a tripod and a low ISO number.

*For this image of a man
walking in the rain across
a street in Times Square,
New York, I selected a low
ISO. I placed my camera
on my tripod and used
a remote shutter release
(see page 213) so that
the camera would remain
steady while the shutter was
open. Although there's a
bit of motion blur in his leg,
I don't mind. I like the way
it gives the image a touch
of energy.*
1/45 SEC. AT f/2.8, ISO 100,
28–105MM LENS AT 35MM

When photographing this girl baking cupcakes, I was hand-holding my camera. The situation required a fast shutter speed to avoid camera shake. I used a high ISO of 1600, which allowed me to shoot with a relatively fast shutter speed.

1/45 SEC. AT f/5.6, ISO 1600, 28–135MM LENS AT 135MM

How Low Can You Go?

To determine which ISO setting I want, I ask myself three things:

1 Do I want maximum image clarity or an image with noise?

2 Is the subject moving or stationary?

3 Is my tripod currently attached to my camera, unavailable, or just out of reach?

If I want the crispest possible image, my subject is stationary, and I have my tripod within reach, I select the lowest possible ISO and use the tripod. If I want a lot of noise (which is rare), I set the ISO number as high as it will go, whether I'm using a tripod or not. If my tripod is in the car and I'm just being lazy, I force myself to go and get it (unless this interruption might cause me to miss the shot!). If I've left my tripod at home but don't mind a little noise, I bump up the ISO as much as it takes to get a fast enough shutter speed—the idea here being to avoid getting a blurry photo due to camera shake (moving the camera when taking the picture). If my subject is on the move and I want to keep it sharp, I use my tripod and again set the ISO high enough to get a fast action-freezing shutter speed.

ASSIGNMENT Learn about Noise

This exercise is designed to show you firsthand just how much noise your camera will produce at high ISO numbers, and just how high you can go with your ISO before you begin to see a serious degradation in quality. Choose a stationary subject in low light and place your camera securely on a tripod. Shoot one photo at ISO 100 and another at the highest ISO your camera offers. Compare the results. If you cannot see the noise in the high ISO version, enlarge both photos on your computer monitor and compare them side by side to see if you can discern the noise. If you still can't, try printing the images.

Shutter Speed

AS I MENTIONED on page 60, think of the camera's shutter like the shutters on a house window. It gives control over the amount of light entering the camera. In the same way that house shutters block out light until they're opened, a camera shutter blocks out light until it's opened. The shutter button opens the shutter for a predetermined amount of time, specified by the shutter speed.

Shutter speeds are measured in fractions of a second. Common shutter speeds include 1/125 sec., 1/250 sec., 1/500 sec., 1/1000 sec., and so on. The higher the fraction denominator, the faster the shutter speed. Some cameras display just the denominator (for example, 500), while others display the fraction (1/500). So, when a shutter speed of 500 is displayed, it really means 1/500 of a second.

The faster shutter speeds (larger denominator numbers, such as 1/250 sec., 1/500 sec., 1/1000 sec., 1/2000 sec.) are appropriate for stopping faster-moving subjects. A shutter speed of 1/500 sec. is relatively fast. It's fast enough to stop most active subjects. A shutter speed of 1/30 sec., on the other hand, is getting pretty slow. When using a typical lens (such as a 50mm lens) and a shutter speed of 1/60 sec. or slower, it's usually best to mount your camera securely on a tripod.

When shooting scenes that require extremely long exposures, such as the streaming lights of traffic at night, your shutter speeds will likely be 1 second or longer. Long exposures can be made with shutter speeds such as 1 second, 10 seconds, or even 30 seconds. Unlike with the fraction denominations, in these cases larger numbers equate to *slower* shutter speeds. But as this kind of low-light photography is much less common, the idea that a larger number (larger fraction denominator) equals a faster shutter speed will work most of the time.

In addition to these shutter speed numbers, many cameras feature a B mode that allows you to open the shutter for as long as you like. Whether you use a fixed shutter speed or the flexible B mode, super slow shutter speeds can create fascinating special effects. (See page 76 for more on using slower shutter speeds for interesting results.)

> **Larger (Denominator) Numbers = Faster Shutter Speeds (Usually)**

1/90 SEC. AT f/2.8, ISO 100

TIP: USE A FAST ENOUGH SHUTTER SPEED

The general rule is: Choose a shutter speed with a fraction denominator that's larger than the focal length of the lens. For example, a shutter speed of 1/60 sec. would be ideal if you're using a 50mm lens, or a shutter speed of 1/300 sec. if you're using a 300mm telephoto lens.

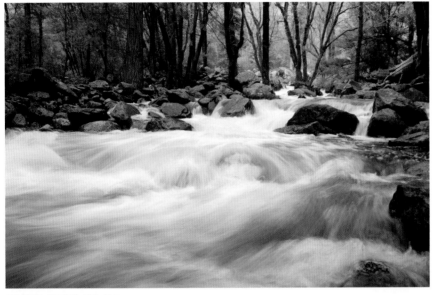

1/8 SEC. AT *f*/10, ISO 100

One of the true joys of manipulating shutter speed is the ability to freeze or blur motion. These three photos illustrate the different effects you can achieve using a variety of shutter speeds. For all of these shots, I used a 16–35mm lens at 16mm. I took the first image (opposite) at 1/90 sec.—you can see how this shutter speed was fast enough to stop the water in mid-motion. I then slowed down to 1/8 sec. (this page, top), which resulted in a blurrier representation of the water. For the final image (below), I used an even slower shutter speed of 15 seconds. Note the softening effect that this long exposure has on the river. My personal favorite one is the middle speed, which combines the best of both extremes.

15 SECONDS AT *f*/22, ISO 100

CATCHING THE MOMENT: FAST SHUTTER SPEED

The whole idea behind selecting the best shutter speed is controlling image sharpness. You get to decide if you want your subject to be crystal clear or a bit blurry. By changing shutter speed, you can either stop time in its tracks or slow it down to such an extent that you create entirely new views of reality. As touched on previously, if your subject is moving fast and you want sharp results, use a fast shutter speed (meaning that the shutter remains open for a shorter amount of time).

Image "softness," or slight blur, could be caused by your subject moving during the moment of exposure, by noise reduction features or software, or by camera shake. To correct unwanted softness, first make sure your shutter speed is fast enough to stop your subject's movement. Then, check if your camera features automatic noise reduction (also see page 69); if it does, turn it off. Most importantly, get and *use a tripod* to avoid camera shake.

I made multiple attempts to capture an image of a leaping mountain lion, with each one turning out blurry. At first, I thought the blur was caused by camera shake. No matter how stable I made the camera, though, the images continued to be soft. I finally realized that the animal was simply moving too fast. I increased the ISO on my camera to allow for a faster shutter speed and succeeded in getting the shot (actually, three shots). I used the continuous drive mode—without it, there's no way I would have been able to capture these three sequential photos.

ALL PHOTOS: 1/1500 SEC. AT f/8, ISO 400, 100–400MM LENS AT 100MM, TRIPOD

TIP: ANTICIPATE THE MOMENT

Many digital point-and-shoot cameras have a big problem called *shutter lag*. This is when you press the shutter button down but the camera doesn't take the photo for another second or so. If your camera suffers from shutter lag , there are three things you can try:

1 Turn off the autofocus because this function can greatly slow down the picture-taking process.

2 Set the focus to infinity.

3 Prefocus on an object that's at the same place you anticipate your subject will be.

While these three suggestions might not make the shutter-lag problem go away completely, they should at least help minimize it.

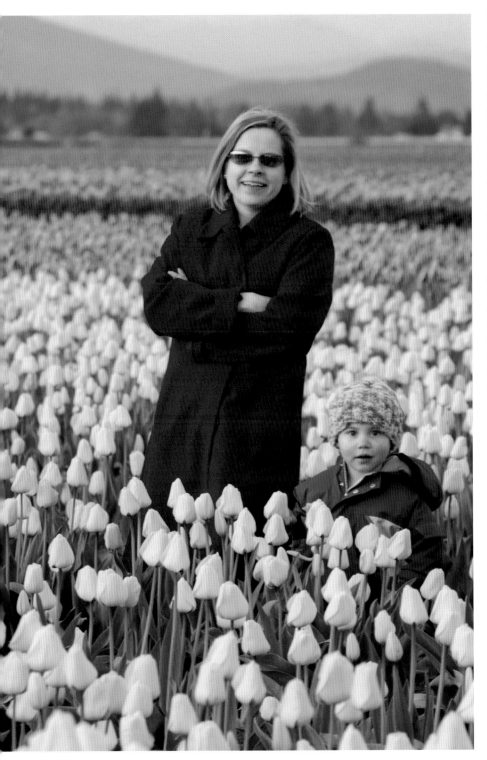

Blur is often the death knell of a potentially great photo. However, some subjects work well with a slightly soft focus. This portrait (made without a tripod) is a good example. When photographing people, a slightly soft treatment can be pleasing and flattering. Just watch out for blur around the eyes. The eyes draw most of the attention of your viewer, and if there's an uncomfortable degree of softness, your audience will likely be visually frustrated. If your image does seem to suffer from too much blur, it may still make a great family snapshot or addition to your scrapbook. Just keep the print fairly small. This will prevent the blur from becoming too noticeable and distracting.

1/6 SEC. AT f/6.7, ISO 100, 100–400MM AT 160MM

USING A TRIPOD

Everybody interested in getting nice, sharp pictures, raise your hand. Now, everybody who religiously *uses a tripod*, keep your hand raised. I think I just heard a whole bunch of hands dropping.

Camera instability is the number one cause of soft, blurry photos. So, *use your tripod*! I lugged around a heavy, secondhand tripod for years. It was a dinosaur, and it weighed a ton, but it was sturdy, let me tell you. Now I have a lightweight but equally sturdy tripod, and I take it everywhere I go. So I don't want to hear any excuses when it comes to using your tripod.

I hear what you are saying, that you just don't want to go through all the hassle. I can relate. I only got into the habit of using a tripod the hard way. In the beginning, I, too, found tripods rigid, cumbersome, and annoying. I was afraid of missing the shot while trying to set up the tripod. Additionally, I feared drawing attention to myself; when I brought out the tripod, people always commented on how I must be a "real photographer." Talk about pressure to produce great images!

After discarding far too many almost excellent images, though, I put aside my silly fears and started forcing myself to use my tripod every chance I could. The only times I don't use a tripod are when:

❑ I'm in a crowd (at a concert or sporting event, for example).

❑ I'm in a museum (or other place where tripods are not allowed).

❑ I'm photographing kids, wildlife, and other fast-moving subjects in bright light with a relatively lightweight lens/camera combination.

INTENTIONAL BLUR

Combining a slow shutter speed with the use of a tripod, you can create photos that have a unique and often otherworldly look. By giving your camera enough time to soak in the light illuminating the scene, you can capture scenes that are simply unavailable to the naked eye. You can blur the elements of your scene together, but you must make the blurriness look intentional. As long as you blur motion in an organized, intentional way, you can give a scene a sense of energy. Take, for example, the bottom image on page 73 in which the water resembles cotton candy.

If your subject is moving, you can keep the shutter open while it moves. If your subject is static, you can move the camera or zoom the lens to create a wild or impressionist look. You may end up playing with motion blur by accident, when you don't have a tripod, as was the case when I created this special effects concert photo opposite.

When Sharpness Isn't Everything

Keep in mind that, sometimes, you'll actually want a bit of blur in your picture. A fast shutter speed can make a fast-moving subject look static. If you use a fast shutter speed, a speeding racecar might simply look like a parked car. Likewise, that beautiful mountain stream might look all the more serene if you made it look like flowing satin. This is when adding a bit of intentional motion blur can make a world of difference in your photo.

TIP: GET THE SHOT EVEN IF YOU DON'T HAVE A TRIPOD

Don't refrain from photographing an interesting, fleeting moment just because you don't have your tripod on hand and can't seem to get a fast enough shutter speed. Just do your best to be stable while you take the shot. Put your camera into a continuous shooting mode and then take three or more pictures in a row. This will greatly increase your odds of capturing a tack-sharp photo of that fleeting moment.

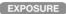

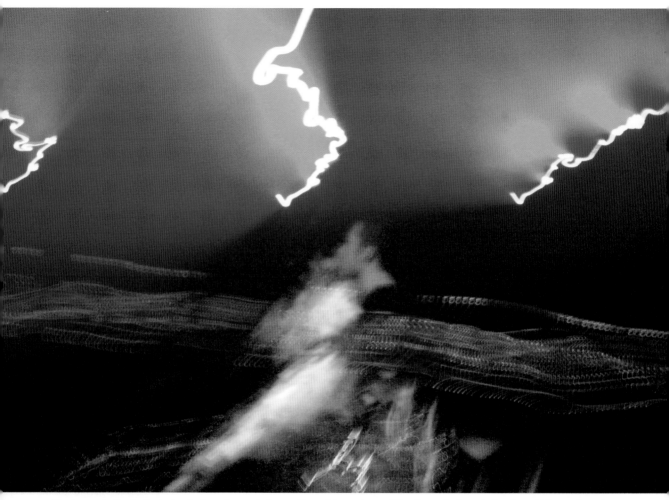

Most people like their photos to be crisp and clear, with no blur and very little discomforting abstraction. At times, though, you have no choice but to try to make the blur work for you rather than against you. At a local concert, I attempted to photograph this musician with clarity, but got only unsatisfactory results. Each time I reviewed the image in the LCD screen, the subject was slightly soft. Even with ISO 1600, the shutter speed was too slow for handholding the camera. I couldn't use a tripod because the venue didn't allow it. I finally realized, with a sort of if-you-can't-beat-'em-join-'em feeling, that I should instead make the shutter speed slower and use my zoom lens to create abstract images that intentionally featured motion blur. So, I dropped the shutter speed down to 3 seconds. As the shutter was open, I held the camera as steady as I could and zoomed the lens in and out. I love the abstract and energetic feeling in the result.

3 SECONDS AT f/27, ISO 1600, 100–300MM LENS AT 260MM

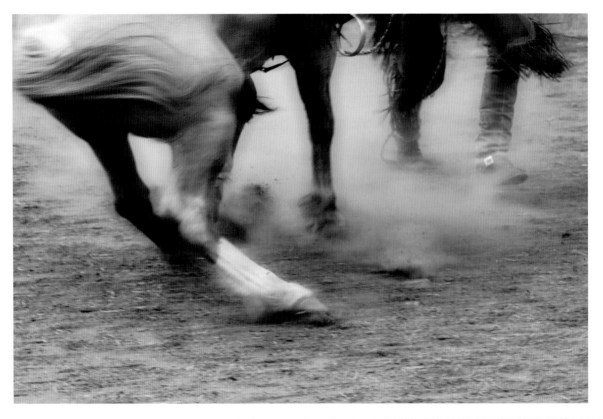

Even though the image above is slightly blurry, I enjoy the way it conveys the movement happening at that time. Just before I shot the photo at right, the horse got spooked and started rearing up. As the rider was working to regain control, I zoomed in for a tight composition of the feet and fired away. Although the 1/180 sec. shutter speed of the top image isn't slow, the activity of the horse was so much faster when I made the photo that it created a blurred effect. The image works because of the motion blur, as well as the extremely tight composition.

ABOVE: 1/180 SEC. AT f/6.7, ISO 100, 100–400MM LENS AT 100MM; RIGHT: 1/250 SEC. AT f/6.7, ISO 100, 100–400MM LENS AT 100MM

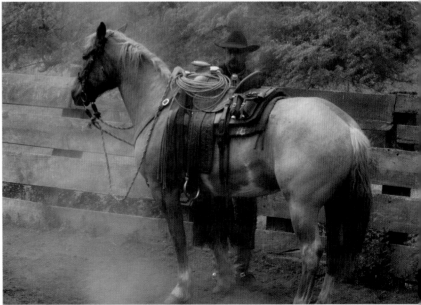

PANNING FOR GOLD

Another fun technique, called *panning*, allows you to capture a relatively sharp subject against a blurred background. This technique solves that parked racecar problem mentioned earlier. By moving the camera along with your subject, you might be able to make it look sharp while the background looks blurry. This can greatly increase the appeal in a photo by adding an element of movement.

To execute this, select a slow shutter speed, such as 1/15 sec., 1/30 sec., or 1/60 sec. at the most. Then position yourself parallel to the path of your subject. Anything moving at a good clip and in a relatively straight line will do. As your subject passes, track it with your camera, pressing the shutter button smoothly and turning your head and body to track the object. Shoot in "mid-swing" and follow through on your tracking even after the shutter has closed.

On my first visit to Manhattan, I was frightened by the way the taxis rushed along the streets like blurs of yellow. On a more recent trip to the Big Apple, I set out to capture this impression with my camera. To do this, I set my shutter speed to 1/15 sec., watched the taxi carefully through my viewfinder as it approached, and then gently pressed the shutter button as it passed, tracking along with it before, during, and after the moment of exposure.

Panning can give photographers hours of fun—or hours of torture, depending on how you look at it. Be patient with yourself, and be sure to select a subject that will pass by you repeatedly. (Or, better yet, ask a friend to pass you again and again, whether they use a car, bicycle, motorcycle, or some other fast method of transportation.)

1/15 SEC. AT f/11, ISO 100, 28–105MM LENS AT 32MM

My son loves to be spun around. Long after I or his mother have become dizzy, he will still be asking for more. One day at the park, I got the idea to document this love of flying in a photograph. I asked my wife to spin him around while I tried to photograph from behind. Keeping up with her as she twirled around turned out to be the most difficult aspect of this endeavor. By using a slower shutter speed and keeping the camera pointed at Julian, I was able to get the panning effect I was after.
1/90 SEC. AT f/3.5, ISO 100, 28–105MM LENS AT 28MM

If you try this panning technique, keep the following in mind:

❏ Panning requires a surprising degree of trial and error before you get that one perfect shot. The process necessitates practice, practice, and more practice. There's no doubt about it: You'll need to take a lot of pictures.

❏ Your subject will likely be less than perfectly sharp. Getting it relatively sharp is the main objective here.

❏ Panning can be especially frustrating if your digital point-and-shoot camera suffers from a bit of shutter delay (the picture isn't immediately taken when you press the shutter button). This means that you'll have to get especially good at anticipating the moment and pushing the button long before the ideal moment occurs. With practice, you will get the shot. It just takes more time and experimentation with a point-and-shoot than it does with an SLR.

ASSIGNMENT
Stop or Blur Action

Now you get to go have fun with what you've learned about shutter speed. There are three options:

1 You can take a picture that freezes a fast-moving subject.

2 You can shoot with a slower shutter speed to blur activity.

3 You can create a good, strong example of the panning technique.

Whichever of the three sound most interesting to you, go for it (or you can try one of each), and remember to have fun! Upload your favorite results to www.BetterPhoto.com to get comments or to enter the contest if you're especially happy with your images.

Aperture

USING SHUTTER SPEED to stop or blur motion is not the only way you can have fun with exposure settings. In fact, the most important component, in my mind—the one that gives you the most crucial control over your photographic results—is aperture.

Aperture is the opening that lets light pass through into the camera. You adjust the size of the aperture to change the amount of light entering the camera and exposing the film. The size of the aperture also affects depth of field, which refers to the plane of focus from front to back (or near to far) within an image, or more simply put, how much of a scene appears to be in focus. Apertures are designated by what are called *f*-stops. *Large* aperture openings—indicated by smaller *f*-stop numbers—cause *less* of a scene to be in focus, while *smaller* openings (indicated by larger *f*-stop numbers) cause *more* of a scene to be in focus.

An easy way to get a feel for how aperture affects depth of field is to simply squint your eyes. Whenever you squint your eyes to make distant objects appear sharper, you are exercising an instinctive understanding of aperture. This sharpening effect occurs because looking through a smaller hole (aperture) causes things to look crisper and clearer. Try it out. Look out the window at something far away, and squint your eyes. Alternatively, you can curl your index finger into your thumb and look through the tiny hole this creates. Things should get sharper.

The same principle holds true in photography. If you reduce the hole through which light enters a camera, you cause more of the resulting image to appear distinct on the image sensor.

Common *f*-stops include *f*/2.8, *f*/4, *f*/5.6, *f*/8, *f*/22, and *f*/32, with *f*/2.8 being the largest and *f*/32 being the smallest of these aperture openings.

If you find this confusing, just turn to the box on page 86, which offers another way to think of aperture, *f*-stops, and depth of field.

Isolated Focus vs. Everything in Focus

Manipulating aperture is really where it's all at with photography—it's where much of the creative magic happens. While shutter speed selection helps you freeze time or blur motion, aperture lets you control what parts of the picture remain in focus and what parts go blurry. Since it gives you the ability to designate your subject, aperture control is one of the most powerful of tools in your photographic toolbox.

With deep depth of field, everything from the near railroad ties to the hills off in the distance would appear sharp. With shallow depth of field, only the first one or two railroad ties would be sharp; the rest of the scene would appear out of focus.

In the image below, notice how the leaves and flower bud in the background are blurrier than the flower in the foreground. This isolated or selective focus helps focus all of the viewer's attention on that flower, without distraction. The blurriness of the background causes it to be less distracting. To get the shallower depth of field, I used a larger aperture (note again that larger apertures have smaller numbers, in this case f/2.8). The left-hand image shows the same scene with a deeper depth of field. With everything appearing relatively sharp, the background becomes more cluttered. To get the greater depth of field, I used a smaller aperture (one with a larger number, in this case f/32).

BOTTOM: 1/60 SEC. AT f/2.8, ISO 100, 100MM MACRO LENS; LEFT: 2 SECONDS AT f/32, ISO 100, 100MM MACRO LENS

I made this image among the lavender fields of Provence, France, during a photography workshop with fellow photographer Bryan Peterson. If you can only go to one place for a photography field trip, this is the place I would recommend. For this shot, I wanted to have as much of the scene in focus as possible. With thousands of bees humming around me, I situated myself in a spot that allowed me to make the most use of the powerful element of line inherent in the subject. As the shutter speed was fairly slow, I attached my remote shutter release and used it to trigger the shutter. This enabled me to capture both the foreground lavender plants and the far shack in focus, without camera shake becoming a problem.

2/3 SEC. AT f/27, ISO 100, 28–105MM LENS AT 105MM

These three interesting crosses atop the local ancient church in Haltwhistle, England, were quite high. So, I began wondering what nearby structure I might climb in order to bring these three crosses into perfect alignment. Then, on taking a closer look, I realized that the farther crosses were actually increasingly higher than the closest cross. So, all I had to do to get these crosses into alignment was to stand in the right place on the ground. Once I found that ideal spot, I made several exposures—each at different f-stops—to illustrate depth of field. The photo above reflects the larger f-stop number (f/16) and, therefore, greater depth of field with all of the crosses in relatively sharp focus. The photo to the right reflects the smaller f-stop number (f/5.6) and, therefore, shallower depth of field with only the nearest cross in sharp focus.

Interestingly, I shot another image of these crosses at f/16, but the 1/20 sec. shutter speed was too slow. Even though my camera was secure on a tripod, the long and heavy 100–400mm lens caused a bit of camera shake when I pressed down the shutter button. I should have used my remote shutter release to trigger the shutter. Live and learn.

TOP: 1/60 SEC. AT f/16, ISO 100, 100–400MM LENS AT 400MM;
BOTTOM: 1/750 SEC. AT f/5.6, ISO 100, 100–400MM LENS AT 400MM

Here's an example of using a large f-stop number for maximum depth of field. My aim was to have everything in focus, from the closest rapeseed flowers to the far oak tree. Use large f-stops when you want everything to be equally in focus—when having one part out of focus would actually be unsatisfying or distracting to the eye. Landscapes often need to be captured with great depth of field and, thus, require a large f-stop.

1/30 SEC. AT *f*/27, ISO 100, 28–105MM LENS AT 80MM

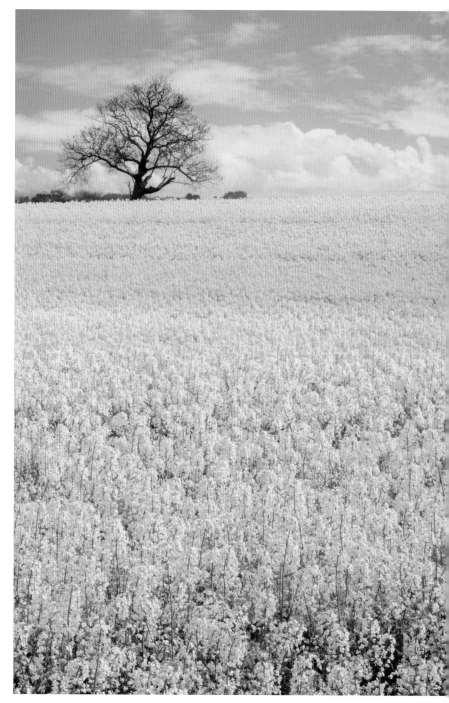

The Simple Way to Remember Depth of Field

Many people find the relationship between *f*-stop numbers and aperture sizes unnecessarily confusing. It is, at first, hard to keep straight that *smaller f*-stop numbers refer to *larger* aperture openings, which in turn result in *shallower* depth of field. If you find yourself having trouble with this, all you have to do is remember this one simple rule regarding depth of field:

Small *f*-stop number = Small depth of field

That's all there is to it. When you want *more* depth of field (i.e., everything in focus), use a *larger f*-stop number. When you want *less* depth of field (i.e., isolated focus), use a *smaller f*-stop number.

It's not always ideal to have everything in sharp focus. In the art of storytelling, there is often more power in suggestion than in outright telling. For this image made in a lavender field in Provence, France, I wanted to "suggest" the house to the viewer rather than literally "tell" the viewer about it. So, I selected a smaller f-stop number for a shallow depth of field and focused on the foreground lavender plants.

1/180 SEC. AT f/5.6, ISO 100, 28–105MM LENS AT 100MM

What Kind of Digital Camera Do You Have, Revisited

Believe it or not, f-stop numbers have different aperture values depending on the type of digital camera you use. For example, f/8 on a compact camera might be more equivalent to f/22 or f/32 on a digital SLR. Therefore, in order to get the creative effects that I refer to on these pages, you'll need to know which f-stop numbers apply to you.

 I use a digital SLR camera and the values for f-stops are relatively the same as those for a traditional 35mm film SLR. If you own a compact digicam with an attached lens, you must mentally adjust the aperture numbers I've given in this section. When I give an example that refers to f/22, translate that to your highest f-stop number, which may very well be f/8. This doesn't mean you don't have the option of getting photos with extreme depth of field. You just have a different scale with which to work. Since this scale varies from camera to camera, you need to think of it in relative terms—i.e., *your* highest f-stop number will get you greatest depth of field, and *your* lowest f-stop number will get you the most isolated focus.

WHERE TO PLACE THE FOCUS

When creating images with isolated focus, where you place the focus becomes very important. You need to consciously decide what needs to be sharp and what gets to be blurry. To determine what object to focus on in the scene, think about what you're trying to photograph and what emotional effect you're aiming to evoke in the viewer.

In order to control the placement of the in-focus area within your composition, you need to fully understand how the *focus lock* feature works on your camera. Usually, the focus lock is activated when you press the shutter button down halfway, and the focus sensor automatically focuses on whatever is centrally located in your viewfinder.

So if your subject is not centrally located, temporarily position your camera so that it is, press the shutter button halfway to activate the focus lock, and then—still holding the shutter button down halfway—return to your original off-center composition. Once the focus is locked on your subject, you are free to recompose, all the while keeping your subject sharp.

Without having a strong grasp of this technique, you will always be relegated to placing the focus on whatever is in the center of your viewfinder. So, this is important—get into the habit of using your focus lock so much that it becomes second nature. You want to keep your options open so that you can place the focus wherever you want it.

These two photos both use a relatively small f-stop, so they both have shallow depth-of-field, but the in-focus area is in a different spot in each composition. The image opposite focuses on the car, while the image at left focuses on the foreground flowers. I prefer the image that places the focus in the foreground, because it gives the scene a dreamy, almost nostalgic feeling. When shooting, I realized that I didn't want the car to be in focus. From previous photos I'd taken, I learned that a photo with the car in focus would look too much like a car advertisement. By throwing the car out of focus, I brought the sentiment of the photo back away from commercialism to something that is more suggestive and romantic.

When you're creating an image with selective focus, it becomes crucial that you focus on the right thing. So much of your viewer's attention goes to the part that is in focus; the sharp part of the scene is seen as the subject. So, make sure you focus on the objects that you most want to be sharp.

OPPOSITE: 1/350 SEC. AT f/6.7, ISO 100, 28–105MM LENS AT 105MM; LEFT: 1/350 SEC. AT f/8, ISO 100, 28–105MM AT 105MM

LIVING WITHOUT *f/22*

As I mentioned in the box on page 87, $f/8$ on a compact digicam is often very different from $f/8$ on a 35mm camera. It might be more equivalent to $f/22$ or $f/32$ on an SLR.

Don't panic if you can't find an $f/22$ option on your camera. The fact that you don't have $f/22$ doesn't mean that you have to go without extended depth of field. It's just that the scale is different on compact digicams than it is on digital SLRs or 35mm cameras. Since the compact digicam features a smaller image sensor, depth of field is measured differently.

So, the good news is that you're not really living without $f/22$. If anything, you might be getting an even higher equivalent f-stop number. That's the good news. . . .

LIVING WITHOUT ISOLATED FOCUS

. . . Now for the bad news for those with a compact, non-SLR digital camera. Since compact digital cameras tend to have a higher f-stop

number on the upper end, they can be somewhat limited when it comes to the lower f-stop numbers. This means that you might find it difficult or impossible to get photos that exhibit a nice degree of isolated focus (where only one part or object in the scene is in focus). It will depend on your subject matter and the lens focal length. Generally, telephoto lenses and macro modes have shallower depths of field than wide-angle lenses. Experiment and find out how far you can go in either direction with your particular camera.

This image features a shallow depth of field simply because the situation allowed for nothing else. My tripod was unavailable and the lighting was fairly dim. At first, because of the low-light situation, the fastest shutter speed I could get was about 1/20 sec. When I selected a faster shutter speed, the f-stop number displayed on my camera (f/2.8) would blink, telling me that this combination of shutter speed, aperture, and f-stop would result in underexposure. To get a shutter speed that I could safely handhold with camera shake, I was forced to keep the aperture on the lowest possible f-stop while increasing the ISO from 100 to 200. This enabled me to increase the shutter speed to 1/45 sec. while still using an aperture of f/2.8. This is called shooting wide open *and results in shallow depth of field. This isn't to say that I would have preferred greater depth of field in this image. I actually like the way the shallow focus gives the subject a great deal of visual attention-getting power.*

1/45 SEC. AT f/2.8, ISO 200, 16–35MM LENS AT 35MM

TIP: SHOOT IN RAW

You can give yourself more latitude when dealing with exposure by shooting in the raw file format, if your camera features this option. Shooting in raw allows you to adjust the exposure quite a bit when opening the file on your computer.

Why You Need to Know All This

You may wonder from time to time why you need to know all of this. With modern cameras, you can often get great pictures by simply pointing and shooting, without ever thinking about aperture and shutter speed. That may be true, but all the same, it is critical that you get these concepts under your belt for the following reasons:

1 The more you photograph, the more you'll want to take control. You need to know how to turn off the exposure autopilot and fly solo.

2 There are times when the camera meter misses the mark. So, you'll want to know what to do when photographing problematic scenes that tend to fool even the most sophisticated exposure meter.

3 Most importantly, this is one area in which you can express a lot of creativity. As you may have already noticed in the images and examples throughout this chapter, you can make a great variety of photographic effects simply by manipulating aperture and shutter speed.

ASSIGNMENT
Control Depth of Field

Create one picture with a shallow depth of field and a corresponding picture with an extended or deep depth of field. Once you're done, select your favorite and upload it to the www.BetterPhoto.com contest.

Exposure Problems

THERE ARE, essentially, three major problems you can encounter with exposure:

1 You can *underexpose* an entire image (meaning the image is too dark).

2 You can *overexpose* an entire image (meaning the image is too bright).

3 You can expose parts of an image properly, while underexposing and overexposing other parts.

SAND, SNOW, AND SKY

First, let's talk about a few elements of the environment that can trick your camera meter into underexposure: sand, snow, and sky. When asked to photograph a big bright expanse of sand, snow,

or sky, the camera meter often doesn't know any better than to underexpose. This makes sense when you think about it. The camera meter doesn't know that the subject is actually bright sand, snow, or sky. It just knows that it is reading a lot of light and, therefore, interprets the scene as too bright. It then compensates by allowing less light into the camera than is really needed, resulting in an underexposed image. This is where you need to come in, think about what you are photographing, and correct or compensate for such errors. The solution here would be to increase the exposure slightly (even though the camera would tell you that you are overexposing things) to compensate for the underexposure that the camera wants to do.

These three images illustrate why you sometimes need to override what the camera would like to do. I photographed all of them with a 100–300mm lens at 220mm. The first image (right) shows how the camera wanted to capture the image. Seeing all this bright white snow, it underexposed the scene, thinking that what I really wanted was an accurate rendition of an average bright scene. The result is not average, though—the underexposure produces a dark- and dingy-looking field of snow.

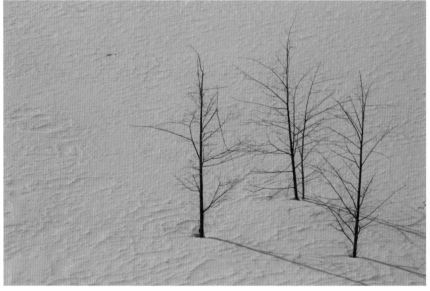

1/500 SEC. AT f/8, ISO 100 (UNDEREXPOSED)

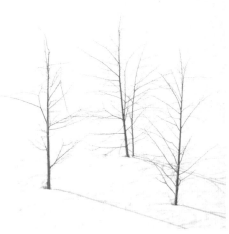

The two subsequent images show what happened when I increased the exposure using the exposure compensation feature. The photo at left utilizes a +2 setting, meaning that I increased the exposure by 2 f-stops from what the camera wanted, to get a 2-stop overexposure. The final photo (below) uses a +1 setting, meaning that I increased the exposure by 1 f-stop to get a 1-stop overexposure from what the camera wanted. I prefer the final version, as it still captures many of the details in the snow and doesn't cause them to be eliminated by too much exposure compensation.

I discuss exposure compensation in more depth on page 105, but for now, know that this feature allows you to darken or brighten an exposure (+1 means you are lightening an image, -2 means you are greatly darkening an image).

1/350 SEC. AT *f*/6.7, ISO 100 (2 STOPS OVEREXPOSED)

1/250 SEC. AT *f*/5.6, ISO 100 (1 STOP OVEREXPOSED)

LARGE BRIGHT OR DARK AREAS

Have you ever tried to photograph someone indoors, standing in front of a large bright window? Such scenes are doomed, photographically speaking. The bright light from the window tells the camera meter to speed up the shutter speed, tighten up the aperture, or do a combination of both to let less light in the camera. The end result? Underexposure. Everything in the scene ends up dark and dingy looking. Bright background windows are a perfect example of when your camera meter can be fooled by a bright, white light.

The camera is only trying to do its best. It only aims to please. However, as it can only capture a limited range of tones, it cannot possibly get everything right in this situation. It doesn't have a clue as to the nature of the subject matter that you're photographing, so it cannot tell that the background window is unimportant to you. The camera doesn't know that all you really care about is the foreground in this situation. So, like a faithful servant, it tries to balance out the very bright window and the fairly dark, shadowy foreground subjects—and in the process, it fails to do justice to either. In all fairness to your camera, what we have here is, as they say in *Cool Hand Luke*, a failure to communicate. You need to tell your camera what part of the scene you are most interested in photographing.

The same principle applies to any scene in which a large dark area dominates a bright smaller subject. The dark area will cause your camera meter to think more light is needed and to, therefore, overexpose your photo. The result is a scene in which the subject ends up ghostly white, with no detail and no color.

When faced with a bright object in your scene, you slow down (lengthen) the shutter speed and/or open up the aperture to allow more light in (to counter the camera's desire to underexpose all the brightness with a faster shutter and a smaller aperture size); and, when faced with a dark object, you need to speed up the shutter speed and/or use a smaller aperture (to counter the camera's desire to overlight/overexpose the image by keeping the shutter open longer and letting more light in with a larger aperture opening).

Subjects like this sheep can be tricky to expose. Whenever you have a dark subject, you have to be sure that you expose properly for it (not for the other areas in the image). If you don't watch out, the rest of the scene will be rendered nicely, but your dark subject will be too dark. The viewer won't be able to see the pleasing details. When facing a subject like this, use your exposure compensation feature (see page 105) and review the photos in your LCD monitor, experimenting until you get the best exposure for your main subject.

1/250 SEC. AT f/5.6, ISO 100, 100–400MM LENS AT 400MM

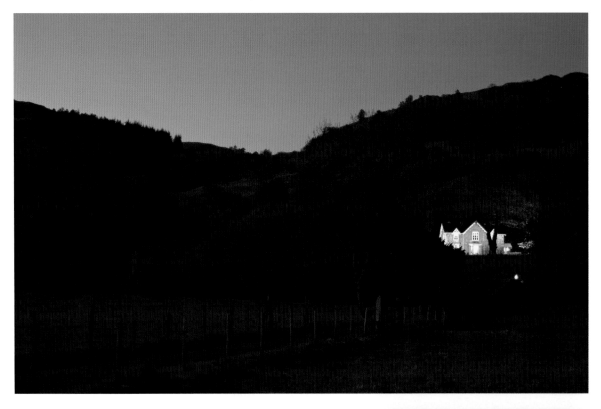

On a trip through the Lake District in England, I stayed behind one evening while the rest of the group drove to the next hotel. I was particularly interested in photographing a particular monument in the late light of the day. When I stopped to photograph this large, well-lit house set against the dark hills, I knew that if I simply relied on my camera's meter, the house would be overexposed and blown out. The camera, not knowing any better, would try to make the overall scene nice and bright and, in the process, would make the house too bright. So, I used my exposure compensation feature (see page 105) and told the camera to take a photo that was 2 stops underexposed. The result features much darker hills than the overexposed version, but the main subject— the house—shows good detail and wasn't overexposed or blown out.

CORRECT

You can really see the value of this when you compare the correct image and details to the overexposed ones. In the correct version, lightening the image (in a software program, like Photoshop) revealed more detail in the shadows. In the overexposed image, darkening the image didn't help bring back any detail in the blown out highlights. This is a very common problem in digital photography; overexposed, or blown out, parts of a scene contain no information whatsoever. Since there was no information there to begin with, no amount of darkening in that part of the image could bring back the details. Using exposure compensation in situations like this will allow you to get detail where you need it—in your subject.

THIS PAGE, TOP: 1 1/2 SECONDS AT f/2.8, ISO 100, 16–35MM LENS AT 30MM;
OPPOSITE, TOP: 10 SECONDS AT f/4, ISO 100, 16–35MM LENS AT 30MM

CORRECT, LIGHTENED IN PHOTOSHOP

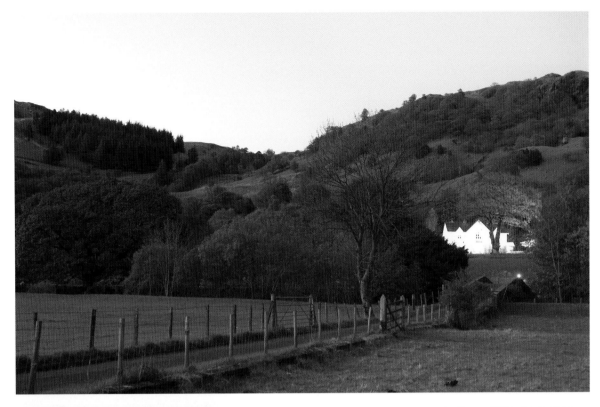

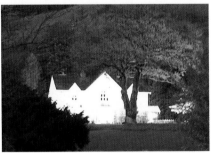

OVEREXPOSED

OVEREXPOSED, DARKENED IN PHOTOSHOP

TIP: REPOSITION TO METER

When you see a large bright object, such as the sun, in your scene, you can make adjustments before shooting. All you need to do is simply position your camera so that you eliminate the meter-confusing elements from the composition, determine that exposure, and recompose. For example, if you're photographing a sunset, temporarily aim your camera so that the sun is completely out of the viewfinder. Taking your reading from a bright—but sunless—part of the sky will get you a correct sky exposure. Including the sun in the scene while metering will cause serious underexposure. The idea is to exclude, while you're metering, any nonessential part of the scene that is either too bright or too dark.

KEEPING YOUR HIGHLIGHTS IN CHECK

If you shoot with other digital photographers, you'll likely hear them complain from time to time about "the whites being blown out." They are concerned about losing the ability to show details in the highlights. When these highlights are too bright, any picture information that might have been there is totally obliterated. That means that there's nothing to work with when trying to correct the photo in a software program, such as Adobe Photoshop. To help with this, many digital photographers (if their camera allows it) set the LCD screen so that it shows blown out highlights by making them blink.

While brightening an underexposed (dark) subject can bring out some details in the shadows, darkening an overexposed (bright) subject does absolutely nothing to the highlights. There, literally, is no picture information in those highlights, so there are no details that can be salvaged by darkening the photo. In the world of digital photography and corrective Photoshop magic, this is bad. There is simply nothing you can do to fix those blown out parts of the picture.

The solution? One possibility is to slightly underexpose. I often use the exposure compensation feature (see page 105) to have the camera capture exposures about a 1/2-stop below what it would normally do. Remember, overexposing adds more light to your photo; underexposing causes a bit less light to get to the image sensor.

In my experience, it's better to err on the side of darker images rather than brighter ones. Of course, it's ideal if you get the exposure perfectly balanced, but if you underexpose, you can often brighten the image up in Photoshop. Especially true when shooting in a raw file format, you have more latitude when underexposing than overexposing. It's easy to make adjustments to exposure when importing and converting raw files.

MAKE USE OF THE LCD

You can turn to your LCD screen to see if your exposures are in the ballpark or not. Exposure is one area in which the LCD screen gives digital photographers an enormous advantage over film photographers. With the ability to immediately see whether your exposure is on the mark, you can decide if you need to reshoot right then and there. With many subjects, this can completely save the day.

Why Does My Camera Only Blink for Blown Out Highlights?

You may wonder why some cameras blink in alarm when the white highlights are blown out but don't blink when the dark shadows are too dark. The reason is that blown out highlights have no picture information in them whatsoever. If you try to darken the photo in a software program, it will be as if that part of the picture is a blank canvas (without any picture information). On the other hand, if you lighten a dark image, you will have more latitude and often be able to correct the problem. While the blown out highlights are a "lost cause," there's hope when it comes to salvaging a photo with overly dark shadows.

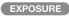
Using the Histogram

SOME PHOTOGRAPHERS prefer to judge the quality of an image's exposure by viewing its histogram rather than the actual photo in the LCD screen. So, let's take a look at this thing they call the *histogram*. If you're very technically inclined and enjoy mathematics and charts, you'll probably enjoy histograms. Also, if you're new to exposure issues and find yourself continually frustrated with the task of identifying good vs. bad exposures, you might learn a lot by looking at your histogram.

WHAT IS A HISTOGRAM

A histogram is a graphic representation of all of the pixels in a digital photograph. Think of it as a simple bar chart, like one you might find in PowerPoint or accounting software. Across the horizontal axis, you see a spectrum representing all of the colors available to each photograph, from lightest to darkest. Along the vertical axis, you are presented with the amount of color in your photo—i.e., how many pixels consist of each particular tone.

Bright images have a lot of high peaks on the right end of the histogram. This usually indicates a tonal imbalance, with the photo leaning toward the brighter tones. Dark images have a majority of peaks on the left end. This usually indicates that the image is too dark. The middle-of-the-road version, wouldn't you know it, has the most peaks in the middle of the histogram.

Generally, then, the thing you want most in the histogram is to have the majority of pixels in the middle, with this middle "mountain" of black stretching across the horizontal axis as far as possible. Too much on the left and too much on the right often means under- or overexposure.

A majority of high peaks at the right end of the histogram indicates a bright, overexposed image (top). A majority of high peaks at the left end indicates a dark, underexposed image (middle). When a majority of the peaks fall in the center, the image is well exposed (bottom).

PHOTOS © DENISE MIOTKE

HIGH-KEY AND LOW-KEY EXCEPTIONS

The general guidelines for histograms mentioned on the previous page hold true for average scenes. However, high-key images (those with large amounts of bright/white areas in them) and low-key images (those with large amounts of dark areas in them) should, naturally, show up differently in the histogram. High-key images have most of their peaks on the right end of the histogram. Low-key images have most of their peaks on the left end of the histogram. These two extremes show the exceptions to the rule when using the histogram to judge exposure.

So, there are no quick-and-easy answers when it comes to using the histogram. Actually, there are no quick and easy answers when it comes to judging overall exposure, for that matter. Both when looking at the histogram and when simply looking at a scene to determine exposure, you need to analyze whether the scene is:

❑ Medium or average in tone

❑ Particularly high key

❑ Particularly low key

❑ A dark subject on a light background

❑ A light subject on a dark background

This scene has so much white space in it that the histogram is bound to have more peaks on the right. While this would indicate an overexposed image when shooting a medium-tone scene, it's perfectly acceptable here.

The dark door dominates so much of this scene that the histogram is bound to have more peaks on the left. While this would indicate an underexposed image when shooting a medium tone scene, it's right on target for this scene.

This picture has a large amount of white background as well as a very dark subject, which causes peaks on both the left and right sides of the histogram. Usually, a histogram with spikes on both ends and little or no black in the middle translates into an overly contrasty image, i.e., one in which the shadows are too dark and the bright areas are too bright. For this particular scene, however, this histogram is perfect.

HOW TO VIEW THE HISTOGRAM

There are a couple of different ways to view the histogram of each photo. Some digital cameras let you view the histogram right in the LCD screen. Check the camera manual to see if your camera has this capability.

Digital image-editing programs often let you see a histogram of your image. In the most recent versions of Photoshop, you can view the histogram on its own palette or go to the Image>Adjust>Levels menu item to view the histogram.

When I want to view the histogram in my camera, I first turn the camera to playback mode. As I review each photo in the LCD, I see a tiny histogram and a few other facts about the image. In this way, I can see the photo and the histogram side-by-side. The downside is that both are somewhat small and difficult to discern.

I could, if I wanted, also set up my camera so that this histogram displays during a 4-second review period after each exposure. I generally choose not to do this because I prefer to see the larger view of the most recent image.

Usually, I prefer to look at the image itself when shooting. This helps me keep my eye on the ball. By examining the photo itself, rather than a technical representation of it, I find it easier to remain focused on my top objective: capturing a beautiful or emotionally evocative photograph. I only review the histogram when I suspect I might be blowing out highlights and want to confirm my suspicions.

TIP: TAKE A TEST PICTURE

Whenever your subject allows for multiple attempts, use the LCD screen to view a test picture before creating your final picture. This way, you can analyze the LCD and/or histogram for this initial shot to determine if you need to make adjustments before reshooting.

Questions to Ask When Determining the Ideal Exposure

- ❑ Is the subject static or in motion?
- ❑ Do I want the subject to be crisp or energized with a touch of motion blur?
- ❑ Do I want just one isolated subject in focus or the entire scene in focus?
- ❑ If the light is dim, do I need to increase the ISO to keep the shutter speed fast?
- ❑ Are there any bright areas or dark areas that might trick my exposure meter?

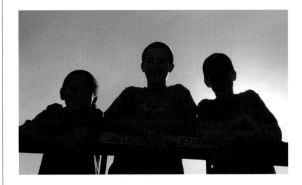

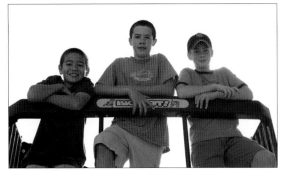

When I made this picture (top), the LCD showed me how underexposed the shot was. For my second try, I exposed entirely for my subjects and let the sky wash out.

TOP: 1/350 SEC. AT f/10, ISO 100, 16–35MM LENS AT 35MM;
BOTTOM: 1/180 SEC. AT f/6.7, ISO 100, 16–35MM AT 35MM

Changing Exposure Settings

NOW THAT YOU KNOW about the three components of digital exposure (ISO, shutter speed, and aperture), as well as when and why you need to know them, the last task is to learn how to change them.

There are several paths you can take for making exposure adjustments. First, you'll need to consult your camera manual to learn how to override the fully automatic mode and shoot with manual or semiautomatic exposure options. This usually involves setting your camera into a different exposure mode. You do this on some cameras by turning a dial. On others, you select from a series of cascading menu options shown on the LCD. The latter is much more difficult in my opinion. If you find yourself getting so frustrated with navigating through menus that you become reluctant to bother controlling exposure, consider upgrading to a digital SLR or other camera that uses knobs instead of menus (more on that in the Digital Camera Buyer's Guide on page 206).

There are many camera modes from which to choose when it comes to controlling exposure. You can greatly simplify your life, and learn photography more quickly, if you just focus on a few of the most important modes.

SHUTTER PRIORITY AND APERTURE PRIORITY

Both shutter-priority and aperture-priority modes give the photographer control over the exposure without completely saying, You're on your own. With each, you select one component and the camera will automatically adjust the other component for you.

Choose shutter-priority mode if you know that you want a particular shutter speed and don't much care about the aperture. So, you select the shutter speed and leave the aperture setting to the camera. Select aperture-priority mode if your first concern is how much of the scene remains in focus, in other words, how much depth of field the photo has. In this case, you would pick the aperture and leave the shutter speed setting to the camera.

I find myself turning to the aperture-priority mode more often than the shutter-priority mode. I prefer to choose the ƒ-stop depending on whether I want the focus isolated on my subject or extensive throughout the picture. I then let the camera tell me the appropriate shutter speed, and if it's fast enough for me to use without getting blurry photos, I take the shot.

If the shutter speed is too low and I still want to use the same f-number, I have two choices: I can increase the ISO if the subject is active and I don't mind noise in the photo; or, if the subject is static, I can place my camera securely on a tripod and use the remote shutter release to take the picture.

PROGRAM MODE

The semiautomatic Program mode causes the camera to select what it considers to be the best combination of aperture and shutter speed. However, it doesn't take away all the control. It gives you the ability to shift your exposure settings in one direction or the other. When you increase your shutter speed to catch a faster-moving subject, the aperture automatically adjusts to a lower ƒ-stop number to compensate. If you would like greater depth of field, increase the ƒ-stop and the shutter speed adjusts for you, as long as it's not already as slow as it can possibly go.

Program mode is a great option when you're working very quickly and don't have a lot of time in between shots. Using this mode, I can take control of aperture and shutter speed while feeling relatively assured that I won't make exposures that are too bright (overexposed) or too dark (underexposed).

FULLY AUTOMATIC AND SUBJECT-SPECIFIC MODES

There are a few modes that you may find on your camera that I do not recommend. One is a fully automatic mode that gives the photographer no control whatsoever. If your camera doesn't let you adjust exposure settings, or it automatically causes the flash to pop up every time you shoot, check to make sure you're not in a fully automatic mode.

This is different than the semiautomatic Program mode mentioned previously. In comparison, the Program mode gives you the ability to shift exposure values and doesn't assume it knows more than you about things like using the flash.

In addition to the fully automatic mode, some camera manufacturers give users subject-oriented modes. These are usually identified as Night, Sports, Landscape, Portrait, and so on. They're often designated with cute, universal icons. The problem with these modes, like the fully automatic mode, is that they do not tell you exactly what your camera is doing. If you don't understand how exposure works, you will never grow confident or proficient when it comes to controlling exposure in the future.

OLD SCHOOL: THE MANUAL MODE

Why would anyone ever want to shoot in the fully manual mode, you ask? For one, you need it if you decide to set up a studio for photographing people, products, and still life subjects in a controlled lighting environment. In such situations, you position and set the brightness of the studio lights, then take a meter reading with a special handheld meter. Using the *f*-stop and ISO that you set in it, this meter will tell you, among other things, which shutter speed will work with that amount of light.

Manual mode likewise comes in handy for photographers who prefer to use a handheld light meter out in the field. It's also great for students who really want to master the understanding of exposure.

If you don't fit into any of these categories at the current time, make it easy on yourself and shoot in aperture-priority, shutter-priority, or Program mode instead of the full manual mode.

For this macro color study, I turned to aperture-priority mode because I wanted full control over aperture. Depth of field was a big concern, as it always is in macro photography. The f/11 aperture meant using a slow shutter speed. Even though I used the flash to add some sparkle, I still also used a tripod to ensure sharp results during the long exposure.

3 SECONDS AT f/11, ISO 100, 100MM MACRO LENS

Other Ways to Adjust Exposure: Lock, Compensate, or Recompose

REGARDLESS OF what mode you're in, it helps to be able to lock your exposure or to adjust it to be brighter or darker. To do this you can either use the exposure lock and exposure compensation camera features, or you can totally recompose your picture.

EXPOSURE LOCK

Like the focus lock feature, *exposure lock* (also called *autoexposure lock* or sometimes just *AE*) lets you point your camera in one direction to set the exposure you want and press a button to hold this setting as you recompose your scene. On some

Before taking a picture, it's a good idea to quickly ask yourself one important question: Do you see both bright whites and dark shadows? If so, know that one or the other is going to be sacrificed in the photo. Without doing some fancy Photoshop work, you can't capture both the bright highlights and the details in the dark shadows. When I noticed the extreme contrast in this scene, I asked myself what was more important: the bright window in the background or the low-lit figures in the foreground. Fortunately, this was a no-brainer. I wanted to accurately capture my baby son and his grandpa and could not have cared less about the window.

The top image is what the camera wanted me to accept as its first exposure offer. (Never accept the first offer!) Even though this was a correct exposure as far as the meter was concerned, it wasn't very pleasing or creative. It certainly wasn't what I wanted. To tell the camera what I wanted, I filled the frame with the part of the picture that mattered the most to me—Grandpa and his grandson. I then locked the exposure by pressing and holding the expo-sure lock button on my camera. While holding this exposure button, I positioned my camera back to the original composition. This resulted in an image that was both "correct" and creative. Although the window area is completely blown out, I don't care at all. My main subjects look bright and colorful—and that was my main goal.

TOP: 1/90 SEC. AT f/4.5, ISO 1600, 28–105MM LENS AT 40MM; BOTTOM: 1/45 SEC. AT f/4, ISO 1600, 28–105MM LENS AT 40MM

cameras, you press the shutter button halfway down to lock exposure. On others, you use a separate button altogether. Note that on cameras that use the shutter button for both locking exposure and locking focus, pressing this button halfway will cause both the focus and the exposure to lock on the same object in your scene.

EXPOSURE COMPENSATION

If you don't have the exposure lock feature, don't fret; your camera might offer another way to control aperture and shutter speed: the *exposure compensation* feature. This allows you to skew the camera's meter reading. You cannot directly control depth of field or shutter speed with it, but you can choose to add a stop of light (+1) or subtract a stop of light (-1) when photographing tricky subjects, such as snow or beach scenes.

Remember the three images of the three trees in the snow (pages 92–93)? They illustrated how the use of the exposure compensation feature can help you in certain problematic situations. As I did with those snow photos, you actually want to add light when shooting such bright scenes (to counter the camera's tendency to underexpose very bright scenes). When you add light by slowing down the shutter speed by a factor of +1, this causes the camera to expose for twice the

> **TIP:** WITH BRIGHT OBJECTS, UNDEREXPOSE SLIGHTLY
>
> If you notice overly white or bright *objects* in your composition, I recommend using exposure compensation to slightly underexpose the scene (-1/2 for example). This is better than slightly overexposing, which could result in the object being blown out. You'll have more detail information in the photo if you underexpose than if you overexpose. (It's only when the *entire scene* is very bright that you would overexpose to avoid underexposure.)

> ## Too Bright? Add Light. Too Dark? Subtract Light.
>
> Bright scenes may need *more* light; dark scenes may need *less* light. At first, this may seem counterintuitive, but practice will show that it works when it comes to dealing with problematic scenes.
>
> For example, photographing your child on a bright beach will likely require you to *add* light by slowing down the shutter speed, lowering the f-stop, or increasing the ISO number. If you don't, the beach will look a bit shadowy and your child will be a very dark shape.
>
> Photographing the moon at night will require you to *subtract* light by speeding up the shutter speed, going with a higher f-stop, or decreasing the ISO. If you don't, the night sky may look okay but your moon will be totally overexposed and look washed out.

amount of time it deems necessary. The result will be a brighter, more correctly exposed image. Remember, your camera meter's goal is to photograph everything it sees as an average scene in regard to brightness. This is why we sometimes need to add a stop or two of extra light to a bright scene. While the camera will try to capture the scene as even, middle-gray tones, this is not what you want; snow should be white, not gray! But your camera doesn't know this.

Exposure compensation is a great way to shift the overall exposure. However, it's not to be confused with direct ISO, aperture, or shutter speed control. While exposure compensation does allow you to shift the exposure in one direction or another, it limits your creative options. You can increase or decrease depth of field using aperture-priority mode, or freeze or blur action using shutter-priority more, but you cannot achieve and adjust these creative effects using exposure compensation.

RECOMPOSING FOR DIFFERENT EXPOSURE

If all else fails and you're still having difficulty getting good exposure, try this simple solution: *recompose* your picture—permanently. If a bright, overcast sky (an element that's far beyond the range that any camera can capture) fills up part of your picture, change your composition to exclude this large bright area.

If you only recompose *temporarily* (using the exposure lock feature), you'll end up with a dull, bright white sky in your image. If you're willing to have a dull-white sky element in your composition, go for it. However, you can also salvage the situation by *permanently recomposing* the scene to eliminate the problem. In the photo below, the difference in exposure is striking; I was able to capture a very different kind of image simply by moving in close to the stained glass window and eliminating any overly bright elements from the final composition.

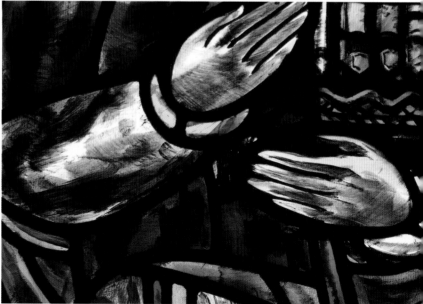

Attracted by the intricate carving, I attempted to capture the detail in this pew ornament in a church in northern England. Unfortunately, the background posed a problem because the stained glass on the left was too transparent and created a blown out, distractingly bright highlight. This trips up a lot of photographers when they try to photograph church interiors and stained glass. You can either photograph the stained glass or the church interior, but because there's so much difference in brightness between the two, you cannot capture both in the same image. So instead, I exchanged my wide-angle zoom lens for a super telephoto zoom lens—mounted securely on my tripod— and moved in tight for a detail photo of the more colorful stained glass window.

TOP: 1/6 SEC. AT f/3.5, ISO 100, 28–105MM LENS AT 28MM; BOTTOM: 1/6 SEC. AT f/5.6, ISO 100, 100–400MM LENS AT 400MM

Recap: The Twelve Ways to Change Exposure

Now that you know the three elements of the exposure triangle—ISO, shutter speed, and aperture—let's recap with a chart that lists the various combinations of the three that let you manipulate exposure.

	APERTURE	SHUTTER SPEED	ISO
1	shift to next higher f-stop	keep the same	multiply by 2
2	shift to next higher f-stop	slow it down	keep the same
3	shift to next higher f-stop	slow it down 2 stops	divide by 2
4	shift to next higher f-stop	speed it up	multiply by 4
5	shift to next lower f-stop	keep the same	divide by 2
6	shift to next lower f-stop	slow it down	divide by 4
7	shift to next lower f-stop	slow it down 2 stops	keep the same
8	shift to next lower f-stop	speed it up	multiply by 2
9	keep the same	slow it down	divide by 2
10	keep the same	slow it down 2 stops	divide by 4
11	keep the same	speed it up	multiply by 2
12	keep the same	speed it up 2 stops	multiply by 4

ASSIGNMENT Change and Control Your Exposure

If the concepts in the chart above still seem a little abstract, go through the following two-part assignment. Putting these concepts into action will help clarify them.

1 Use either exposure lock, exposure compensation, or recomposing to shift your exposure. Take both *before* and *after* pictures, and compare the results. If at first you don't see a noticeable difference, increase the amount that you're shifting the exposure. Instead of doing +1, for example, do +2.

2 Get out your camera and play around with your exposure settings in a variety of situations to see how the exposure numbers change. Find the following subjects, and be sure to keep the scene and lighting conditions consistent. Also be sure to focus on the changing exposure data. While you're working, slow down and think carefully about how the changes you make are affecting your exposure.
 ❑ Photograph your kids and change to a faster shutter speed. Make the f-stop smaller or, when it is as small as it goes, raise the ISO.
 ❑ Photograph a landscape and increase the deep depth of field (you'd want a larger f-stop number, therefore). Make the shutter speed slower or, when it is as slow as it can go (or you can't go any slower due to possible camera shake problems), raise the ISO.
 ❑ Photograph an evening scene with a tripod but without flash and use the smallest possible ISO (ISO 100). To do this, make the f-stop number smaller and the shutter speed faster, or make the shutter speed slower and the f-stop number higher, depending on how much depth of field you want.

When all is said and done, examine your images on your computer, using an EXIF-reading software program. This will help you remember what changes you made and understand how these changes adjusted your exposure.

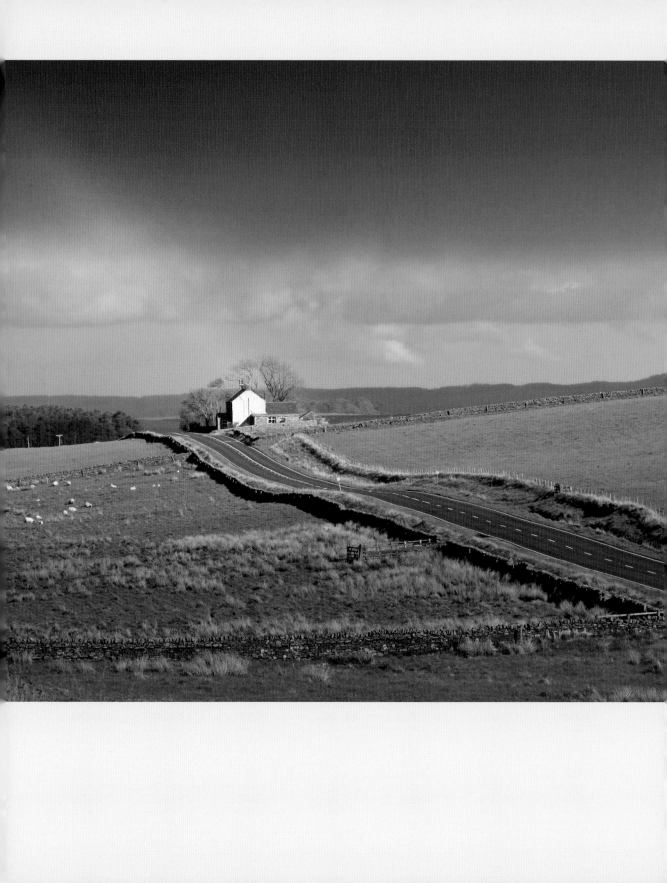

Light

LIGHT HAS A VARIETY of characteristics or personalities. Depending on time of day, direction, and intensity, the quality and color of light can change dramatically. Sometimes, the color can influence the camera in the wrong way and cause an image to look tinted and unattractive. One way to balance and correct such results is to use the white-balance setting. In this chapter, you'll learn how to use this feature to your advantage. And, we'll take a look at the various colors of light, as well as the way direction and time of day can influence light and, therefore, affect your photos.

Most people think that to make great photos, the weather needs to be beautiful and sunny. This is a myth. You can often create great images in poor or marginal weather. The key is to have great flexibility. If, for example, you go out photographing a particular subject that only looks good in a certain light, and you don't find that light, you may need to shift gears and photograph an entirely different subject.

That's what happened to me one overcast afternoon when I was driving around looking for pockets of sunshine. No sooner had I finally found some sunshine and opened up my camera bag than it began to rain. Still, I made several exposures, protecting my gear as best as I could, and this rainbow image was my favorite result. I like the way the composition utilizes the line of the road to lead the eye to the house and rainbow.

1/250 SEC. AT f/8, ISO 100, 100–400MM LENS AT 100MM

The Characteristics of Light

LIGHT REVEALS ITSELF with infinite characteristics and subtleties. Natural light (light that's not from flash) can change from a cool blue to a warm pink in a matter of seconds. In portraits, light that provides a soft, even glow can hide wrinkles, while light that's dramatic and directional (coming from the side, for example) can intensify a subject's weathered features. I often find myself thinking more about light than the subject itself.

The main thing to keep in mind with natural, or "available," light is that it can change fast! For this reason, the ideal situation is to be at the scene and ready to go *before* the good light arrives. It also pays off to stick around, when the light is not good, and wait for it to improve. So, two qualities that greatly help the photographer are preparedness and patience—getting to the scene ahead of time and being able to wait, if necessary, for the ideal moment.

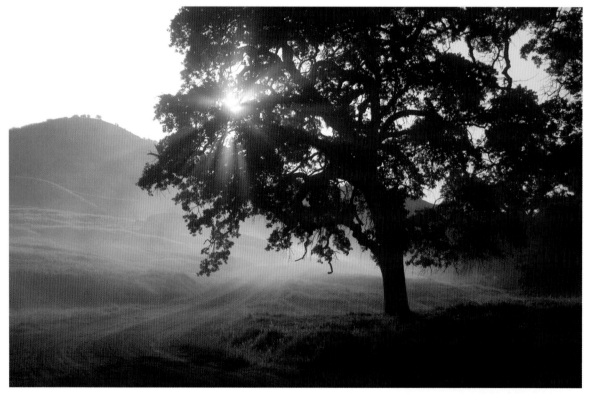

When it comes to working with light, one great trick is to simply turn around. Whenever you find yourself admiring a particular scene, turn 180 degrees around and see how the light looks. Often, when the light catches your eye while facing one direction, it will be equally or even more interesting when you face another direction. This is exactly what happened here. The morning sun was behind me as I prepared to photograph a black bear in the gorgeous morning light. Noticing the way my vehicle had kicked up a great deal of dust, I wondered how the light would look filtering through it. So, I turned around and captured both a vertical and a horizontal version of this scene.

1/90 SEC. AT f/5.6, ISO 100, 28–105MM LENS AT 45MM

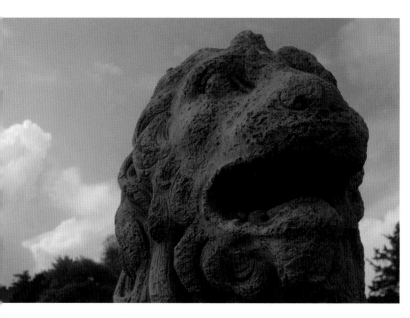

After making several exposures of this statue in England when a cloud was blocking the sun, I finally gave up, climbed down, and started shooting something else. As I turned around to head back to my car, I saw the light breaking through the clouds and climbed up again for this second shot. You can see the effect different light has on the subject. (I also used a different, super wide-angle lens for this second image. This allowed me to include the castle in the background. We'll talk more about lenses and composition in chapter 6.)

LEFT: 1/180 SEC. AT f/10, ISO 100, 28–105MM LENS AT 28MM; BELOW: 1/250 SEC. AT f/8, ISO 100, 16–35MM LENS AT 16MM

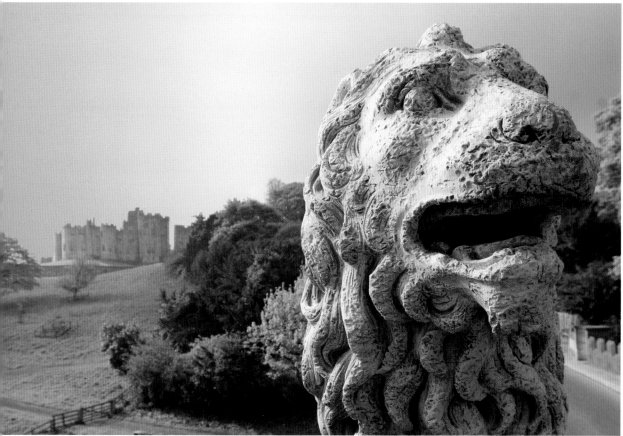

COLOR

Light takes on many different hues, each having a very different effect on the subject. The more technical among us describe the various colors of light as different temperatures. For example, candlelight can be expressed as 1900 degrees Kelvin (1900K) and noontime daylight might be around 5500K. Light is also referred to as *cool* or *warm*, depending on its temperature or color cast.

It doesn't matter how you describe light, as long as you get into the habit of noticing the various colors that light can offer. When you do, you'll see the quality of your pictures immediately begin to improve. With each photographic outing, you'll become more and more aware of the effect that the light has on your subjects. You'll see how subtle changes in these hues can completely transform your photos.

Every so often, I would catch myself thinking in church, Wow, the light coming in through those stained glass windows sure would make a wonderful photo. So, one Sunday morning before church, I brought my camera with me and began making photographs. A friend who was with me asked me about depth of field, so I demonstrated the concept with these flowers. I enjoy the way this image uses both deep depth of field and the soft, glowing light from the window to give the subject a warm, yet sharp look. Let there be light—amen to that!

1/45 SEC. AT f/22, ISO 100, 28–105MM LENS AT 72MM

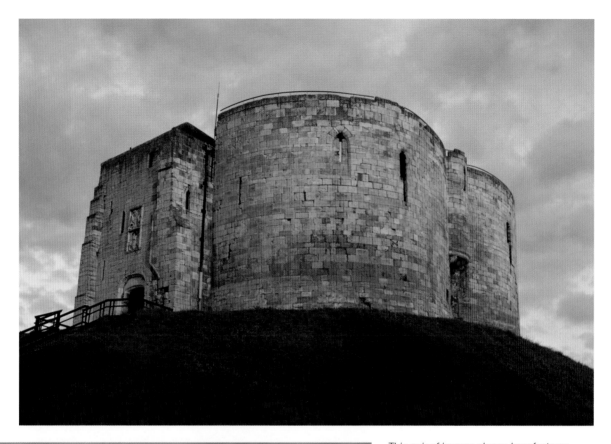

This pair of images shows how fast you sometimes have to be when taking pictures. I could see that the light was changing quickly. The beautiful warm glow of the early morning was transforming into a dull, unattractive gray right before my eyes. I quickly made an exposure with the lens that was on my camera, without fiddling with the settings or making sure that I had all the knobs and buttons in their perfect positions. After I took this "safety shot," I changed the lens. Even though I was moving quickly—with the lens change only taking nine seconds (according to my EXIF data)—I was too late. The sun had already moved into low clouds on the horizon, and the warm light was gone. The show was over but, fortunately, I got the shot that I wanted by acting quickly when taking the first picture.

ABOVE: 1/60 SEC. AT f/4.5, ISO 100, 28–105MM LENS AT 28MM; LEFT: 1/125 SEC. AT f/4.5, ISO 100, 16–35MM LENS AT 16MM

DIRECTION

It's also essential to consider the direction and angle of the light. When the light source (usually the sun) is behind you and hits the *front of your subject*, this is called *frontlight*. When the sun is in front of you and hits your face and the *back of your subject*, this is called backlight. Backlighting is much trickier to work with than frontlighting, but it can often result in interesting, creative images.

Light that comes directly from above, as when the sun is high in the sky, is generally considered less than ideal for taking pictures. This overhead light is usually too bright and harsh. Objects appear flat and lifeless, without texture. Harsh overhead lighting can also cause unflattering shadows in portraits, such as the "raccoon eyes" effect when the eye sockets get filled with shadows. It can also cause your subjects to squint, which always looks worse in the final photo than it did in the viewfinder.

Light that comes from the side, or *sidelight*, accentuates the three-dimensionality and depth of a scene, and the picture looks more interesting. In sidelit scenes, even slight shadows add drama and give viewers something more enjoyable to look at.

This series shows the variety you can get with the same subject in different light. In the photo above, the family was in direct sunlight on a bright day. Even though the flash fired when I took this picture, you wouldn't know it. The sunlight is far too bright and harsh. When making portraits, pay attention to your subjects; if they're squinting, see if you can find another location in nearby shade.

1/200 SEC. AT *f*/10, ISO 100, 28–105MM LENS AT 105MM

We did just that at left, trying another location in open shade; however, I forgot that I still had the camera set for flash. Even though the flash did fill in the shadows, it also produced light that had a cool, flat quality. I noticed this when viewing the image in the LCD monitor and decided to try again. The result was my favorite shot below, which utilized the available light without resorting to the boring, flat light of the flash.

LEFT: 1/60 SEC. AT f/5.6, ISO 100, 28–80MM LENS AT 80MM;
BELOW: 1/60 SEC. AT f/4, ISO 100, 28–80MM LENS AT 60MM

Time of Day

HAVE YOU HEARD photographers talk about the "golden hours"? These are the brief periods of time around dawn and dusk. During these times, the light is often amazingly warm and directional. Compared to the rest of the day, the light you encounter during these fringe times is pure magic. Experienced photographers know that the way to get stunning, breathtaking images is to take full advantage of these brief windows of opportunity. You'll find these photographers out in the field in the early morning, even before sunrise, and there in the late evening, when everyone else has gone to dinner. If you want to get great photos, be ready and waiting for the photo op to occur at the beginning and ending of each day.

THE EARLY BIRD GETS THE WORM

If you think about it, waking up before first light increases your chances of getting great pictures by about 150 percent. If you can get ten good pictures in one evening, you can get twenty-five if you shoot both morning and evening. Why 150 instead of 100? In the morning, there are fewer people around, less traffic, and calmer winds and waters. Photograph a lake in the early morning, and you're more likely to capture the perfect glasslike reflections you're after.

If you find it practically impossible to get out early, it may help to analyze the reason. Photographers don't procrastinate because they're lazy; they fail to get out early because they haven't realized what they could be capturing. If you continually fail to get out of bed before sunrise, fine-tune your understanding of what you're trying to accomplish. Do you want to be a famous artist? Do you want to make your first photography sale? Do you want to make so many sales that you can actually quit your day job?

MORNING = WARM COLORS, DRAMATIC SHADOWS

MIDDAY = BOLD COLORS, HARSH LIGHT, LACK OF SHADOWS

EVENING = WARM COLORS, DRAMATIC SHADOWS

Also, don't be afraid to use whatever tricks you have at your disposal—tricks that help you get going. You may discover that you need to be on a trip, traveling in an exotic location, to feel the sense of urgency to get out there creating images. Without any of the daily business to distract you, you might find it easier to dedicate a full morning to photography. When I'm traveling, I find it easier to appreciate that *today is the day*, that in the blink of an eye I will be in a totally new place. This kind of *carpe diem!* attitude has helped me time and time again.

> **TIP: SKIP A MEAL**
>
> Skip breakfast if you have to—just bring a snack instead. You can always get breakfast in the late morning, once the sunlight becomes less interesting.

One fear people have of rising early is that, after they go through all the work to get out there early, the golden sunlight will fail to appear. It's true, this can happen. Some mornings turn out to be overcast and dull. If this is the case, you have three choices:

❑ As long as the light is still bright (which is often the case even on overcast days), you can photograph things like animals or people. These subjects actually benefit from the soft, nondirectional light of an overcast sky.

❑ You can photograph in a garage or kitchen studio (whether makeshift or professional).

❑ You can go back to bed.

MIDDAY

Although the morning and evening are the best times lightwise, there are still great ways to make the most of midday light. If this is the only time you can shoot, you can:

❑ Move in closer and focus on the details.

❑ Take advantage of a passing cloud, shooting in its shadow.

❑ Work in the shade, forcing your flash to fire so that it will even out any extremes in contrast.

❑ Look for the ways that certain subjects, such as leaves in a tree, might be photographed while backlit by the bright sun.

❑ Take advantage of the light for photographing scenes in deep canyons or underwater (only if you have a waterproof camera, of course). Such environments, brightest during the midday hours, are often easier to shoot at this time.

❑ Focus on bold colors that will pop out even more when lit by bright, direct sunlight.

Keep these options in mind and the pictures you take in between 10 a.m. and 2 p.m. can still be beautiful.

LATE AFTERNOON OR EARLY EVENING

During the late afternoon and early evening, the light becomes especially warm. With the business of daytime activity subsiding, this may be an even better time to photograph people than the early morning hours. More people are bound to be out—whether they're just getting home from work, taking a walk, or mowing the lawn—and the late afternoon light casts a glow much like that of morning light.

If a sunset catches your attention, by all means, take a few pictures of it. Once you're done, though, remember to turn around and look at the things the sunset light hits; use this warm light to illuminate a composition. Photographing a person, animal, or any other scene bathed in this light will likely result in a great picture.

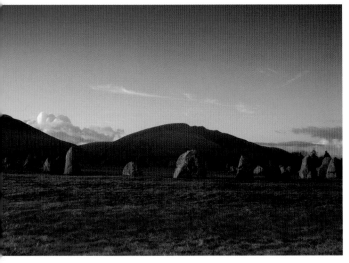

This pair of images illustrates how dramatically a scene can change when it's viewed in different light. Within a couple of hours, the scene was entirely transformed.

ABOVE: 1/45 SEC. AT f/3.5, ISO 100, 16–35MM LENS AT 16MM;
RIGHT: 1/90 SEC. AT f/16, ISO 100, 28–105MM LENS AT 28MM

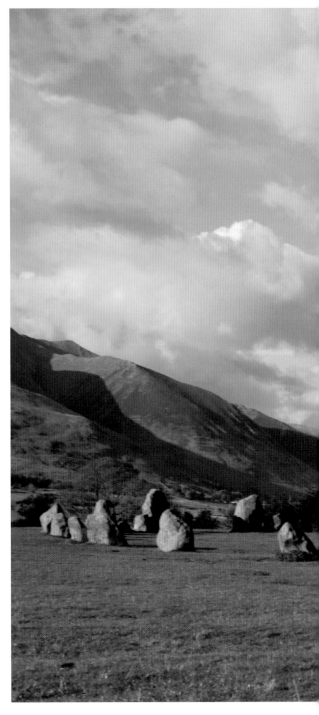

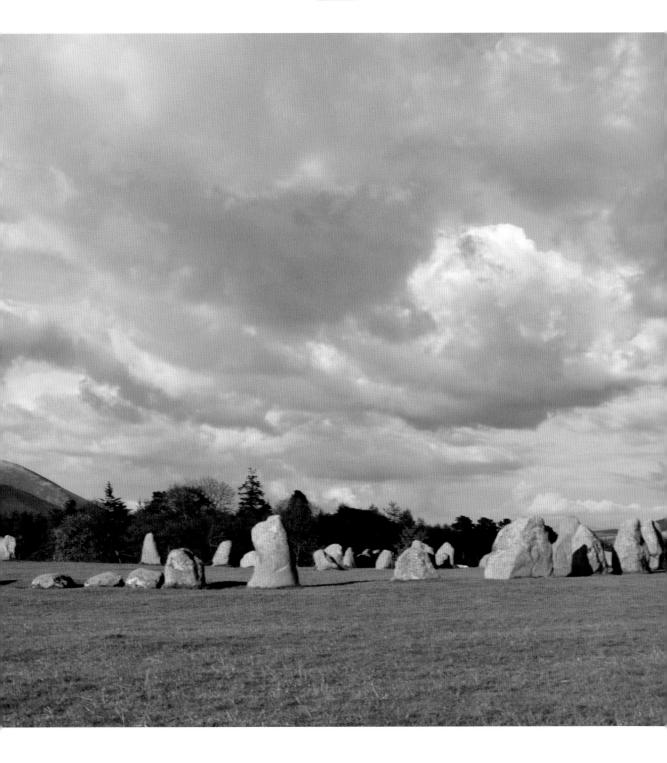

EARLY MORNING
1/90 SEC. AT f/5.6, ISO 100, 100–300MM LENS AT 300MM

LATE MORNING
1/500 SEC. AT f/8, ISO 100, 100–300MM LENS AT 270MM

I shot these six images on a recent trip to Russia. The nature of the trip caused me to be waiting in my hotel room for long periods of time. I decided to make the most of it. I shot images of the same subject, the kremlin in Kazan, at various times of the day. I found the subject fascinating but even further enjoyed comparing the quality, color, and direction of light as it changed over the course of the day.

LATE AFTERNOON
1/500 SEC. AT f/8, ISO 100, 100–300MM LENS AT 300MM

LATER AFTERNOON
1/500 SEC. AT f/8, ISO 200, 100–300MM LENS AT 290MM

EARLY EVENING
15 SECONDS AT f/38, ISO 100, 100–300MM LENS AT 300MM

NIGHT
6 SECONDS AT f/19, ISO 100, 100–300MM LENS AT 300MM

NIGHT

Probably the most overlooked, and often most rewarding, time of the day for photography is long after the sun goes down. With a tripod and a remote shutter release or self-timer (to minimize camera shake), you can get fascinating new views of normal, everyday scenes. Just be sure to use either a remote release or a self-timer. You need one of these because you need to take the picture without actually touching the camera—the slightest movement can cause the photo to come out blurry. As long as you can make a long exposure in this way, you can create beautiful photographs of night subjects, such as light reflecting on water, buildings lit in dramatic ways, and cityscapes dotted with twinkling lights.

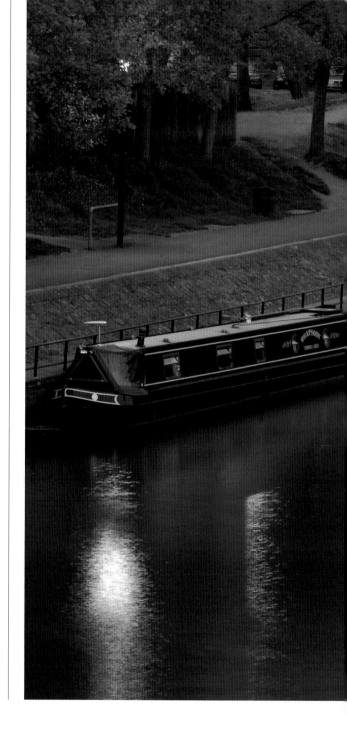

After the sun had set in Bath, England, I noticed this romantic scene and used a long 30-second exposure.
30 SECONDS AT f/19, ISO 100, 100MM MACRO LENS

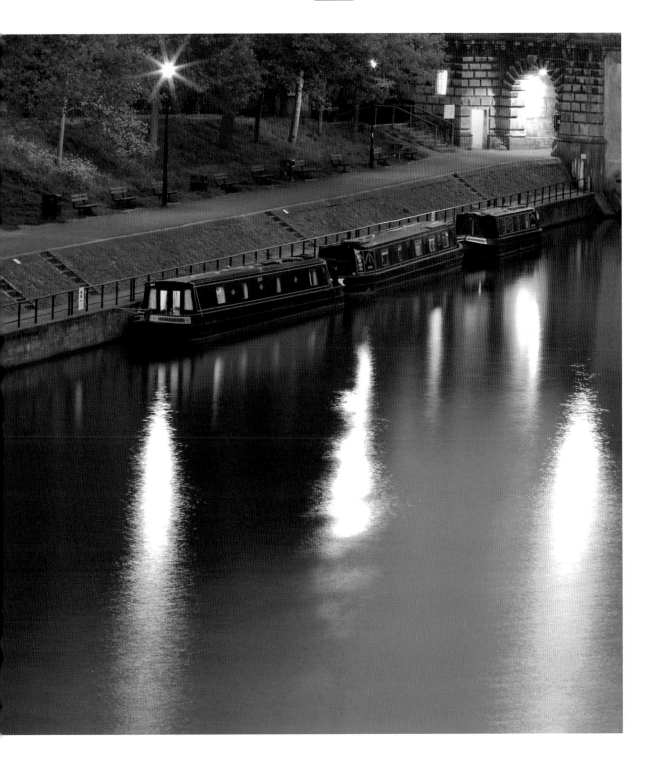

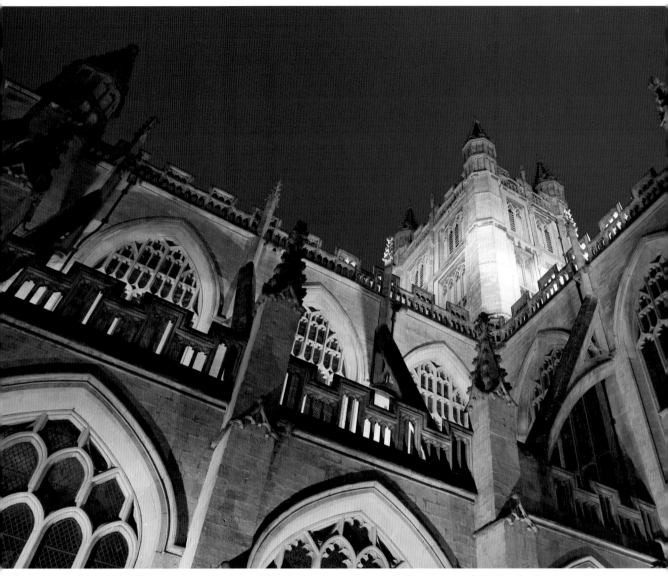

ABOVE: *Since this subject was so much more brightly illuminated than the river scene on the previous page, and since I required less depth of field, the shutter speed for this image was much faster.*
2/3 SEC. AT f/5.6, ISO 100, 16–35MM LENS AT 16MM

OPPOSITE: *On Queen Anne Hill in Seattle there's a park famous for its view of the Space Needle. Every evening, photographers gather to attempt to capture its beauty. The trick is to photograph the scene just after sunset as the city lights begin to twinkle on. For this 8-second exposure, I placed my camera securely on a tripod, attached my remote shutter release, and fired away. I used Photoshop after the fact, to pump up the purple in the sky.*
8 SECONDS AT f/4.5, ISO 100, 28–105MM LENS AT 105MM

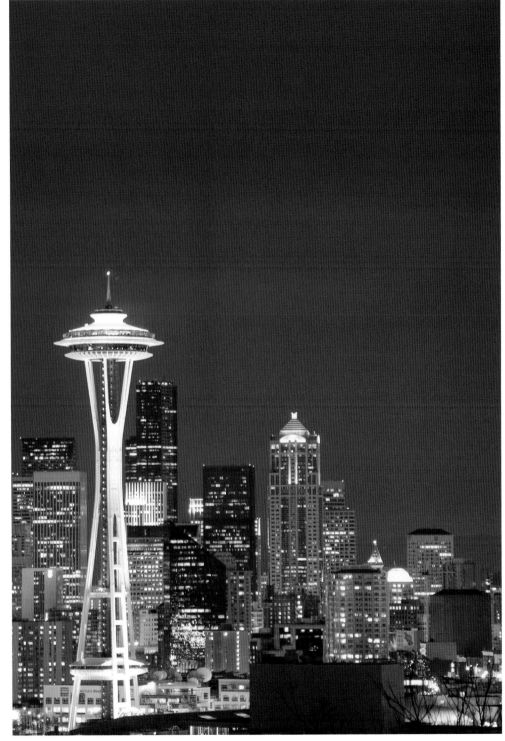

Understanding White Balance

WE LIVE IN a rainbow of colors. You may not notice this rainbow, but all the same, it's there. Every scene features objects illuminated by light that's slightly blue, green, pink, orange, yellow, or another color. Contrary to what we seem to see, light is rarely crystal clear and colorless. We only think the light is colorless because, when we view such scenes, our eyes naturally compensate for the various colors of light, without even thinking about it.

Our cameras, on the other hand, don't have it so easy. They don't necessarily know how to auto-matically compensate. When presented with an overall yellow light, for example, cameras will simply render the scene with a yellow cast. When the light is slightly blue, cameras will render the final image slightly blue—unless we set the camera to do something to change this.

The process of compensating for color tone in light is referred to as balancing the light or, simply, *white balance*. A bit of blue added to overall yellow light will balance things out; a dash of yellow added to blue light, will result in clear, balanced light. All the colors in that image will look natural and realistic. Similarly, adding red to a photo with a blue cast and red to a photo with a green cast will produce images with clear, realistic colors.

In order to balance the color of light, the camera has to first find what is called the *white point*. This is the point at which a white object within a photo would be rendered as pure white. When there's no white object, a best guesstimate has to be made. While most digital cameras will gladly try to do this guesswork for you, automatically determining white balance by scanning the image for a white point, it's not wise to rely on these automatic white balance modes all the time. Just as with exposure, there will be times when the camera's automatic functions lead you astray. At these times, you'll want to know enough about white balance to manually adjust the settings until you get natural, clean, and realistic colors.

This is especially true if you photograph scenes that are bathed in a particular color. For example, if you're photographing a mountain peak radi-ating pink in the aspen glow of a summer evening or a person's face bathed in the beautiful light of the sunrise, the automatic white balance will often defeat the purpose. Wrongly identifying these warm tones as an unwanted color cast, the white balance will likely compensate enough to cause this interesting light to disappear. The idea is that you want to *balance* the whites in your image; you

All You Really Need to Know about Color Temperature

If you find color temperature numbers confusing, just keep this in mind when learning about white balance:

Use higher color temperature numbers to warm things up (removing blue cast)
Use lower color temperature numbers to cool things down (removing reddish/yellow cast)

So, when you're presented with lighting conditions that are very blue (like open shade for example), you'd shoot with a higher color number, such as the Shade white balance setting with a color temperature of approx-imately 7000K. When presented with lighting conditions that are overly yellow light (such as household lamps), you'd match this up with a white balance setting like Tungsten (incandescent) at approximately 3200K.

Knowing this general principle will help you when you're trying to figure out if you're dealing with a warm or a cool image. This is all you really need to know about color temperatures.

want your image to be not too pink, not too blue, not too green . . . but rather "just right."

The ability to control white balance while shooting is another thing that gives digital photographers an advantage over film photographers. Like the ability to switch ISO on the fly, the ability to adjust white balance from photo to photo adds a tremendous convenience to digital photography. Additionally, if you shoot in the raw file format, you can choose white balance after the fact, when you are processing your images on the computer. This gives you even more flexibility when it comes to dealing with color casts. In fact, most photographers who shoot raw don't even think about white balance while shooting, because they know they can adjust it later.

TIP: THINK OF WHITE BALANCE AS A FILTER

If you're an ex–film photographer, you might find it easier to think of white balance in the same way you'd think of filters. When shooting an indoor scene lit by tungsten light, slide-film photographers must use special film or special corrective filters. If not, the images will come back from the photo lab with a color cast. With print-negative film, there's generally less concern about this because the lab will balance the colors for you. Most labs fix color casts when developing negative film or printing pictures. But with slide or digital photography, you need to either use a filter or set your white balance to capture the balance accurately in the first place.

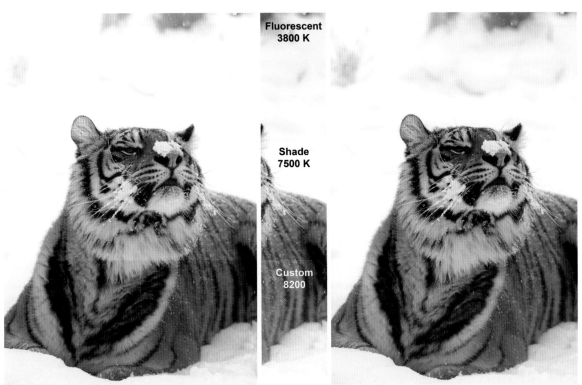

Fluorescent 3800 K

Shade 7500 K

Custom 8200

These photos illustrate the process of using white balance. The upper left corner shows an overly warm interpretation. Balancing this warm light with a cold fluorescent white balance setting results in the natural whites on the right side. Balancing the increasingly colder lights with increasingly warmer white balance filters achieves the same, balanced results.
FINAL IMAGE: 1/250 SEC. AT f/5.6, ISO 200, 100–400MM LENS AT 180MM

White Balance Choices

UNDERSTANDING the white balance options requires simplification and experimentation. First, let's look at the various white balance settings found on most digital cameras. In my experience, the most important are Daylight, Shade, and Tungsten. These three will get you by in most lighting conditions.

AUTO. This is when the camera does its best to select the correct white balance for a given exposure.

DAYLIGHT. This is the setting appropriate for most outdoor situations. It balances the colors using the temperature of sunlight as its standard.

SHADE. This setting acts much like a warming filter, adding a bit of red to a scene. As open shade is notorious for imparting a blue cast, the Shade setting will help you bring images made in shaded lighting conditions back to a more natural, daylight look.

TUNGSTEN. The Tungsten setting takes care of the overly yellow/orange casts that often occur in images made indoors without a flash. This is good when the scene is illuminated by tungsten, incandescent, or halogen lights—the kinds of bulbs found in most household lamps.

CLOUDY. The Cloudy setting adds a little bit of warmth to an image made on an overcast day. Some photographers shoot with the Cloudy setting all the time, to give every photo an extra bit of warmth. Be careful about doing this. It is much better if you actually think about it first and only use this setting when the light appears to be too cold.

FLUORESCENT. This setting may come in handy if you shoot in stores and other commercial locations where this kind of light is used. Most of the time, the indoor lighting you encounter around the home will be tungsten. But if your images look greenish, or you notice a lot of neon-type bulbs about, try the Fluorescent setting.

FLASH. This is a very nice setting for when you're forced to use flash as your light source indoors. The Flash setting warms up your subject, effectively eliminating the bluish cast that often occurs with this light source. One exception to using the Flash white balance setting with flash is when you're shooting outdoors and using fill-flash to brighten up shadows and create catchlights in your subject's eyes. In such situations, I recommend using the Daylight setting. But don't just take my word for it. Try out both the Flash and the Daylight settings. You might find that you like the extra bit of warmth offered by the Flash setting.

CUSTOM. Custom and direct color temperature controls may be useful for those doing professional product, portrait, and other studio work. When shooting a series of products or people

TIP: AN EASY WAY TO AVOID THIS WHOLE WHITE BALANCE QUESTION

If you're an ex–film photographer, there's one easy thing you can do to avoid this whole white balance mess: Simply rely on the Daylight setting. This will be just like shooting with daylight-balanced film. You can treat light as you always have, using your regular filters to control color casts. And best of all, you won't get unexpected, surprising results like you often might from the Auto white balance setting.

against a white background, it's important that they all have the same color cast. This becomes even more crucial if all the images are going into the same printed catalog or Web gallery. Custom white balance allows you to measure the white point from a white sheet of paper and then use this white as your standard, setting the camera to use this temperature for a series of images. If your camera offers this feature and you do a lot of studio photography, the Custom white balance feature can come in handy. If used properly, all subsequent images will be consistent in color.

When It's Crucial to Set White Balance in Your Camera

If you're using either the JPEG or TIFF format, setting the white balance becomes very important. Unlike photographing in the raw format, which lets you easily adjust white balance when importing the image into your software, shooting JPEGs and TIFFs requires that you set the white balance correctly at the time of shooting. White balance is much more difficult to change with JPEGs and TIFFs.

WHERE'S INCANDESCENT?

The color temperature of incandescent light is basically 3000K. This puts it so close to tungsten that the Tungsten setting works just as well. Your camera might have an Incandescent setting. If it does, you can use it for tungsten and halogen light sources, as well. So, when you're shooting indoors, odds are very good that you'll need to use this Tungsten (incandescent/halogen) setting.

Taken indoors in my kitchen, this image is nice and warm, illuminated by a mixture of incandescent light and daylight. To get this shot, I used a super-wide-angle focal length and stood on a step stool so that I could look down at my subject from a high point of view. (More on focal lengths in chapter 6.)
1/60 SEC. AT f/6.7, ISO 100, 16–35MM LENS AT 16MM

Compare these images taken with different white balance settings. Notice how the Daylight, Cloudy, and Flash settings are similar, with the Cloudy and Flash versions being a bit warmer than the Daylight version. This is because they're all using a white balance setting close to 5200K. So in this situation, either of these three settings would be fine. Whether you go with the warmer Cloudy or Flash settings vs. the cooler Daylight setting is largely a matter of personal preference.

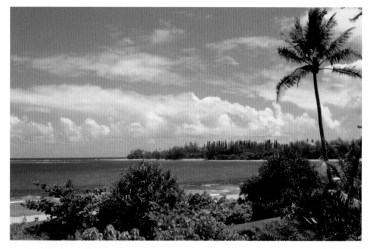

DAYLIGHT

CLOUDY

FLASH

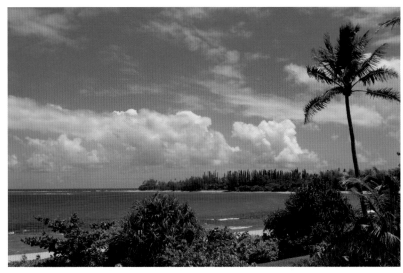

TUNGSTEN

You would certainly want to avoid the Tungsten and Fluorescent settings, unless you were purposely trying to make a creative, artistic effect. The most important point is that you want to get a knowledge of white balance so that you can keep the color shifts under your control, instead of leaving it up to the camera.

ALL PHOTOS: 1/350 SEC. AT f/9.5, ISO 100, 28–105MM LENS AT 28MM; EXCEPT OPPOSITE, TOP: 1/250 SEC. AT f/9.5, ISO 100, 28–105MM LENS AT 28MM

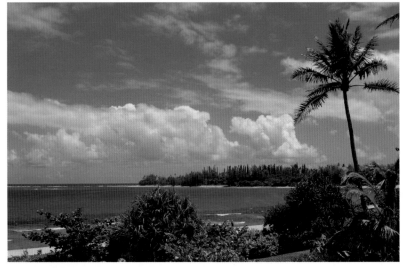

FLUORESCENT

TIP: REMEMBER TO SHOOT SOMETHING WHITE AT NIGHT

In order to see the effects of the various white balance options while you're photographing at night, be sure to select a subject that has white in it. If you only shoot a nighttime sky, for example, it will be very hard to see the different effects the various white balance options have on the scene.

Selecting an "Everyday" White Balance Setting

WHITE BALANCE can get your head spinning in circles, but it really doesn't have to be that way. My suggestion (along with shooting in raw format) is to experiment for a bit, and then select one white balance to use as your "everyday" setting—the one you'll use 99 percent of the time. This lets you keep things simple, allowing you to concentrate on the things that matter even more—i.e., moving in close, composing carefully, and metering the best exposure.

One last thing: It might help if you ask yourself if you ever shoot in a studio environment with controlled lighting. If you rarely shoot in such conditions, you'll likely be able to get by without a Ph.D. in white balance. Use the tips in this chapter to come up with a simple game-plan for handling most of your shooting. Then, when you get into studio photography, you can return to the subject to master the nuances, such as setting custom white balance settings. The bottom line is, learn just enough about white balance to keep you going strong. Don't let it keep you from shooting often and with a sense of enjoyment.

The Exception to the Daylight Rule

I've mentioned how I prefer to shoot with the Daylight white balance setting most of the time. So, it might be a good candidate to be my "everyday" white balance. But let's look at an exception—a time when I would definitely want to shift gears and use a different white balance setting.

The Daylight white balance setting doesn't work for this scene, lit as it is by tungsten lamps. In the end, the Tungsten white balance setting does the best job of balancing the light. This most closely approximates how the scene looked to the human eye. Daylight causes the subject to look too yellow.

DAYLIGHT SETTING

TUNGSTEN SETTING

Saving White Balance for When You're at Your Computer

IF YOU'VE DECIDED to shoot in the raw file format, you don't need to worry about white balance while you're shooting—you can easily adjust it when you open up the raw files on your computer. You'll still want to understand the various color temperatures, though, and how each white balance setting relates to the others.

RAW IS EASIER TO FIX LATER BUT . . .

JPEG images captured with the wrong white balance settings are fairly difficult to correct. The raw format offers much more flexibility and latitude when it comes to correcting white balance in a software program. While many corrective measures can be taken at the postprocessing stage with Photoshop, or equivalent software, setting things up for correct white balance will save you time in the long run, even in the raw format—and especially if you shoot in the JPEG file format.

Inaccurate white balance can make postshooting Photoshop work difficult. When dealing with major color casts or trying to correct tricky things like skin tones, you'll find it much more time efficient if you shoot in the right setting first, rather than correct the colors later. So, the two best options are to either shoot in raw or do your best to capture accurate white balance at the time of shooting.

> **TIP: TAKE NOTES**
>
> If you look for the EXIF data in the File Browser of the most recent version of Photoshop, you may not see which white balance settings you selected. Sometimes this data is not displayed. This is a good reason, when you are still learning about white balance, to write down what you do when shooting; your notes will allow you to easily sort it out later, when you're sitting at your computer.
>
> Another option is to download EXIF-reading software that provides information relating to the white balance settings. (A good option for this is listed on page 220.)

ASSIGNMENT **Shoot the Same Scene throughout the Day**

As I did with my six Kazan kremlin photos, shoot the same scene at various times of day. Get up early, shoot a few images, and then shoot again and again throughout the day. Keep your camera set on a tripod in the same place, and return to it whenever you get a chance. Photograph the same subject at least three times—morning, midday, and evening. If you can, also photograph it at other times of day. The more sessions you do, the more images you'll have to compare.

For this assignment, keep the white balance setting fixed to Daylight. This will prevent the white balance setting from influencing your results. If you shoot in camera raw, you can change this white balance setting later; all the same, it will help if you keep your white balance at a constant of Daylight while shooting. Then, have fun shooting and learning to appreciate the light.

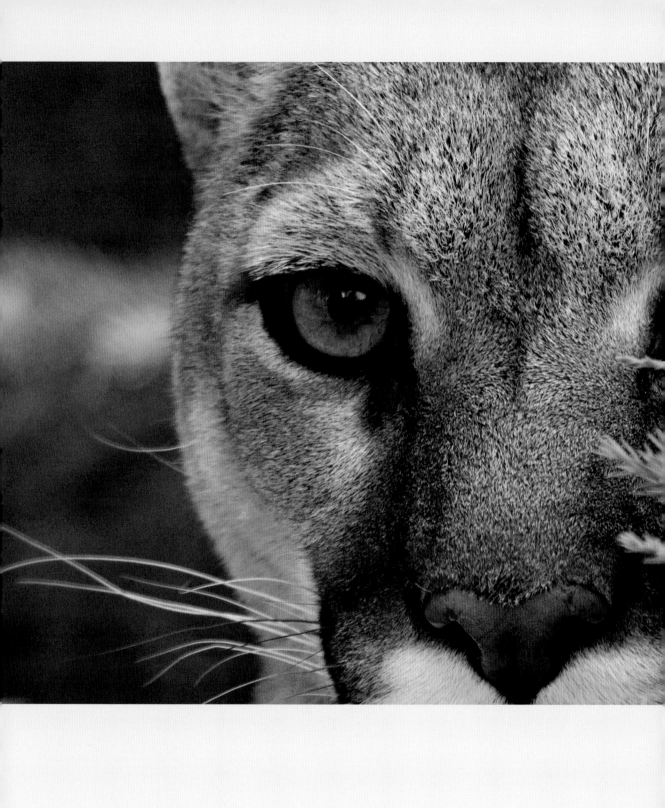

Composition, or What Goes Where

UNDERSTANDING COMPOSITION—the conscious placement of elements in a picture—will help you get better photographs. The principles of composition—especially getting closer to your subject, the Rule of Thirds, and orientation—give any photographer an express route to picture-taking success. The beautiful thing about these principles is that you can make use of them with any digital camera, whether a sophisticated SLR or a fits-in-your-shirt-pocket point-and-shoot. Best of all, practicing good composition is just plain fun.

Working with a 2x teleconverter disables the autofocus and increases the challenge of getting a tack-sharp photo. I had my lens mounted securely on my tripod and made seven exposures to get this one keeper. The key to its success is its up-close-and-personal composition.

1/180 SEC. AT f/11, ISO 800, 100–400MM LENS WITH 2X TELECONVERTER AT 800MM (THE 35MM EQUIVALENT OF A 1280MM LENS)

Will the Real Subject Please Stand Up?

THE LIBERATING THING about understanding composition is that *you* decide what to include in the photo, where to place it, and how much of the picture the subject occupies. Just as important, you decide what to *exclude* from the photo. You dictate how your subject relates to the foreground (whatever is in front of the subject) and the background (whatever is behind it).

By simply changing your point of view or position, you can capture a completely different image.

By moving a little to the left or right, a little up or down, you can cause the various elements in the scene to work with (or against) one another in unique and sometimes surprising ways. The choice is up to you: You can accept the world as it is presented to you, or you can move around and experiment with various views, exploring how each change can dramatically alter your photo.

Before you begin to arrange the various elements in your photo, however, you need to determine what

These three examples illustrate a situation in which you can rearrange your subject (as opposed to repositioning yourself) to get the composition you want. The top left photo is displeasing because it has no order. However, the bottom left photo is too orderly, too "staged." The right-hand photo is also staged, but because the composition is simple, it is much more pleasing to the eye.
ALL PHOTOS: 1/125 SEC. AT f/11, ISO 100, 100MM MACRO LENS

you're trying to shoot. This is often more difficult than it sounds. It may be easy when you're making a portrait of your family or your cat, but it can be extremely challenging when shooting other subjects. For example, when photographing a landscape or travel destination, you need to consciously ask yourself, What *exactly* is attracting my attention in this particular scene?

This thought process is challenging because the decision involves making sacrifices. As much as you might wish to include everything in the picture, selecting one main subject and letting go of the other elements in the scene will help you make a better composition. Most photographers avoid making this decision and just hope the

picture will turn out; they step back, take a photo of the entire scene before them, and later wonder why their pictures are so boring.

After deciding on your subject, dig even deeper, asking yourself questions like, What would I like to *do* with my subject? and, What effect would I like to have on my viewer? This is where the real art of photography comes in. Once you've chiseled out your vision, you can then use the principles of composition, as well as other guidelines presented in this book, to create the effect that you're after. Making this kind of conscious expression may sound challenging, but believe me, with a little help and a little reliance on the guidelines, you can do it!

When photographing this subject, I sensed that I wasn't successfully capturing the image I had in mind. At first, I couldn't determine what exactly the problem was. So, I did what I often do when faced with such difficulty—I exchanged the normal zoom lens on my digital SLR camera for a 100mm macro lens and moved in superclose. Honing in on this one detail of the horse and saddle brought me much more satisfaction than trying to capture the entire subject.

ABOVE: 1/350 SEC. AT f/6.7, ISO 100, 100–400MM LENS AT 160MM;
RIGHT: 1/250 SEC. AT f/4.5, ISO 200, 100MM MACRO LENS

Move Closer

COMPOSITION is all about organization and simplification. Every element in your photo has a place. If it doesn't have a place, it needs to be eliminated. The easiest way to eliminate extraneous elements is to move in closer toward your subject. In fact, nine times out of ten, once you know what your subject is, all you need to do is simply move in closer to it. If your subject doesn't completely fill the frame in your viewfinder, the picture will likely include details that can distract the viewer's attention.

Twigs, telephone wires, pieces of trash, camera straps, you name it . . . anything competing with your subject for attention should be eliminated. Filling the frame with your subject is a surefire way to get rid of this visual competition.

SMALL SUBJECT? BIG PROBLEM!

Even if there are no distracting things along the edges of your composition, the blank space around your subject can pose a similar problem. Too much negative space around your subject tends to lessen the picture's impact. You want your subject to be right in your face, up close and personal, so it can't possibly be missed.

This isn't to say that you can never again use the wide-angle option on your lens. Just make sure that when you do shoot wide-angle, the entire scene plays an active role in your image. Every element in the composition, whether it plays the "starring role" or helps out as "best supporting" element, needs to be absolutely necessary and required. If it isn't, cut it out.

> **TIP:** ADD AN ELEMENT OF INTEREST TO LANDSCAPES
>
> When you want to capture a large expanse of a beautiful landscape, it often helps to have a good point of interest. A foreground rock, bed of wildflowers, old rusty piece of farm equipment, or a little red car can give the eye something to focus on and add a sense of depth and scale.

For the initial wide-angle image, I wanted to show the coyote in its environment. My subject was the relationship between coyote, land, and sky. The photo works, but it would be more engaging if the coyote were looking to the left, back into the scene. A few minutes later, the coyote moved extremely close to me. Fortunately, I still had my 16–35mm lens on the camera and was able to get the close-up wide-angle image opposite. While both photos are good, the second one does a better job of capturing the character of the coyote.

RIGHT: 1/350 SEC. AT f/10, ISO 400, 16–35MM LENS AT 16MM; OPPOSITE: 1/500 SEC. AT f/11, ISO 400, 16–35MM LENS AT 34MM

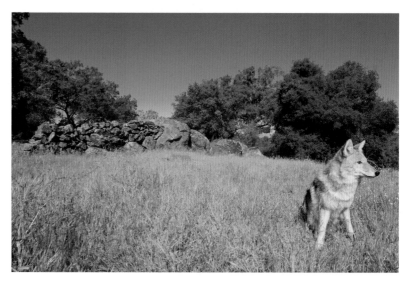

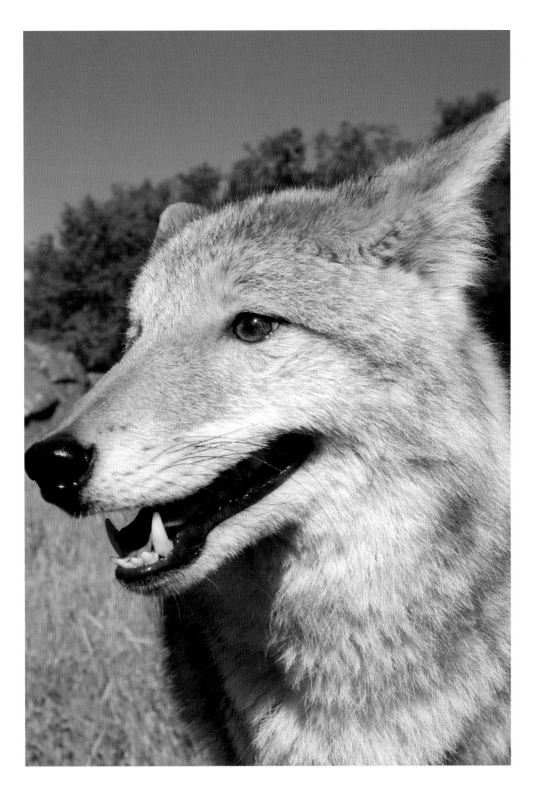

HOW TO GET CLOSER: WALK, ZOOM, OR RUN

Anyone using a camera with a zoom lens—whether it's a digital SLR or a compact digicam—can quickly change composition by simply zooming in or zooming out. Zoom in for a tighter composition and zoom out for a more expansive, wide-angle view. A focal length of 16mm to 35mm is considered wide, and a focal length of 110mm to 300mm or more is considered telephoto.

Telephoto and Wide-Angle Lens Attachments

As soon as photographers with compact, fixed-lens digital cameras experience the limitations of their zoom lens, they want a way to either get closer to their subject or create a wide-angle image. Some manufacturers have responded to this by offering lens accessories, such as screw-on or clip-on lenses to change focal length. In my experience, these lenses often result in a noticeable reduction of clarity, accuracy, and quality. If you're considering purchasing these add-on attachments, you might want to consider saving up for a digital SLR camera instead. Actually, the cost of a compact digicam with an add-on lens attachment could easily exceed the cost of a digital SLR. You might actually *save* money going with a digital SLR! (See the Digital Camera Buyer's Guide on page 206 for more.)

While photographing landscapes one day, I learned of a nearby falconry. My schedule didn't allow me to stay for a falconry demonstration, but I was still able to spend some time getting very close to a variety of birds. This tight head-shot of a Bateleur eagle successfully conveys the intensity of the subject and also utilizes the Rule of Thirds (see page 156 for more on the Rule of Thirds).

1/180 SEC. AT f/11, ISO 200, 2X TELECONVERTER AND 100–400MM LENS AT 400MM (THE EQUIVALENT OF A 1280MM LENS ON A 35MM CAMERA)

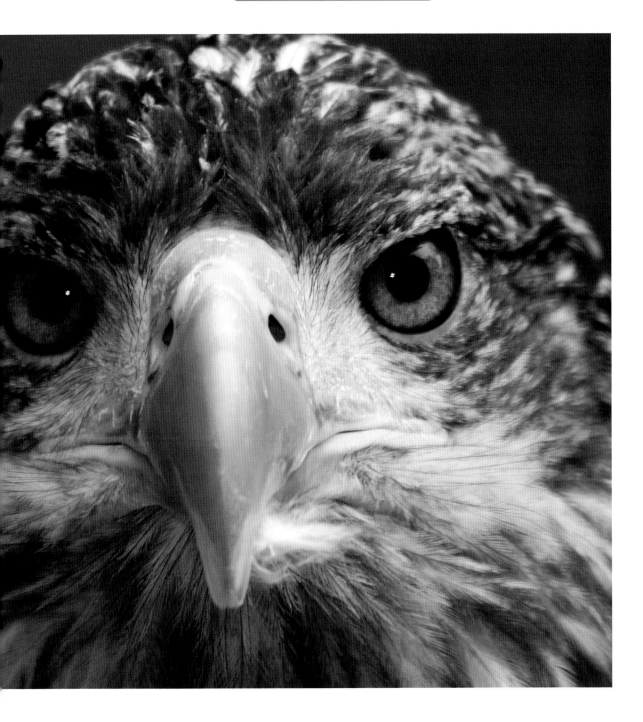

Here's another example of how working your subject—shooting in a variety of ways—can pay off. For the initial photo above, I placed the petal on a light box and composed in a way that included the petal's reflection. Then, I gradually moved in closer, making a variety of exposures in the process. By the time I made the final image at right, I was quite close to the petal. I positioned the camera so that the focal plane was parallel to the petal. I did this to get as much in focus as possible, considering the narrow depth of field inherit in macro photography. Additionally, I wanted the one strong red line to travel diagonally through the frame, adding a sense of vitality to the abstract composition.

ABOVE: 1/2 SEC. AT f/32, ISO 100, 100MM MACRO LENS; RIGHT: 1/3 SEC. AT f/11, ISO 100, 100MM MACRO LENS

Keep It Simple

Regardless of subject size, however, the idea here is that you want your composition to be clear, simple, and easy for the eye to understand. Simplicity is one of the most powerful things to keep in mind when composing your photographs. Be brutal! Like the Terminator, you want to scan your scene—looking for any distraction—before pressing down the shutter button. Then, you want to take steps to annihilate anything that doesn't belong in the picture.

The Truth about Digital Zooms

YOU MAY HAVE HEARD Robert Capa's famous quote "If your pictures aren't good enough, you're not close enough." What most people don't know is that just after uttering these immortal words, Bob's eyes glazed over and he prophetically added, "But, whatever you do, don't use your digital zoom." (That's a joke, of course. Robert Capa died long before digital cameras became popular.)

Like countless photography instructors, I used to think that the digital zoom always resulted in low-quality images. I would tell students, Whatever you do, don't use the digital zoom feature of your camera. I advised them to rely on the optical zoom, as this produced images with higher resolution and quality. Getting myself all worked up, I would call the digital zoom a marketing gimmick, whose sole purpose was to trick novice photographers into forking over their hard-earned dollars on a new digital camera.

But then I tried it out for myself, comparing digitally zoomed images with those enlarged in Photoshop. I humbly admit that I found the digitally zoomed versions better looking than those enlarged in Photoshop.

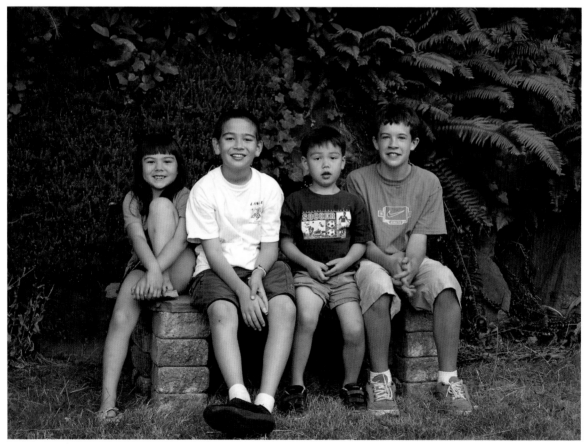

OPTICAL ZOOM

DIGITAL ZOOM

The image on the opposite page was shot at the maximum optical zoom setting. The close-up to the left is at the maximum digital zoom. Although it is a bit pixellated (meaning you can see the individual pixels, or bits of information that make up the image), this digital zoom example is not as bad as I would have expected. I actually find it more pleasing than the version beneath it that I enlarged in Photoshop. The lower quality of that image is most likely due to the fact that I photographed the optically zoomed original as a JPEG. When enlarged, the artifacts from JPEGs become more visible. If you shoot in TIFF or raw format and don't mind cropping images in a software program, you might be happiest sticking with the optical zoom. In any other case, don't refrain from using the digital zoom. Just be sure to (a) use your tripod and (b) closely examine your first results to see if they are of an acceptable quality to you.

OPTICAL ZOOM ENLARGED IN PHOTOSHOP

Digital SLR Cameras with Interchangeable Lenses

If you shoot with a digital SLR that features interchangeable lenses, you have additional options for further manipulating your composition. As long as your pocketbook can bear it, you can buy and use a wide variety of zoom or fixed lenses—everything from super-telephoto lenses to special macro lenses. Each lens costs a fair amount of money, though. Before you take the plunge into the wonderful world of digital SLR photography, understand that lenses can cost more than the price of the camera body, and digital SLR photography will likely lead to a substantial investment in the future. I still recommend it; just prepare yourself for the potential costs.

There still are a few things to keep in mind when using the digital zoom feature. First, placing your camera securely on a tripod will greatly improve your ability to capture satisfying images. If you don't, your camera will jiggle as you take the picture, and this movement (camera shake) will result in blurry pictures. Second, cameras with lower pixel resolutions will likely perform poorly in the digital zoom department. These digital cameras have been known to behave in one of two ways and both ways have disadvantages: If the camera is designed to crop in and reduce the resolution of your image, you'll find that the zoomed image doesn't print as big as optically zoomed images; or, if the camera tries to fit the smaller, zoomed-in view to its original pixel resolution (without cropping and reducing resolution), you'll find that the artificially enlarged image doesn't produce high-quality prints.

Having said all this, there is a useful purpose for the digital zoom feature. It can be helpful if you don't feel comfortable cropping pictures in computer software. Photographers who take their memory cards to a photo lab to have their images printed directly on a kiosk printer will appreciate that the images they have digitally zoomed in camera are ready to go. Although you can crop an image before printing on a kiosk, many will still find the digital zoom method easier than cropping on a kiosk or computer.

While you're still learning, the best practice is to take one of each—one photo with the optical zoom and one with the digital zoom. Although digital zooming technology has progressed significantly, many may still find that they prefer the quality of an optical zoom. My advice is to try out the digital zoom and, if you like it, use it with a tripod, taking backup optically zoomed photos whenever possible.

If you can't optically zoom in closer, first try moving closer to your subject. If your subject is an animal, it may bolt (or attack—so be careful) if you get within its flight range. If this or any other considerations keep you from getting physically closer, place your camera on a tripod and use the digital zoom. Shoot both optical- and digital-zoom versions. This way, again, you'll have a

Cropping in Camera or on the Computer

You have three choices when it comes to removing extraneous details surrounding your subject:

1 You can physically move in closer at the time of shooting.

2 You can use the optical or digital zooming features of your lens. These first two options are called *cropping in camera*. (See page 166 for more.)

3 You can crop after the fact, using software, but this takes time and a certain willingness to learn these software techniques. More importantly, it reduces the file size of your image. Unless you're only e-mailing or displaying your photo on the Web, your photos may suffer; i.e., you won't be able to print them as big without seeing a noticeable reduction in quality.

backup that you can crop in the computer if the digitally zoomed version is unacceptable. Give yourself more choices rather than less. If you shoot the entire scene first, you'll have the option of cropping the photo in a slightly different way in your software at a later time.

Even Bigger Birds and Bees: SLR Magnification Factor

When teaching 35mm film photography, I used to tell photographers interested in making images of birds that a 300mm telephoto lens just wouldn't cut the mustard. Those photographers just could not get close enough to such small subjects with that lens. If you use a digital SLR, this may no longer need to be the case. Standard 35mm lenses, when used on most digital SLR cameras, are magnified by a factor of 1.3 to 1.6. What would be a 300mm lens on a film camera instantly becomes a super-telephoto, with over 500mm of magnifying power, when placed on most digital SLRs.

For those interested in moving close to distant subjects, this kind of lens power can come in very handy. It's a great feature for those who like to photograph wildlife and other subjects that generally don't like it when you get too close. This can also help out a lot when shooting shy subjects, such as when you're trying to capture candid photos of your children, spouse, or friends.

When photographing this golden eagle, I set my 100–400mm lens to its maximum focal length (400mm). I then doubled this length with the addition of a 2x teleconverter. What's more, because I was using a digital SLR camera with a 1.6 magnification factor, this 800mm focal length would be more comparable to a 1280mm lens on a standard 35mm film camera. Talk about getting close to your subject! I love this advantage of shooting with a digital SLR.

1/180 SEC. AT f/11, ISO 100, 2X TELECONVERTER AND 100–400MM LENS AT 400MM (FOR A FOCAL LENGTH OF 800MM TOTAL)

ASSIGNMENT Move in Closer

Use your telephoto lens (whether it's an optical or a digital zoom), and move in as close as you can to a subject that pleases you. Get to the point where you think the subject is looming huge in the viewfinder. Then take two steps closer, and make the picture. Upload your favorite resulting image to the BetterPhoto.com contest.

Getting Superclose:
Macro Modes and Lenses

EACH LENS has a limit as to how close it will enable you to get to your subject. This is called the *close-focusing distance*. Move in closer than this distance, and the lens will refuse to focus. So, what do you do if you want to take a picture of a tiny subject, such as a ladybug or the world inside a tulip, and the lens will not focus when you fill the frame with your subject? This is where specialized macro (close-up) modes and lenses come in. By turning on the macro mode (or using a macro lens), you enable the camera to photo-graph things in very close proximity.

Macro photography is exhilarating! You often see an entire universe open up right before your eyes. Small subjects—such as flowers, stamps, coins, jewelry, and insects—suddenly become large and beautiful.

Now that I don't shoot slide film anymore, what do I do with my light box? I use it as a prop. For this image, I cut a kiwi into thin slices and placed them on my light box. I hand-held my camera so that I was able to move it around until I found a composition that intrigued me, and once I did, I secured the camera to my tripod. The kiwi, when composed in this way, reminded me of a glorious sunrise.
2/3 SEC. AT f/16, ISO 100, 100MM MACRO LENS

ABOVE: *On a day trip to a local island community, I noticed a wall constructed of backlit blue glass blocks. I wanted to capture the beautiful quality of light as it filtered through the glass but knew that if I shot from a distance, the composition would include too many distractions. So, I placed my macro lens on my camera and moved in extremely close to one of the blocks.*
1/350 SEC. AT f/5.6, ISO 100, 100MM MACRO LENS

LEFT: *For this image, I placed my camera securely on my tripod and attached a 100mm macro lens. I then placed two gummy fish candies on my light box. In one hand, I held my remote shutter release (to ensure that I did not move the camera at all when releasing the shutter), and in the other hand, I held a flashlight to add a bit of sidelighting that would bring out the texture of the colorful candy (which also made a delicious treat once I was finished with the shoot).*
1/8 SEC. AT f/11, ISO 100, 100MM MACRO LENS

MAKE SURE WHAT YOU SEE IS WHAT YOU GET

When doing macro photography, make sure what you see in the camera's "eye" is what you get in your final image. With an SLR camera, this is never a problem. You always view the scene through the same lens that your CCD uses. Therefore, what you see is what you get. In fact, this is one of the great advantages to using a digital SLR over a point-and-shoot digital camera.

With compact non-SLR digital cameras, what you see is *not* necessarily what you will end up with in the final image. Especially when you get superclose to your subject, the viewfinder—because it's located at a slightly different spot on the camera and doesn't look through the same lens—shows you a slightly different view.

To resolve this inconsistency in macro photography with a compact digicam, use the LCD screen as your viewfinder. With many digicams, this is the only option. The LCD monitor is forced to display continually when you turn the camera to the macro mode.

At all other times, I recommend that you *do not* use the LCD monitor as your viewfinder. Unless you're doing macro photography, or shooting in unusual conditions that require the use of the LCD screen, look through the optical viewfinder instead. Among other things, this is a financial consideration: You'll get a lot more mileage out of your batteries if you use the optical viewfinder to compose your nonmacro images. More importantly, it will help you create consistently sharp images by helping you hold the camera still.

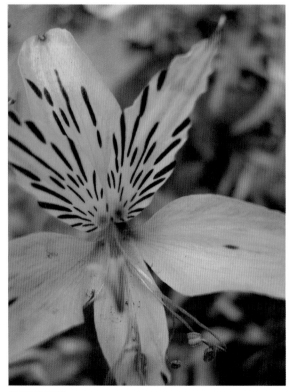

WHAT I SAW

WHAT THE LENS SAW

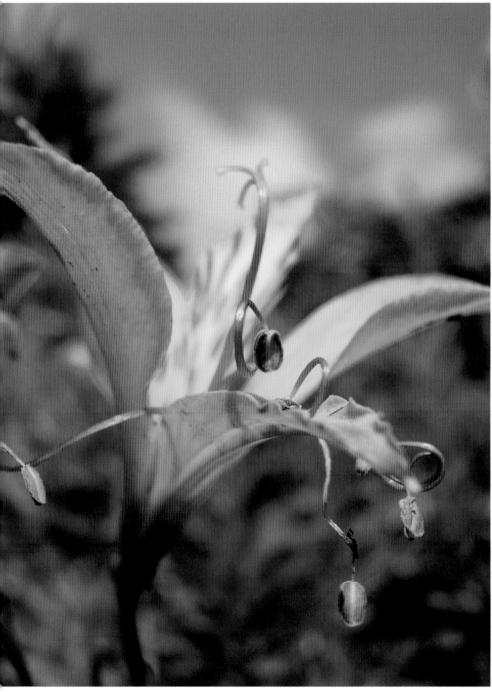

RECOMPOSED VERSION

The left-hand photo on the opposite page represents what I saw through the optical viewfinder when shooting with a compact, non-SLR Nikon Coolpix camera. The photo next to it shows what the CCD would have captured—I would have totally missed my subject! Noticing this discrepancy, I recomposed, shifting the camera to the left. I then used the LCD screen to compose in order to ensure that I got the image I was after. While I was at it, I decided to alter my point of view, getting down much lower than the flower. Looking up at it allowed me to get a pleasing color combination with the orange flower against the blue sky and green foliage. (For more on point of view, see pages 174–181.)

TIP: USE A TRIPOD FOR MACRO PHOTOGRAPHY

When doing macro photography, I highly recommend using a tripod. After discarding far too many "almost" photos, I can honestly tell you it's worth the cost and inconvenience. It may be difficult to position the camera on your tripod. You may need to purchase a special attachment or invert the tripod's center column in order to get close enough to your subject. But when shooting macro, depth of field is so shallow that the slightest movement can cause the wrong part of your subject to be in focus, and a tripod will really help keep things steady.

For this image, I sliced up a red onion into pieces of varying thickness and placed them on a light box in my garage studio. Before attaching my camera to my tripod, I looked through the optical viewfinder at each slice to determine which one looked best. During this process, I noticed this composition, which featured an off-center subject and made good use of the graphic pattern inherent in the onion slice. I then placed my camera securely on my tripod and made a variety of slightly different images. After each shot, I reviewed the image in the LCD screen to determine if I had captured the exact composition that I wanted. In this manner, I was able to reposition the subject and myself until I created the image I had in mind.

2/3 SEC. AT f/19, ISO 100, 100MM MACRO LENS

When examining this beautiful rose, I noticed an interesting graphic pattern in the petals that reminded me of a nautilus shell. I mounted my camera on a tripod and selected a macro lens, positioning the camera fairly close to the rose. During a long twenty-second exposure, I placed a handheld flashlight behind the rose, positioning it to give the rose a soft, unique glow. The LCD screen came in handy as my first few attempts suffered from a bit of strange flare (light bouncing back into the lens and causing distracting spots to appear in the image). Seeing this flare, I was able to reposition the flashlight to get cleaner, more pristine results.
20 SECONDS AT f/32, ISO 100, 100MM MACRO LENS

ASSIGNMENT Go Macro

If your camera features a macro mode or if you own a digital SLR and macro gear, go out photographing macro subjects. First scout out the environment, searching for subjects to which you would like to get especially close. Anything small with detail generally works well. I like to look for interesting flowers, bugs, candies, sliced fruit, and the like. Usually, calm days are best for outdoor macro photography; if it's windy, move indoors or to a sheltered location so that your subject doesn't blur in the breeze. When you find a suitable subject, put your camera in the macro mode (or use a macro lens or extension tubes if you use a digital SLR) and place your camera on a tripod. Move in as close as you possibly can, and watch your tiny subject become huge and impressive.

The Rule of Thirds

PHOTOGRAPHERS ARE often disappointed with their images, saying that the scene was wonderful but the photos feel static and boring. This can frequently be fixed with another powerful compositional guideline: the Rule of Thirds.

You've probably noticed that placing your subject a bit off-center can actually be a good thing, adding an amazing degree of visual interest. In fact, placing your subject in the exact center of the composition more often than not detracts from the effectiveness of the photo.

The use of the Rule of Thirds goes all the way back to ancient Greece, and it works. It's so effective that through the centuries, it has been passed down from artist to artist as an easy way to add vitality to your pictures. It works in photographs in the same way it has worked in paintings.

The general principle behind the Rule of Thirds is actually quite simple: Place your subject a little off to the side.

Not haphazardly, mind you. According to the Rule of Thirds, there are specific *sweet spots* for your subject. To find these sweet spots, imagine drawing four lines across your photo: Draw two evenly spaced horizontal lines and two evenly spaced vertical lines, like a tic-tac-toe game. The points at which the lines intersect are the sweet spots.

When composing any scene, you can position your subject at one of these four places (where these lines intersect). This allows the eye to pleasantly travel around the photo before coming to a satisfying rest on your subject. Even though this all happens for the viewer within a split second, this tour around the photo is likely to be enjoyable and satisfying. Furthermore, this careful placement helps the eye quickly determine what the subject is and what part of the photo deserves the most attention.

To determine which of the four points of intersection to use, you need to think about two things:

1 Is your audience in the Eastern Hemisphere or the Western Hemisphere?

2 What's going on in the rest of the composition?

The first consideration has to do with how we're trained to read and write. If you're a Westerner like me and read from left to right, you may prefer off-center subjects that are positioned on the right rather than the left. This placement encourages the eye to scan across the scene in an uninterrupted way from left to right until it reaches your subject.

The second consideration has to do with the environment surrounding your subject. If you notice distracting elements above your subject, you might want to place the subject on one of the two upper horizontal lines, thereby eliminating the distractions. If you notice an object that could play a nice supporting role above and to the right of your subject, you might place your subject in the lower left position. This will cause the two to play off of each other and is often an excellent way to balance out your subject or give it additional environmental meaning.

You may find it difficult to decide which intersection point to use. The differences between each composition can be subtle and hard to see. Try taking a couple of pictures to find out. Place the subject on the upper right Rule of Thirds intersection point. Then shoot a second time, with the subject on the upper left, and compare the two photos. You may feel that both ways work equally well. Often, the most important thing is just placing your subject on *one* of the Rule of Third sweet spots (rather than agonizing over which spot to use). The most important point is just using the Rule of Thirds in the first place.

Dividing your image into nine parts—by visualizing two lines cutting the composition into equal thirds on both the vertical axis and horizontal axis—sets you up to use the Rule of Thirds. Then, all you do is place your subject on one of the places where the lines intersect. This is a simple and effective guideline for producing interesting, balanced compositions.
1/350 SEC. AT f/10, ISO 100, 16–35MM LENS AT 35MM

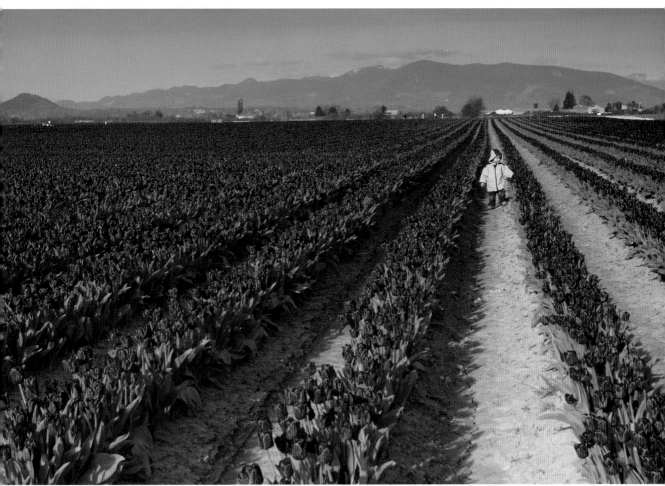

There are two principle times you can apply the Rule of Thirds. We've just covered the first—placing the subject on one of the four sweet spots. The other is when you're shooting a landscape and the composition includes the horizon. In my online photography courses, I often see students placing the horizon line in the middle of the photo. When the horizon falls in the middle, it effectively divides the image into two halves, and the viewer is left to decide which half is most important.

Before you press down that shutter button, decide which half of the photo, either the earth or the sky, comprises the main subject of the photo. Then, instead of cutting the composition in half, move the camera to reposition the horizon up or down within the frame to feature more of your main subject. If the sky is spectacular, move the horizon down to the lower third of the image to help the eye appreciate that amazing sky. When using the Rule of Thirds for scenes that include the horizon, you may not need to place the subject on a point of intersection; simply align the horizon with either the upper or lower horizontal line.

TIP: LOCK FOCUS

The key to getting sharp off-center compositions is to understand how the *focus lock* feature on your camera works. Generally, the idea is to first center your subject, press the shutter button down halfway, and then recompose, placing your subject on one of the Rule of Third sweet spots while still holding the shutter button halfway down. Once you position the subject exactly where you want it, press the shutter button down fully to take the picture.

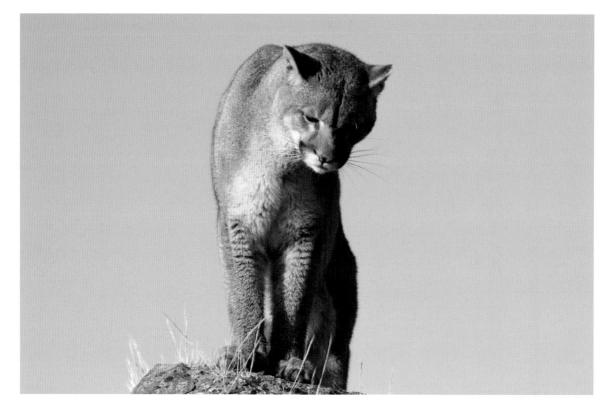

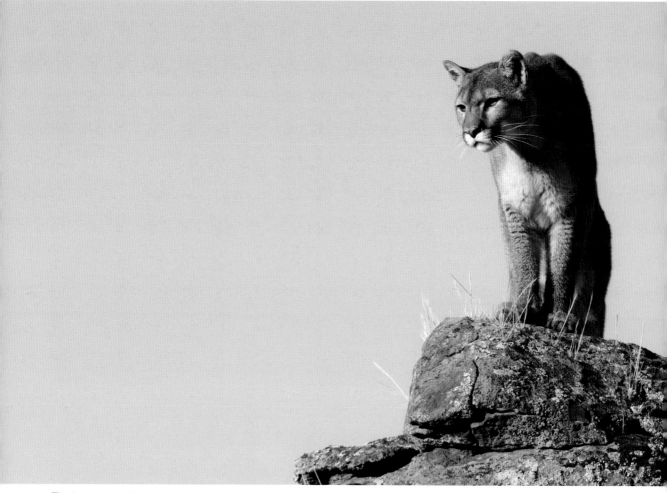

The image opposite is an ineffective composition. Placing the subject in the exact center of the photo splits the image into two equal parts. The eye doesn't know what to do except look briefly at the central figure and move on.

The image above, on the other hand, is much more successful, with the most visually interesting element—the mountain lion's face—in the upper right area of the frame. To do this, I first locked my focus on the lion's face and then recomposed. I waited for the lion to look up before pressing the shutter, because my goal was to capture the exact moment when the lion either made eye contact with me or looked into the left side (my left) of the scene. Having the lion's eyes in the upper right guides the viewer's eye through the composition: scanning from left to right, then up the body to the payoff of the animal's face, and finally back to the left where the lion is looking. This visual cycle produces a pleasant, satisfying experience for the viewer.

OPPOSITE: 1/250 SEC. AT f/4.5, ISO 400, 100–400MM LENS AT 250MM; ABOVE: 1/250 SEC. AT f/5.6, ISO 400, 100–400MM LENS AT 260MM

THE EXCEPTION TO THE RULE

The only time I don't use the Rule of Thirds is when I'm aiming for an intentionally symmetrical look. At such times, I strive to have everything perfectly symmetrical, either from left to right, from top to bottom, or both. For example, a photo of a mountain lake with the trees reflecting in the water is a good candidate for horizontally centering the horizon line instead of placing it at the top or bottom third of the composition. Likewise, humorous photos often seem even funnier when the subject is perfectly centered and/or the composition is symmetrical.

When making portraits, treat the Rule of Thirds as you do when photographing landscapes with horizons. Portraits of people, pets, and wildlife often work best when the subject is horizontally centered, with the eyes on the upper horizontal line.

RIGHT: *Here's an exception to the Rule of Thirds. Since this was a portrait, I was inclined to center the subject on the horizontal axis. However, I also centered the main focal interest (his eyes) on the vertical axis. This doesn't technically obey the Rule of Thirds, but it still works very effectively. Perhaps the viewer responds positively to the centered placement because it adds to the feeling of almost comical cuteness. Whether that's the case or not, the point is that sometimes the "rules" are meant to be broken. As long as you're aware of the rules, taking them into consideration when you compose your photo, don't hesitate to experiment with bending them to fit the particular needs of the situation.*
1/350 SEC. AT f/5.6, ISO 100, 100MM MACRO LENS

OPPOSITE: *Portrait compositions can be made to obey the Rule of Thirds in a slightly different way: Instead of placing your portrait subjects off to the right or the left, you can center them vertically within the image but place the eyes along the upper horizontal Rule of Thirds line.*
1/125 SEC. AT f/5.6, ISO 400, 100–300MM LENS AT 300MM

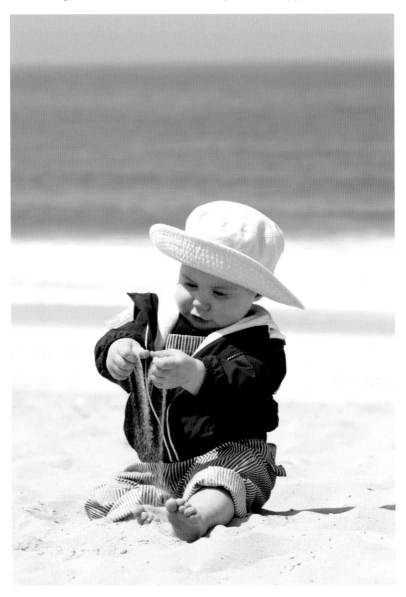

Vertical vs. Horizontal

REMEMBER TO TURN your camera on end and shoot vertical pictures from time to time. Occasionally turning the camera and shooting in the vertical orientation is not just great for portraits; it's also an excellent way to eliminate unnecessary clutter in all kinds of photos.

Each potential photograph tests you to frame the subject most fittingly. If turning the camera on end and shooting the subject in a vertical orientation eliminates attention-grabbing clutter or unnecessary negative space in the background, be sure to shoot at least one image in the vertical orientation. Without such distractions, the eye will find it easier to focus on the subject and your photo will be all that much more effective and powerful.

By habit, I shoot verticals almost all the time. After capturing a horizontal image of a scene I find particularly appealing, I turn the camera on end to capture a vertical version. Additionally, if a subject or scene is particularly challenging—it's not working no matter what I try—I turn to the vertical orientation to see if it offers a more satisfying composition.

There's also a psychological effect to take into consideration when deciding between a horizontal or vertical composition. Horizontal photographs tend to connote serenity while vertical photos come across as more active and dynamic.

Take both a vertical and a horizontal version of your favorite scenes and decide which version you most prefer later on when you review the results. You may have to work a little harder, shooting and editing more images, but at the very least, you will have more variety in your collection of photos.

Sometimes Both Work

While sometimes you will find that a subject works much better in one or the other orientation, at other times a subject will work equally well in both the vertical and the horizontal formats. The scene might not have any distractions that need to be eliminated by changing orientation. One version might simply tell a different story than the other, perhaps giving a more unique or startling impression of your subject. By all means, if this is the case, photograph the subject in both orientations.

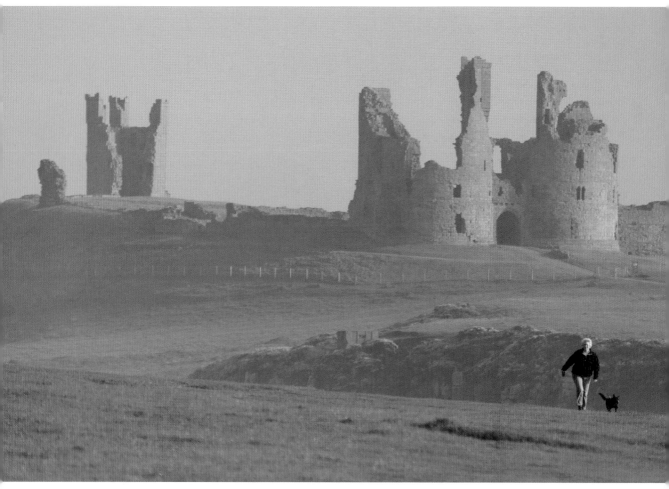

Although I like both versions of this scene in Northeast England, most people respond with greater enthusiasm to the horizontal version. It does a better job of expressing the peaceful and recreational nature of the scene. It also communicates the impressive scale of the ruins in the background while showing the expanse of the land, something the vertical image does not do as well.

OPPOSITE: 1/250 SEC. AT f/6.7, ISO 100, 100–400MM LENS AT 135MM; ABOVE: 1/350 SEC. AT f/5.6, ISO 100, 100–400MM LENS AT 285MM

This is a nice example of the vertical format and how it can complement a subject. This man graciously agreed to pose for me with his standard poodle. I turned my camera on end and waited for the perfect moment— when they were both looking in the same direction. The image would not have been as striking if I had used the horizontal orientation.

1/90 SEC. AT f/5.6, ISO 100,
28–105MM LENS AT 28MM

As you look at a scene, decide which shape your subject best fits into: a vertical rectangle or a horizontal rectangle? For this image, the vertical was clearly the orientation that better suited the subject. Turning my camera on its side allowed me to include only the elements that mattered and crop out the distracting, light background in camera.

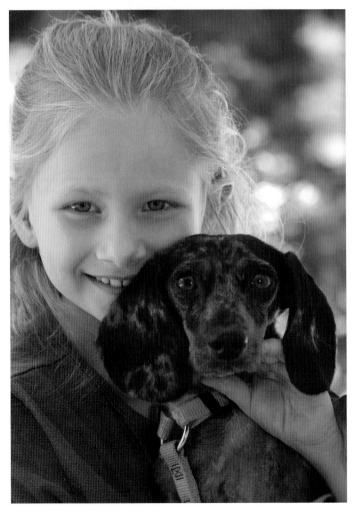

ASSIGNMENT

Apply the Rule of Thirds to a Vertical Composition

Find a subject that you think fits well within the vertical orientation. Then lock focus on your subject and recompose until it is on or near a Rule of Thirds point of intersection. You're going to like this assignment so much you're going to start using the Rule of Thirds everywhere.

Cropping in Camera vs. Cropping on the Computer

IF YOU FAIL to compose perfectly while shooting (in camera), fear not. As a digital photographer, you can turn to Plan B: cropping the image on your computer. Trimming the edges in a software program will often give you a second chance to apply the various composition concepts: moving in closer, the Rule of Thirds, and vertical vs. horizontal orientation.

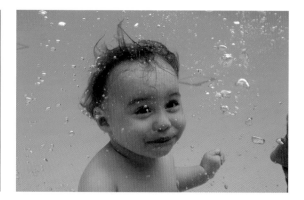

The top image is the original, with my nose peeking in on the right edge. The shaded edges on the bottom image indicate what I cropped off on the computer. Turn to page 99 to see the cropped version.
Photo © Denise Miotke
1/180 SEC. AT f/8, ISO 100, 28–105MM LENS AT 28MM

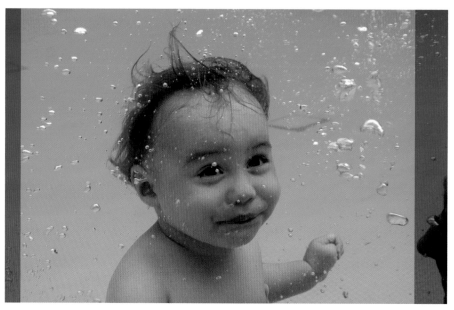

8 × 10

If you plan to place your images into standard 8 × 10-inch frames, you will likely need to trim your photo. With a vertical photo, the top and bottom edges will need to be cropped about an inch. With a horizontal photo, the left and right edges will need to be trimmed off. Keep this in mind when preparing an image for 8 × 10-inch printing. If you want to keep more of one side, pre-crop the image. If you don't, both edges will be trimmed equally when you go to print. If you don't plan ahead, this could result in something important being cut out.

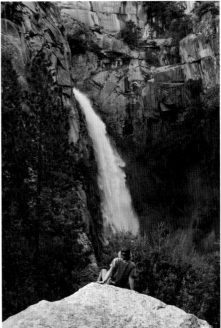

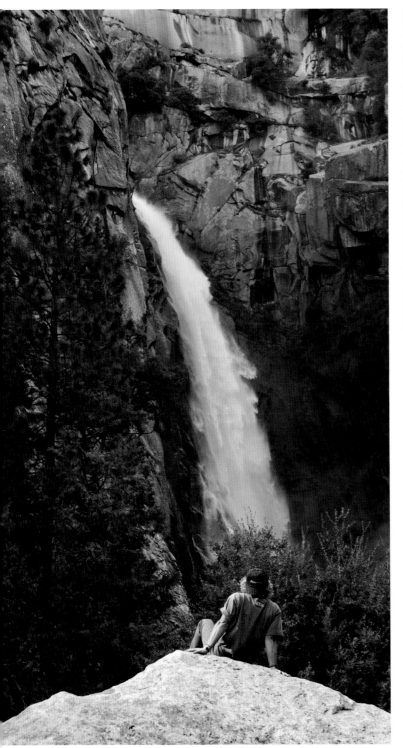

The original version of this image above appealed to me but never seemed to be a total success. I couldn't figure out why until I realized that the subject (the man in the red hat) was fairly centered, with a great deal of negative space on both the right and left. I then cropped the image in a way that placed the man on the lower right Rule of Thirds sweet spot and the supportive background object (the waterfall) more toward the upper left. This balanced the man with his environment, giving the composition more meaning and a feeling of completeness.

The man in the photograph is actually a fellow photographer whom I asked to pose for me. Never be afraid to ask for assistance if it might result in a great photo.

1/8 SEC. AT f/4, ISO 100, 28–105MM LENS AT 55MM

Cropping Caveat

As easy and as fun as it can be to crop your image on the computer, you need to be aware of a few downsides. First and foremost, when you crop an image on the computer, you cannot print it as big as the original. Cropping removes part of the image, which means that there is less image material for you to work with when you're printing. Trying to enlarge the cropped version to print as large as the original lessens the pixel resolution as the computer tries to stretch out less image material (fewer pixels) over the same amount of space. The result would be a fuzzier, less pleasing image. Notice how the three cropped versions of the same photo become smaller and smaller as printed images.

Another downside to computer cropping is that it takes time and a knowledge of the software. Furthermore, there are some changes that cannot be easily made in software, such as shifting your point of view or creating the fun distortions attained by using particular kinds of lenses. (See page 172 for more on these lenses.)

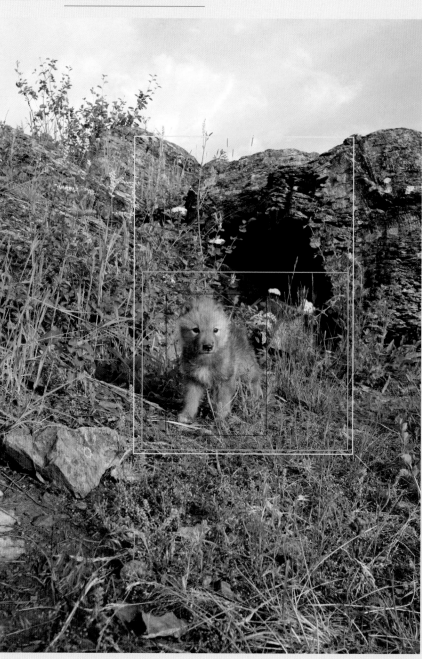

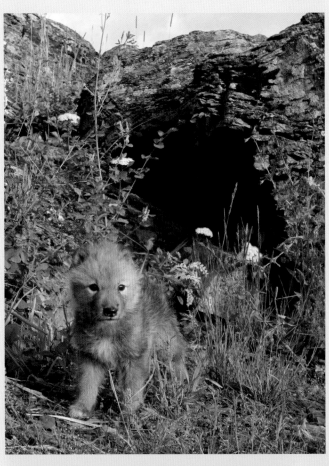

The yellow, orange, and red boxes on the image opposite indicate how each subsequent image was cropped. The increasingly smaller picture sizes reflect that there's progressively less and less image material to work with when printing.

1/250 SEC. AT f/4, ISO 400, 16–35MM LENS AT 27MM

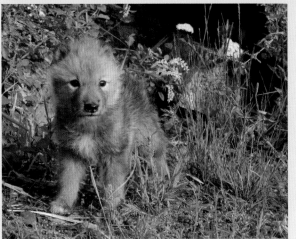

Telephoto Lens: Good for Getting Close and More

MOST PEOPLE THINK of telephoto lenses—100mm or more—as accessories to help them get closer to a subject. It is true that this is a big feature of these lenses. However, another interesting thing happens when you use a long telephoto lens. The distance between your foreground and background objects appears more compressed. The more telephoto the lens, the more compressed this distance will appear. What once seemed far off in the distance will now look surprisingly close, as if the landscape had been compacted right before your eyes.

Using more telephoto lenses to compress the foreground and background can be a lot of fun, and it can be a powerful tool when composing objects in a photo.

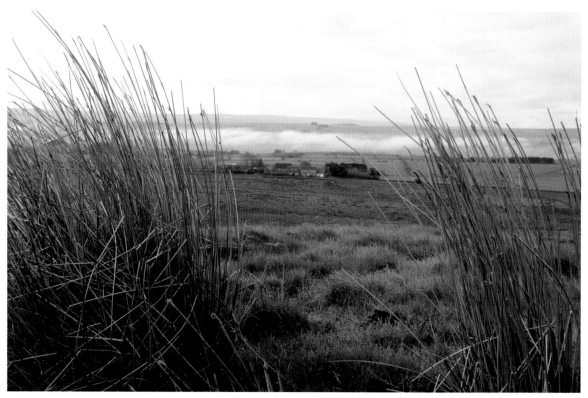

Most people understand that telephoto lenses make a subject look bigger and that wide-angle lenses let you include more in a scene. This is just the tip of the iceberg, though. Actually, what's going on when you zoom in on a subject is that the distant object appears to be closer to the foreground. These three photos illustrate this. In the photo above, notice how small the buildings appear in comparison to the foreground grass. For the photos opposite, I walked increasingly further away from the subject as I zoomed in on it. This enabled me to keep the grass about the same size in each picture. As I increased my focal length, and then switched lenses to get even greater focal length, the buildings appeared much larger and closer to the foreground grasses.

ABOVE: 1/10 SEC. AT f/22, ISO 100, 28–105MM LENS AT 28MM; OPPOSITE, TOP: 1/6 SEC. AT f/27, ISO 100, 28–105MM LENS AT 105MM; OPPOSITE, BOTTOM: 1/45 SEC. AT f/10, ISO 100, 100–400MM LENS AT 250MM

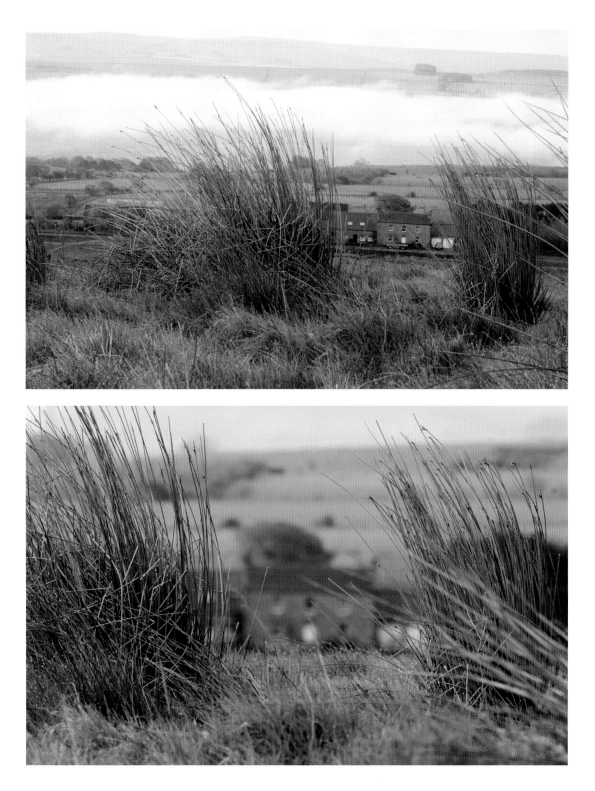

GETTING CLOSE WITH A WACKY WIDE ANGLE

Most people, when they want to get close to their subject, reach for their telephoto lens. And this generally makes sense. The telephoto magnifies distant objects, making it easier to fill the frame with the subject. However, there's another possibility. You can instead choose a wide-angle lens or setting—such as 16mm or 20mm—and get as physically close to your subject as you possibly can. Take a look at these two examples to see what I mean.

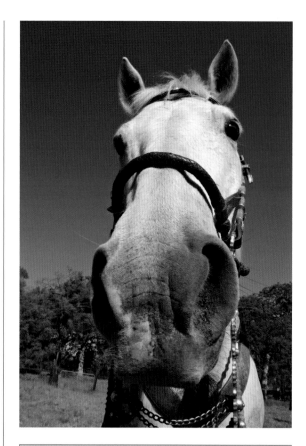

Bad News for SLR Users: Wide Angle Lenses Aren't So Wide Anymore

Unless you can afford a very expensive digital SLR camera, you will likely not be able to shoot wide-angle images like you can with a film SLR camera. The reason for this is that digital SLR cameras feature a chip smaller than a 35mm frame of film. This results in images being magnified, usually by about 1.5 times. In other words, a 20mm lens becomes the equivalent of a 28mm or 30mm lens when placed on your digital SLR.

Without spending serious money, wide-angle options are limited. So, if you are accustomed to shooting super-wide-angle images, remember that the SLR lens magnification factors of digital SLR cameras will make this difficult or impossible.

For a period, I particularly enjoyed photographing extremely wide-angle images—those in which the subjects became uniquely distorted and visually compelling. When I bought my first digital SLR camera, I lamented the fact that, because all my lenses were now magnified, I no longer could create those wacky and wild super-wide-angle images. Over the months, however, I forgot about this loss. It wasn't until a lot of time and images had passed that I realized that, subconsciously, I had found a way to work around the wide-angle problem. I was simply moving back whenever I needed to get a wider angle of view in the picture. Oh so simple . . . and yet so effective.

Four Lens/Proximity Options

Telephoto Lens/Close to Subject. This combination is often great for macro photography and tight detail shots of close-up objects.

Wide-Angle Lens/Close to Subject. This combination often produces comical, wild views with lots of distortion.

Wide-Angle Lens/Far from Subject. Great for scenic landscapes encompassing entire vistas, this more traditional use of the wide-angle lens can create some amazing, expansive compositions.

Telephoto Lens/Far from Subject. The traditional use of the telephoto lets you bring the unapproachable within reach (e.g. wildlife, kids, athletes).

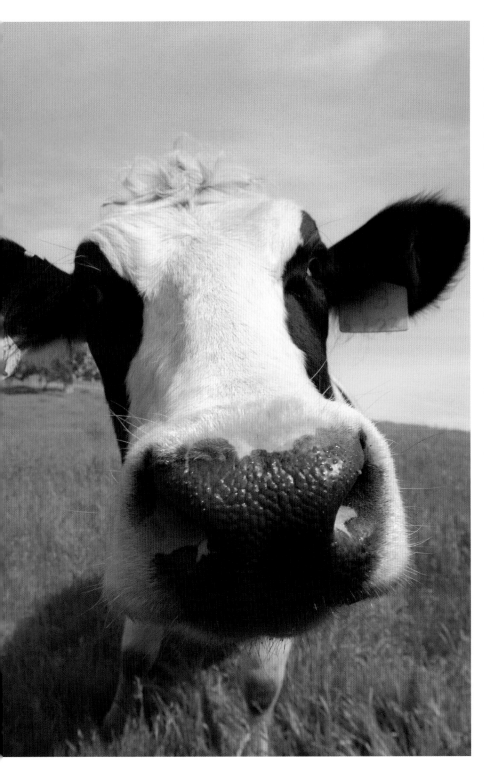

OPPOSITE: *To create this comical "Mr. Ed" kind of image, I used a 16–35mm wide-angle zoom lens and made it as wide as possible. I then got extremely close to the horse (my lens would have been "slimed" if it had stuck out its tongue) and shot from a low point of view.* 1/45 SEC. AT f/19, ISO 100, 16–35MM LENS AT 16MM

LEFT: *Before trying to photograph this subject, I selected my 16–35mm wide-angle zoom lens and tripod. Then, for about twenty or thirty minutes, I worked on approaching this cow so as not to frighten her off. I started by trying to coax her and her friends closer to the fence with some grass to eat. Although I told her it was "the good grass" from the other side of the fence, she didn't buy it. After I felt I had been near long enough for the cows to feel somewhat comfortable with my presence, I slowly climbed the fence and stood closer to them. I waited patiently and moved in a bit closer every few minutes. After some time, they fully accepted me as one of the herd. This particular cow that I had been trying to photograph gave me a bonus by sniffing my camera lens and giving me some curious close-up looks.* 1/350 SEC. AT f/10, ISO 100, 16–35MM LENS AT 16MM

Altering Your Point of View

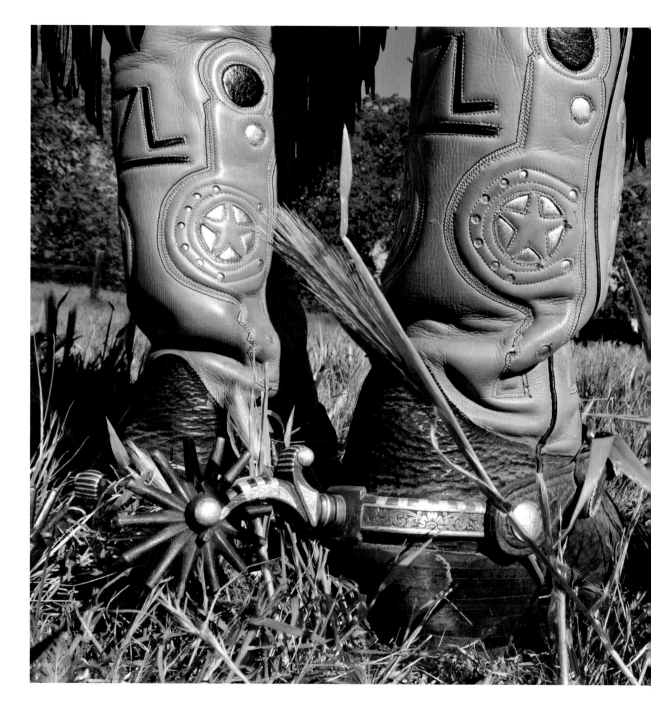

IN ADDITION TO using a variety of lenses and orientations, getting in close and keeping the Rule of Thirds in mind, you can also create unique compositions by altering your point of view—changing the position from which you take the photo.

By getting low, for example, you can photograph your kids or small animals on their level, instead of looking down on them. Getting even lower on the ground and aiming up at a subject like a flower, enables you to include the sky in your background and treat your viewers to something new and unique, something they wouldn't likely have ever seen without your help.

Conversely, getting above your subject will also produce a unique composition. Getting slightly above a person makes them appear a bit smaller (and thinner). Climbing up on top of a ladder will give you a unique point of view when photographing scenes like fields, with any crop rows producing strong and compositionally valuable lines. We'll talk more about how graphic elements, such as line, shape, and pattern, can be photographic gold mines. For now, just remember to ask yourself before taking each picture, Will changing my position produce a more interesting and unique point of view?

After a couple of hours spent photographing this rancher at work branding his cattle, I asked him if he wouldn't mind posing for me one last time. He reluctantly agreed, and I led him back to the cow pasture. After adjusting his pant legs to show off his interesting boots and positioning myself flat on my belly on the ground, I fired off several compositions with a wide-angle lens. My goal was to get an image with his boots in the foreground and a cow in the background. This was the first exposure I made, and it turned out to be the best.
1/45 SEC. AT f/16, ISO 100, 16–35MM LENS AT 16MM

These two photos capture the same subject: a bobcat kitten. The subject in the first photo, however, looks nothing like the subject in the second. Why is that? Simply because I used different lenses. For the first (right), I stepped back away from the kitten and used a long telephoto lens (100–400mm telephoto zoom lens at 400mm). The background is dark and nondistracting, the light is good, and the subject is cute.

For the second photo (below), I changed to a 16–35mm wide-angle lens and got very close to the kitten. I was actually about an inch away and slightly below it, but the wide-angle lens makes it look like I was farther away. More importantly, it caused a slight distortion in the subject and scene. Even though I like the first photo, I like this one even more because it is so much more unique and unusual. The blue sky in the background adds a pleasing splash of color.

On another note, the second photo is a good example of when having a photo assistant comes in handy: My wife was snapping her fingers and jingling a set of car keys just above my head to keep the kitten's attention directed toward the camera.

RIGHT: 1/250 SEC. AT f/5.6, ISO 100, 100–400MM LENS AT 400MM;
BELOW: 1/180 SEC. AT f/5.6, ISO 100, 16–35MM LENS AT 16MM

The background in the version at left is cluttered and unattractive. By simply changing my point of view, I was able to simplify the background and make it complement the foreground tulip.

LEFT: 1/125 SEC. AT f/4.5, ISO 100, 28–105MM LENS AT 105MM;
ABOVE: 1/180 SEC. AT f/4.5, ISO 100, 28–105MM LENS AT 105MM

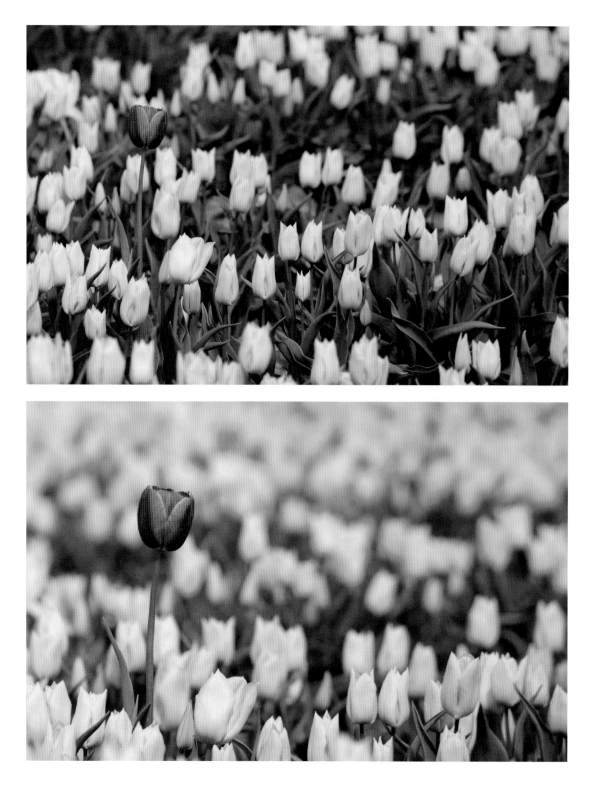

My first attempt with this subject (opposite, top) was too cluttered for my taste. To capture the second photo (opposite, bottom), I simply squatted down to get a lower point of view. This caused the tulips in the background to merge into one unified carpet of yellow, which was an improvement. Then, I walked closer to the subject to make an isolated portrait of the lone pink tulip (left).

OPPOSITE, TOP: 1/350 SEC. AT f/6.7, ISO 100, 100–300MM LENS AT 300MM; OPPOSITE, BOTTOM, AND LEFT: 1/500 SEC. AT f/6.7, ISO 100, 100–300MM LENS AT 300MM

*When I took this photo,
I was standing on a five-
gallon bucket for a slightly
higher vantage point. Aiming
the camera down on my
subjects caused them to
look up at the camera. This
helped create a nice look,
and the slightly altered point
of view resulted in a less
run-of-the-mill portrait.*

1/200 SEC. AT f/10, ISO 1600,
28–105MM LENS AT 98MM,
FILL FLASH

By standing on a chair and positioning the camera almost directly above my subject, I was able to both minimize distractions and capture an image with a unique point of view.

1/160 SEC. AT f/4.5, ISO 100, 28–105MM LENS AT 28MM

ASSIGNMENT ## Get Down, Get Up, Get Wacky, Get Wild

Think of a subject that you can shoot at relatively close proximity, a subject that you can either get above or below. Some possible subjects might include pets, family members, flowers, and fields. Avoid distant landscapes, cityscapes, and other far-off subjects, as these will not be affected as much by a change in point of view.

First, take a few pictures at your standard height. Then, get down on the ground. Don't worry about getting dirty or being embarrassed—these are the risks you have to take to produce great photos. Once you're in an extremely low position, shoot up at your subject, remembering to keep as close to it as possible. Watch out for bright overcast skies in the background. These can wreak havoc on your exposure. When the sky is overcast, try to change your point of view so that a darker element is in the background. If this isn't possible, just be sure to adjust your exposure settings to favor your foreground subject. (See chapter 4.)

Finally, find something that you can stand on, such as a stepladder, chair, bench, five-gallon bucket, or other supportive container. Be careful to keep your balance, and then photograph looking down on your subject from this higher vantage point.

When you're done, compare the results and think about the different psychological effects each point of view produces. Select your favorite and show it to your friends and family, or upload it into the contest or galleries at BetterPhoto.com.

Graphic Elements

LINE, SHAPE, AND PATTERN are the final design elements of a composition to consider. They are the ingredients with which top-notch photographers work. Recognizing these elements is the first step toward making exciting, graphic photographs. And, looking for them can be extremely fun. When you find these graphic elements, use them thoughtfully in your photographs. As you read about each of the following elements, consider how you might put them to use in a future photo.

LINE

Line is one of the most readily available and visually powerful graphic elements to use in a photograph. Lines are not difficult to find—they're all around us. They can be curved or straight, long or short, fat or thin. However, as with all design elements, it's not enough to just shoot line. If you notice a strong line in a scene, you can do more with it than simply snap a picture of it. Arrange the various objects in your composition so that the line leads up to the subject. Give the eye a "pay off," a reward for following the line all the way into your composition. Use line to guide the eye through the image on a fun journey. Take your viewers by the hand on a visual tour of your photograph instead of just plopping them in the middle and letting them wander.

TIP: GET IN LINE

Whenever you notice a strong line in a scene—whether it's curved or straight—look for some interesting object to use as a visual "destination" for the viewer. Then choose a composition that causes your line to lead the eye to that point.

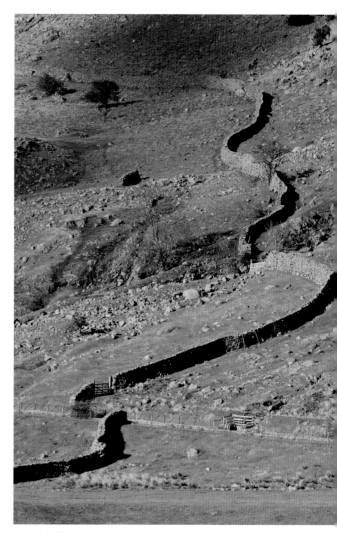

ABOVE: *In England's Lake District, I noticed the irregularly curving line formed by this stone wall and admired the way it divided the hillside. The line leads the eye on a pleasant journey into the scene.*
1/125 SEC. AT f/8, ISO 100, 28–105MM LENS AT 105MM

OPPOSITE: *Shot in Yosemite National Park, this could have been a standard (and boring) photo of a waterfall. By placing the crooked walkway in the foreground, however, I was able to add a lot of interest and impact to the photo.*
1/8 SEC. AT f/22, ISO 100, 16–35MM LENS AT 17MM

While photographing the image on page 183, I turned and noticed this father and son approaching, with the son acting as the perfect payoff. Here's proof that lines are indeed all around us!

1/125 SEC. AT f/5.6, ISO 100, 100–400MM LENS AT 100MM

LEFT: *The character of line can change dramatically simply by the way it is oriented. When lines are horizontal, the visual effect is calming and static. When vertical, lines connote strength and power.*

Note how there are two sets of lines at work in this image of an iron door in a historic mining town in California. The converging lines of the floorboards lead the eye into the scene and add a bit of perspective. The vertical lines in the door take you where the lower lines leave off and give the door an air of towering strength.

1/125 SEC. AT f/4.5, ISO 100, 16–35MM LENS AT 35MM

BELOW: *When positioned diagonally, lines can be especially eye-catching and dynamic. Compare these two images below to see what I mean.*

BOTH PHOTOS: 1/180 SEC. AT f/6.7, ISO 100, 16–35MM LENS AT 33MM

SHAPE

A photographer with a good eye is ever on the lookout for shapes, such as triangles, rectangles, squares, circles, and ovals. When you notice one of these shapes in a scene, position yourself or your subjects in a way that accentuates or balances out the shape.

Shapes can be made more evident by contrast, when one object is much darker or lighter than a neighboring one. Silhouettes provide excellent opportunities for focusing on shape. When a silhouette image is exposed properly, the foreground objects are rendered black, with crisp sharp outlines separating them from the brighter background. Silhouettes eliminate any sense of depth in the subject and cause it to be seen as a simple shape.

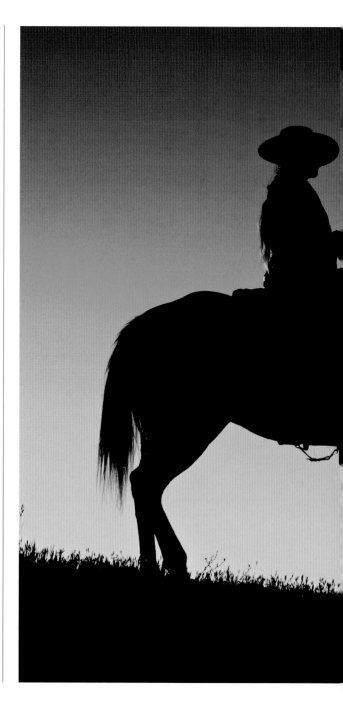

Silhouettes can be an awesome source for subjects that emphasize shape. Since the main subjects are rendered as pure black, they become flat shapes. This graphic nature of silhouettes becomes all the more evident when the subject is set against an equally simple background, such as this orange sky.

1/90 SEC. AT f/4.5, ISO 100, 100–400MM LENS AT 100MM

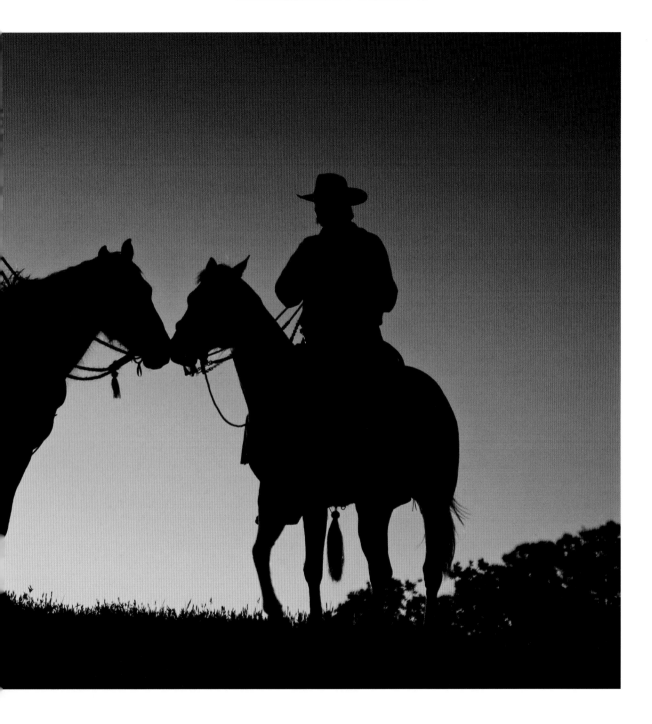

Shadows can be another great source for compositions that emphasize shape. Keep an eye out for shadows when photographing any subject. If you notice an interesting, distinct shadow, be sure to include it in your composition, carefully arranging things so that the shadow is balanced with the other elements in your photo.

1/90 SEC. AT f/5.6, ISO 100, 100–400MM LENS AT 260MM

TIP: DON'T MERGE

When emphasizing shapes, shadows, and silhouettes, make sure the forms do not merge with one another. Keep each element distinct and separated. If shapes are touching or merging together, try to reorganize your composition by shifting your point of view. Your goal: to keep those shapes simple, distinct, and orderly.

ABOVE: *Many scenes feature more than one graphic design element. This image could be seen as an example of line (with the one strong line of ice in the middle of the leaf), shape (with the three shapes created by this diagonal dividing line), and pattern (with the pattern formed by the cracked ice covering the leaf). (See the next page for more on pattern.)*
1/20 SEC. AT f/11, ISO 1600, 100MM MACRO LENS

LEFT: *This composition also makes use of both line and shape: The strong lines formed by the green hedges define the shapes.*
1/500 SEC. AT f/8, ISO 100, 100–400MM LENS AT 400MM

PATTERN

Pattern is an organized series of graphic elements, such as lines or shapes. To be easily recognized as a pattern, there needs to be at least three or more repetitions of the elements. Five or more repetitions make the pattern even easier to see.

Including an odd number of repeating elements seems to be more pleasing to the eye than including an even number of repeating elements.

Whatever these repeating elements are, they need to be arranged in an organized way. The most important aspect of this arrangement is that

It's good, when photographing patterns, to find one thing that doesn't fit into the pattern— an anomaly. In this photo, the anomaly is the boy with the red umbrella, red shirt, and red socks who breaks up the linear pattern created by the rows of daffodils.

1/250 SEC. AT f/6.7, ISO 100, 28–105MM LENS AT 105MM

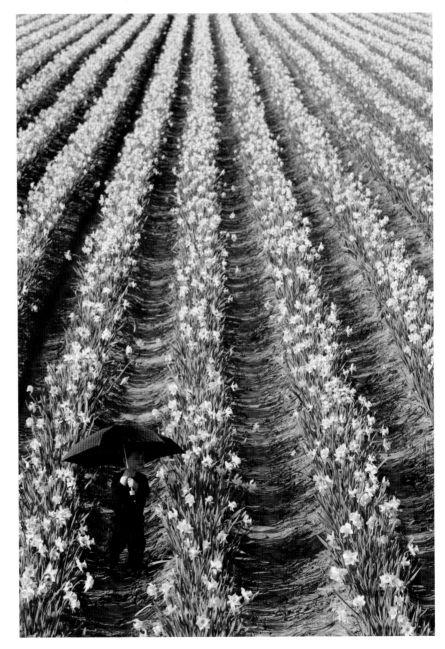

you exclude extraneous elements. Nine times out of ten, moving in closer will cause the pattern to become more apparent.

The natural world provides an abundance of photo opportunities when it comes to shooting patterns. The patterns found in nature are often soft, curved, and flowing—such as spider webs, ripples in sand or water, and flowers. Even more so than when they're represented individually, curving lines, when arranged into a nice pattern, have a pacifying effect on the viewer. They evoke a feeling of serenity. Sometimes, patterns in nature are straight and angular. Keep an eye out for these unique natural patterns; they are, in photographic terms, pure gold!

However, nature does not by any means have a monopoly on pattern—or any design elements, for that matter. Cities, roads, traffic, and millions of manmade objects offer excellent opportunities to photograph patterns. Fields of crops—good combinations of the natural and the manmade—can be a wonderful place to find strong patterns. In the urban, manufactured world, look for patterns comprised of straight hard lines, right angles, triangles, and rectangles, some of which are rarely found in nature. If you happen to find a soft, curving line or pattern in the manmade world, make the most of it.

You can find interesting lines, shapes, and patterns in both the natural world and in environments that have been changed by man. These design elements are everywhere! All you have to do is learn to recognize them, and once you find them, use them thoughtfully in your compositions.

In this image, the anomaly is the bit of blue in the lower right corner, which adds interest to this study of color and pattern. To get this image, I used my macro lens and moved in close to a two-seater bicycle seat.
1/500 SEC. AT f/6.7, ISO 100, 100MM MACRO LENS

Framing

ONE OTHER ELEMENT of composition and design to keep in mind is framing. Whenever you notice lines surrounding your subject—either above, below, or on the sides—see if you can use them to create a natural frame around your subject. This will help keep the eye on the subject of the composition.

The idea here, like the Rule of Thirds, goes way back. Artists have known for centuries the value of framing their subject. Surrounding a scene with an edge—and, if possible, including negative space around an object—causes it to stand out more. Modern framers understand this when they place a picture in a big white mat before framing it. Photographers can also put this rule to use by composing the scene so that surrounding elements that occur naturally in the scene frame the main subject.

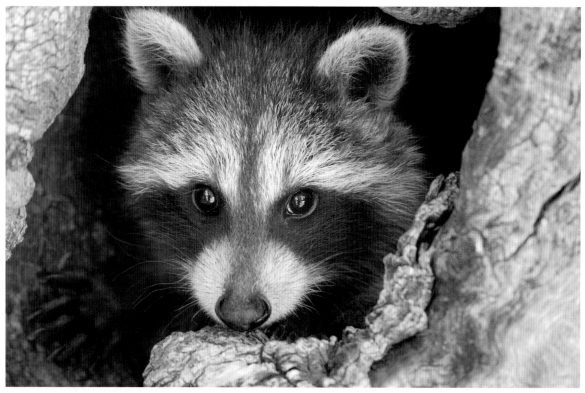

My wife photographed this cute baby raccoon at Triple D Game Ranch in Montana. The surrounding log provided a natural and perfectly complementary framing device. Photo © Denise Miotke

1/45 SEC. AT f/5.6, ISO 100, 28–135MM LENS AT 90MM

This pastoral scene benefits greatly from the horizontal branch along the top edge, which keeps the eye from wandering off that edge and helps frame the overall scene.
1/2 SEC. AT f/22, ISO 100, 16–35MM LENS AT 35MM

ASSIGNMENT

Make Use of Line, Shape, Pattern, and Framing

You can do this assignment anywhere. It's easy, fun, and opens up wellsprings of inspiration. This is when we get to put the "graphic" back in "photographic." Go out on a treasure hunt for the three graphic elements of design: line, shape, and pattern. Once you find them, work with these elements in a meaningful way, incorporating them into your compositions. Line should be evident and put to good use. Shape should help create a clean and simple composition. And, pattern should be used in a pleasing way. While you're doing this, try to think about how you're framing your images, as well.

Regardless of which kind of camera you use, you can put these principles of composition to use. Move in as close to your subject as you can—with a telephoto lens, by walking up closer, or with a wide-angle lens for that fun, distorted effect. Balance your subject with its environment by using the all-time classic Rule of Thirds. And remember, turn your camera on end from time to time, whenever you think your subject might be better suited to the vertical orientation.

While this image doesn't make obvious use of a tree branch or other naturally occurring physical element to frame its subject, the foreground earth and background railings and cowboys serve to frame the cows, which occupy the entire width of the image, all condensed into relatively the same part of the picture plane. This highlights the cows and divides the composition pleasingly into three horizontal bands (the foreground, the cows, and the background). Actually, the real reason I wanted to end the chapter with this image is that I find it funny.

1/125 SEC. AT f/5.6, ISO 100, 16–35MM LENS AT 35MM

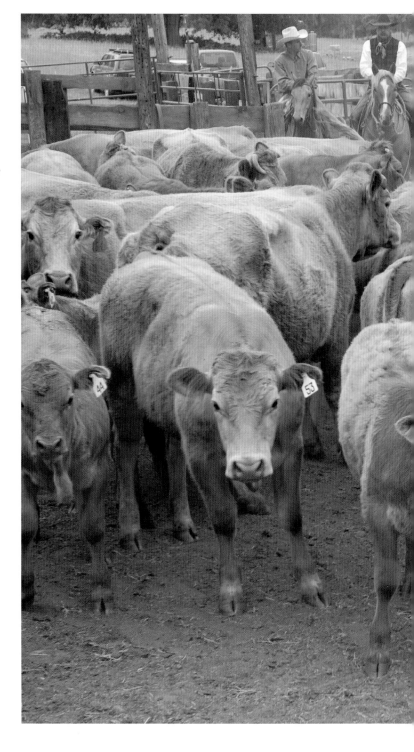

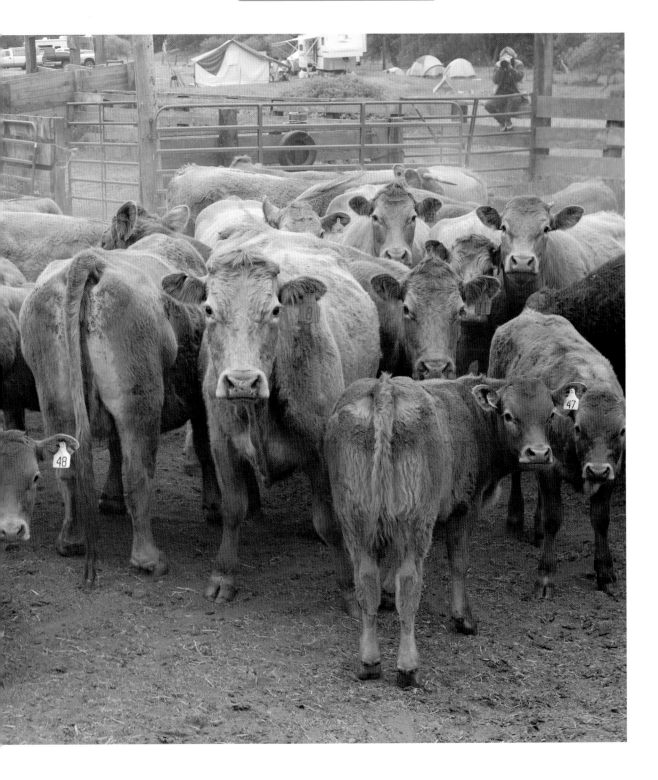

Glossary

A *See* aperture mode

AE *See* autoexposure

AF *See* autofocus

AF lock *See* autofocus lock

aperture The adjustable lens opening that controls how much light enters the camera.

aperture mode Also called *aperture priority* and referred to as *A* in camera options, this is the mode, offered on some cameras, that automatically calculates shutter speed after you specify the aperture that you would like to use. Most of the less expensive compact digicams do not feature this option.

aperture priority *See* aperture mode

archiving The act of saving images (on storage devices other than the camera) for future use.

artifacts Bad effects seen in files that have been compressed too much. Also known as *jaggies*, these artifacts make the image look blocky and can cause continuous tones to look banded.

autoexposure Also called AE mode, this is a camera option in which the camera automatically sets the aperture and/or shutter speed to the setting it considers best for a particular lighting situation.

autofocus Also referred to as AF, this is the camera mode in which the camera focuses for you, as opposed to *manual focus*, for which you have to set the focus yourself.

autofocus lock A function that allows you to hold focus on a selected subject while you move the camera to recompose your photo. It also allows you to prefocus on a fast-moving subject as a way to help you catch the right moment when photographing action.

Av *See* aperture mode

backlight Also referred to as *backlighting*, this is the type of light that occurs when the light source (the sun, if you're outside) is in front of you and behind your subjects, lighting them from behind.

B exposure mode A camera setting that lets you keep the shutter open as long as you like. This comes in handy when photographing special effects with things like fireworks, lightning, and streaking car break lights at night.

camera shake The problematic subtle movement of the camera that can occur when the shutter button is depressed and that can cause blurriness in the resulting photograph.

candid A picture of a person or a group of people that is less formal and staged-looking than a portrait.

card reader A device that you attach to your computer so that you can transfer digital images from a camera to the computer more easily.

catchlight The tiny reflection of light in the eyes of people or animals that you photograph.

CCD (charge-coupled device) The chip which records the image in a digital camera; the sensor.

CD burner A device that saves, or *burns*, images onto a CD for archiving, storage, safekeeping, and future retrieval.

CD-R, CD-ROM *Compact disc* storage media that allow you to store 650–700 MB of information.

cloning A technique used in Photoshop to cover up imperfections—such as dust spots or small scratches—in a photo.

close-focusing distance The minimum distance you can get to a subject before the lens can no longer focus properly.

close-ups *See* macro

compact digicam A point-and-shoot camera, as opposed to an SLR (single-lens-reflex) camera, this kind of digital camera is much smaller and often doesn't feature the same kinds of creative controls that a digital SLR offers.

compact flash card One variety of memory card (a type of digital media) used by many digital cameras to store images.

composite A digital image combining two or more photos.

compression When image data are squeezed into a smaller package. This makes the image quicker to download but can reduce the its quality.

contact sheet An 8 × 10-inch print with thumbnails (small versions) of all the photographs in a particular folder or grouping. Photoshop offers an automated function for producing contact sheets so that you can more easily choose which photos you would like to print.

contrast *Contrast* refers to the difference in tone between the bright and dark areas of a photograph. High-contrast photographs have very dark and very light areas in the same image. Low-contrast photographs have a more even-toned look.

conversion The process of importing raw files and changing them into a format that you can work with in a program like Photoshop.

cropping Recomposing an image by cutting off its edges, either by changing the camera position while photographing (cropping in camera) or by trimming off the edges in a program like Photoshop (cropping in the computer).

Curves An application in the most recent, full version of Photoshop (not Elements) for correcting the color and brightness of an image.

depth of field (DOF) The range, plane, or area—from front to back—in an image that remains sharp. Shallow depth of field means that only a limited area is in focus. A deep depth of field means everything in the picture looks sharp, from the closest to the farthest objects.

diffuser An accessory that softens the light source. A diffuser can be anything—from a cloud to a piece of fabric—that can disperse light to reduce contrast in an image. When you're using flash, your diffuser might be a little piece of semi-opaque plastic. You can also use your hand to block some of the light or, if you can change the angle of your flash, bounce the light off of the ceiling or a wall. Also, a diffuser may refer to a filter that softens focus.

digital imaging As opposed to *digital photography*, this term refers to the overall art of using a computer in your photographic workflow. This includes images shot with a film-based camera and later scanned into a digital format.

digital photography As opposed to *digital imaging*, this term refers to shooting techniques. Rather than including the art of scanning film, this term applies only to images created with a digital camera.

digital zoom As opposed to an *optical zoom*, the digital zoom feature artificially enlarges a portion of an image file by electronically cropping in on it. It is basically a simulated zoom. Generally, it's best to stick with the optical zoom (which provides better quality), unless you absolutely need to zoom in more with the digital zoom.

DVD A storage medium that stores about 4 GB of information.

DVD burner A device that saves, or *burns*, images onto a DVD for archiving, storage, safekeeping, and future retrieval.

EXIF data Also called *metadata*, this is information electronically attached to each image file, such as shutter speed, aperture, ISO, lens length, white balance, and other settings used when taking the picture.

exposure The amount of light that is allowed to hit the sensor. Balance is key to making a good exposure. Too much light results in overexposed (too bright) images; too little light results in underexposed (too dark) images.

exposure compensation A camera function that lets you slightly adjust exposure levels to compensate for things that might trick the camera meter, such as extremely dark or bright objects in a scene.

exposure meter *See* light meter

fast ISO An ISO with a higher ISO number, such as 800 or 1600. Faster ISOs are more appropriate in dimmer lighting conditions or when you are trying to freeze action. *See also* ISO

file format The way (or format in which) you store your image data (for example, JPEG, TIFF, raw, etc.).

fill flash Refers to the flash you use during somewhat bright conditions to fill in shadows.

filter A circular piece of glass placed over the lens that filters out certain kinds of light. Filters can wash an entire scene in a certain tone, correct bad lighting conditions, make skies brighter, and more. Also, the term can refer to software functions that make an image look softer, sharper, or creatively manipulated—all at the touch of a button.

fixed lens A lens that cannot be zoomed in or out; it is permanently fixed at one focal length, stuck with the fate of being wide-angle, telephoto, or something in between. Also called a *fixed focal length lens*.

flare An unwanted burst of light in an image that is the result of beams of light directly hitting the glass of the lens.

flash A camera function or accessory that provides additional, artificial light to a scene.

focal length A way of measuring the magnifying power of a lens. A 50mm lens has a focal length of 50mm and sees things at roughly the same size as the unaided human eye. A 400mm telephoto focal length is like looking through a pair of binoculars—things far away are greatly magnified. A 20mm wide-angle lens squeezes in an expansive vista. Note that many digital SLR cameras have a magnification factor that increases this number when compared to traditional film cameras. For example, a 400mm lens on a digital SLR camera might be more like a 560mm lens on a traditional film camera.

focal plane The point in your photo that is in focus, along with everything else at that same distance from your camera.

focus-ready lamp Sometimes called the *focus-OK lamp*, this is a little light, usually in the viewfinder,

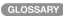

that tells you when the camera thinks it has achieved sharp focus.

frame The view through the camera's viewfinder. Also, *framing* can refer to the compositional technique of using an element within the image, such as tree branches or a window, to frame the main subject of the composition.

frontlight Also referred to as *frontlighting*, this is the type of light that occurs when the light source (the sun, if you're outside) is behind you and in front of your subjects, lighting them from their front.

f-stop The numbers used to indicate the size of the aperture (the adjustable opening in a lens). The size of the opening, combined with the shutter speed and ISO, serves to expose each photo with the correct amount of light.

GIF A file format that uses a limited palette of colors. GIF is better for flat color graphics, such as cartoons, than it is for photographs.

glossy A shiny surface finish (for example, of photographic paper) as opposed to a matte finish. A glossy photographic print accentuates nice, bright colors but it also shows fingerprints more than matte.

grayscale A range of tones from black to white through intermediary shades of gray. Also, an image composed only of gray tones. Commonly used to refer to black-and-white images, as opposed to color ones.

healing brush A Photoshop software tool used to cover up imperfections—such as dust spots or small scratches—in a photo.

highlights The extremely bright parts of an image.

image management The art of keeping your digital photos organized. As it is often easy to shoot a great number of digital photos, figuring out a good image-management system will help you be more time efficient when it comes to working with your image collection as it grows.

infinity lock A setting that locks focus on objects in the scene that are at the farthest distance from the camera sensors; can come in handy when taking pictures through a window.

interchangeable lens A lens that can be removed from one camera body and placed onto another.

interpolation An artificial way of increasing or decreasing a file's dimensions by either adding or removing pixels in an imaging program. Used when you want to print an image at a different size than the current resolution allows, interpolation often results in lower-quality images.

ISO The abbreviation for International Organization for Standardization, more commonly referred to as International Standards Organization. Based on 35mm film light-sensitivity ratings, this refers to how sensitive the CCD is to light. More sensitive or fast ISOs react more quickly to light, and less sensitive or slow ISOs react more slowly. A fast ISO, such as 1600, will capture images more quickly and is better in dim lighting conditions. A slow ISO of 50, on the other hand, reacts much less quickly to light, is much less sensitive to it, and works best in bright light or when combined with the use of a tripod.

isolated focus Shallow depth of field, when one object is in focus while the other areas (in both the foreground and background) are out of focus. Same as *selective focus*.

JPEG (Joint Photographic Experts Group) An image file format that compresses an image,

allowing you to fit more pictures onto the digital storage media. However, repeatedly resaving JPEG images (sometimes called "JPEGing," "jaypegging," or "JPEGGing") can lead to a reduction in image quality.

K (Kelvin) The unit of measurement for light temperatures.

landscape An outdoor scene. In photography, a landscape image is usually made with a somewhat wide-angle lens. Nature scenes make up the bulk of landscape subjects, although sometimes people shoot cityscapes and seascapes, too. This term is also used to refer to images that are horizontal in orientation, as opposed to vertical (or "portrait") images.

Layers A Photoshop function in which one element is placed on top of another. Like acetate pages in an atlas or encyclopedia, the Layers function allows you to work on one element in a picture without affecting other parts of the photo.

LCD (liquid crystal display) A monitor on a digital camera that allows you to review images immediately after shooting them.

LED (light emitter diode) Refers to an electronic display that tells you things like how many exposures you have left, whether your flash is on, and other information.

Levels A feature in Photoshop and Photoshop Elements for correcting the color and brightness of an image.

light meter A device that measures the brightness (the amount of light) in a scene to help the camera get the proper exposure. Most cameras have built in light meters, but some photographers use special, handheld light meters.

long lens *See* telephoto lens

lossy The term *lossy* refers to a type of file format that results in a reduction in image quality each time the file is resaved. A JPEG is a lossy file format. A *lossless* file format, on the other hand, is one that reduces file size without lowering image quality. TIFF and raw files are examples of lossless file formats.

macro Another term for *close-up* photography. A macro mode or macro lens is great for taking pictures of flowers, bugs, stamps, and other tiny objects.

manual focus The camera function that allows the photographer to adjust the focus. So, you focus the camera on your chosen subject, as opposed to *autofocus*, for which the camera automatically does the focusing.

master file Your original image file that you should back up/archive to CD-ROM, DVD, or other media for safekeeping before you make major changes to it.

matte A matte surface finish, as opposed to *glossy*. Matte photographic paper has a protective finish that hides fingerprints and is less shiny than *glossy* paper.

megapixel One million pixels; also, a unit of measurement used to indicate the pixel dimensions of a digital camera's sensor and, therefore, the camera's resolution. An 8 megapixel camera, for example, has a resolution of 8,000,000 pixels.

memory Where your photos are stored. Usually this consists of a removable card on which memory is measured in megabytes. The more megabytes, the more storage room, meaning the more images you will be able to store on your card before having to download them to your computer to free up more space on the card.

memory card *See* compact flash card

Memory Stick A brand of memory card.

mm The abbreviation for *millimeter*; used when referring to lens focal lengths (for example, a 100–400mm zoom lens). It is also used to specify filter sizes on some lenses. For example, you may have a 50mm lens that accepts 52mm filters. The "2" is the clue that 52mm refers to a filter: Common filter sizes include 48mm, 52mm, 58mm, 62mm, 72mm, and so on, while common lens sizes include 16mm, 28mm, 35mm, 50mm, 80mm, 100mm, and up.

muddy A term often used to describe underexposed images and pictures in which it is hard to make out the subject. Muddy images often look dull and brownish.

noise Texture (in an image) that is made up of tiny dots. A noisy image looks kind of fuzzy or grainy, and the colors are dull. This is a side effect of using fast ISOs and is especially noticeable in extreme photo enlargements.

normal lens A normal lens "sees" things at about the same size or magnification level as the unaided human eye. *Telephoto* and *wide-angle* lenses, on the other hand, make subjects appear bigger or smaller than they really are.

optical viewfinder The little window you look through when taking a picture, usually located top center on the back of the camera. This is not the same thing as the LCD screen.

optical zoom As opposed to *digital zoom*, the optical zoom is achieved with mechanical lens adjustments that alter the focal length of the lens, rather than with digital enhancement. Optical zoom usually results in higher-quality images.

overexposure When an image looks too bright.

P *See* program mode

panorama An expansive, very wide view of a scene. A panoramic photograph is very long and thin. *Panoramics* can be either superwide (when horizontal in format) or supertall (when vertical in format).

parallax A problem in which the viewfinder no longer accurately represents the scene to be photographed when you get too close to your subject.

point-and-shoot camera A fully automatic or semiautomatic digital camera. Point-and-shoots are usually less expensive and more compact than digital SLR cameras.

point of view The place and position from which you shoot.

polarizer A kind of filter used to make skies deep blue and clouds ultrawhite.

portrait A picture of a person or a group of people. The term also refers to pictures that are vertical in format.

prefocusing *See* autofocus lock

previsualization The art of imagining ahead of time what you intend to photograph.

program mode The mode, on some cameras, that automatically calculates both aperture and shutter speed for you. Most compact digicams only offer this mode.

raw A proprietary file format that offers great latitude and control over the final image. Raw files are much larger than JPEG files, and therefore, less of them will fit onto a given memory card.

red-eye The red glare effect in a subject's eyes; can be reduced or eliminated with pre-flash.

S *See* shutter mode

Selection A technique in Photoshop for isolating one part of a photo from the rest.

selective focusing The art of limiting depth of field so that only the subject is in sharp focus. The same as *isolated focus*.

self-timer A feature that delays the moment when the camera takes the picture. A self-timer allows you to get into the picture yourself or to shoot without actually moving the camera (the camera depressed the shutter for you), thus avoiding the camera shake problem.

sensitive A term used to describe ISO. A sensitive ISO is one that makes the CCD react more quickly to light than other ISOs. The higher the number, the more sensitive the ISO. For example, ISO 1600 is very sensitive.

sensor *See* CCD

sepia A brownish-gold tone. A sepia print looks just like an extremely old photograph.

sharpness The degree of clarity and crispness in an image.

short lens *See* wide-angle lens

shutter The mechanism that opens and closes to control how much light is allowed into the camera.

shutter button The button you press to take the picture. It operates the shutter.

shutter priority Also called *shutter mode*, this represents the mode, available on some cameras, that automatically calculates aperture after you specify the shutter speed. Many compact digicams don't offer this feature.

shutter speed The amount of time the shutter stays open (letting light into the picture), or how long the camera takes to make the picture. A longer/slower shutter speed will allow more light into the camera, while a shorter/faster shutter speed will allow less light into the camera.

slow ISO An ISO with a lower ISO number, such as 50 or 100. The opposite of fast ISOs, slow ISOs generally produce brighter, less noisy pictures but can be more difficult to shoot, especially in low-light situations. *See also* ISO

SLR (single-lens reflex) camera An SLR camera allows you to use interchangeable lenses; features sophisticated focus, exposure, and flash systems; and requires users to look through the lens itself to see the scene, as opposed to most other cameras, which use a separate window as the viewfinder. When compared to a compact digicam, a digital SLR is bulkier but offers greater (and/or easier-to-use) creative controls.

SmartMedia A brand of memory card.

soft Term used to refer to photographs that are slightly blurry and out of focus. Can also refer to a diffused, gentle kind of light, like that of a bright, overcast day.

telephoto lens A lens that magnifies, enabling you to photograph things that are very far away. Telephoto lenses usually have a focal length of 80mm or above.

thumbnail A tiny version of a picture.

TIFF (Tagged Image File Format) An image-file format that retains maximum quality but takes up more space than JPEG format.

tv (time value) This refers to the shutter-priority exposure mode. *See also* shutter priority

underexposure When an image looks too dark.

Unsharp Mask A filter function in Photoshop that's used to hide, or mask, unsharpness. This feature makes digital images appear sharper.

xD-Picture Card A brand of memory card.

viewfinder *See* optical viewfinder

viewpoint *See* point of view

white balance The camera settings used to correct any subtle color shifts in an image that sometimes occur in different kinds of light. The white balance setting can be set by either the camera or the photographer, depending on the camera model.

wide-angle lens A lens that gives a wide, expansive view of a scene. Because more of the scene is squeezed into the picture, objects look smaller through such a lens than they do in real life.

workflow The step-by-step system a photographer has for capturing, archiving, cataloging, manipulating, and sharing images. Photographers develop their own workflow as best suits their way of working.

WYSIWYG Pronounced wizzy-wig, this acronym stands for "what you see is what you get." Compact digital cameras (as opposed to digital SLR cameras) often only show you an approximate view of your scene. SLR cameras, on the other hand, let you see exactly what the CCD sees, giving you a much more accurate idea of how the final image will look.

zoom lens A zoom lens gives you more flexibility by allowing you to easily change the amount of magnification just before you shoot. You can either *zoom in* to make faraway things appear closer, or you can *zoom out* to make more things fit into the picture. On compact digicams, zooms are usually electronic and controlled by a toggle on the camera itself. On more expensive cameras, you often move through the range of focal lengths by twisting the lens or switching it with another lens altogether. *See also* interchangeable lens.

1/180 SEC. AT f/6.7, ISO 100,
100–400MM LENS AT 300MM

Digital Camera Buyer's Guide

TRYING TO DECIDE which digital camera to buy can feel overwhelming. There are so many models on the market that you might think it takes a Ph.D. to make sense of all the choices. However, shopping for a digital camera need not be so intimidating. Once you ask yourself a few key questions and see how similar many of the models are, you'll find the task of buying a digital camera much easier.

There's no one best camera. Each camera has its own strengths and, therefore, has a most fitting purpose or application. So, for some photographers, a compact digital camera may be the best choice. Others may be frustrated with anything less than a professional digital SLR camera.

You can have fun learning the art of digital photography with practically any digital camera. The real danger is buying a camera that quickly becomes nothing more than a paperweight. To keep this from happening, you need to learn about the various kinds of cameras and analyze your own needs. This will ensure that you get the camera that's best for you.

THE SHORT ANSWER

If you're seriously interested in exploring digital photography as a hobby, get a digital SLR camera with at least one good zoom lens. Two lenses—one in the 28–105mm range and another in the 100–300mm range—will take you a very long way. Eventually, you'll also want an accessory flash that attaches to the top of your camera, but in the beginning, the two lenses are the things that will come in most handy.

If you're tight on cash, don't really know how far you're going to take this photography thing, and/or need a camera that fits into your shirt pocket, you may be happier with a compact digicam. If you go this route, a camera with a strong optical zoom lens will be much more versatile than one without.

Either way, be sure to also get a sturdy tripod, a huge memory card, and a card reader to attach to your computer. We'll explore these accessories more at the end of this buyer's guide.

COMPACT DIGITAL CAMERAS VS. DIGITAL SLRS

Now that the quick answer is out of the way, let's dig deeper to get a full understanding of things, before you find yourself in a camera store. First, we will look at the various kinds of cameras, and then we'll explore a few of the most essential features. There's also a pop quiz—twelve quick questions to ask when purchasing a digital camera.

COMPACT DIGICAMS AND CAMERA PHONES. Most digital cameras are in the quality range of inexpensive point-and-shoot film cameras. The electronic technology inside most digital cameras is so expensive that it makes them a hard item for manufacturers to produce on a tight budget. In an effort to keep costs down, they often skimp on the more creative controls and photographic features. With most compact digital cameras (or *digicams*), composing your picture involves looking through a separate viewfinder (rather than looking through the lens itself as you would with a digital SLR camera). These cameras usually have one attached fixed or zoom lens, and most models have an automatic, built-in flash.

These cameras are usually simple. There are, generally, very few options or controls to worry about. Compact digicam users can often get by without ever having to open the owner's manual. Some of these cameras offer the ability to select special modes and to control whether the flash fires or not, but others—such as most camera phones—offer no creative controls at all. So, with all or most of the photographic decisions being made by the camera, the compact digicam may not be

the ideal solution for those interested in learning how to make the artistic decisions themselves. Additionally, inexpensive models often don't have enough resolution to create high-quality prints.

Some of the more expensive compact digital cameras give you lots of control. Even with these cameras, though, operating these creative controls can be more laborious and difficult than on other cameras. You often have to follow a complicated set of instructions, press a bunch of tiny buttons, and scroll through multiple menus in order to change settings. What a hassle!

Many digital camera owners complain about a delay between the moment you push the button and the moment the camera actually takes the picture. If you're photographing a dolphin jumping out of the water, for example, you'll have to get very good at anticipating the jump to catch the picture. If you push the button while the dolphin is in mid-jump (or even just popping its head out of the water), the dolphin will likely be back under the surface by the time the camera fires, and you will have missed the shot. Therefore, these cameras can be less than ideal for photographing fast-moving subjects.

DIGICAMS WITH MANUAL EXPOSURE OPTIONS. Some high-end compact digicams do allow you to control aperture, shutter speed, and ISO settings. These more expensive compact digital cameras are popular with photographers who shoot often, need high quality, and like the compactness of the digicams. But what if even the most flexible and powerful of compact digicams is not enough? What if you find your high-end digicam too limited? What if you find the menus frustrating or yearn for easier creative controls?

DIGITAL SLR CAMERAS. SLRs are a popular camera type among serious hobbyists and a favorite among wildlife photographers, photojournalists, sports fans, and many other photographers. SLR stands for *single-lens reflex*. With an SLR, you actually look through the lens itself, so the lens functions as your viewfinder. Since you're looking through the same lens that is used to take the picture, you see in the viewfinder a good representation of what you actually end up getting in a print. What you see is what you get. This camera is best for people who want more from their photos, don't mind a bulky camera, and feel comfortable with a bit of technical complexity.

With an SLR camera, you can easily control the focus so that you select which parts of the picture are sharp and which parts are not. Many students use SLRs to learn how to control aperture and shutter speed for proper exposure. You can shoot quickly with an SLR, which makes it ideal for photographing fast-moving subjects; there isn't the shutter delay from which many compact digicams suffer.

Unlike most compact digicams, which are one complete camera in themselves, SLRs usually consist of two parts: the lens and the separate camera body. Most SLR camera starter kits come with both a camera body and a lens, but sometimes camera bodies and lenses are sold separately. Rather than buying a third-party lens made by another manufacturer, buying a lens from the same company that makes the camera body will often ensure the sharpest results and the fastest, quietest focusing. These do cost more, however, and many photographers on a budget are perfectly happy with third-party lenses.

The cool thing about being able to detach the lens from the camera body is that you can change lenses to get amazingly different effects. For example, you can:

❑ photograph extremely distant subjects such as an eagle high up in the trees with a telephoto lens.

❑ shoot an expansive vista or the interior of a tight room with a wide-angle lens.

❑ get close-up or life-size photos of tiny things, like bugs, with a macro lens.

While you can get some flexibility with a zooming compact digicam, an SLR camera offers a much wider range of focal lengths. There are even specialized lens options and accessories from which to choose, such as fisheye lenses, telescope adapters, microscope adapters, and more.

Most SLR cameras are designed with future expansion in mind. Different options are available with regard to flash, remote control, multiple exposure, studio lighting set-ups, and fast continuous shooting modes. If people start asking you to shoot their wedding photos, for example, you can easily adapt your camera to meet these new needs. Even if such an idea never occurred to you at the time of purchase, these SLR cameras can grow with you as you grow.

Although most SLR cameras are flexible and adaptable, they're still easy to use right out of the box. They need not present any more complications or problems than a compact digicam. In fact, you can set many SLR cameras on an easy automatic Program mode while you learn to make more challenging photographs. In this automatic mode, SLR cameras operate just like compact digicams; the only difference is that you have the options of expanding the camera or of going into a more manual mode when you want to. The great thing about this is that your early photo shoots won't be as frustrating as they could be; you can come home with wonderful pictures right from the beginning, learning and mastering advanced features as you go.

Having said all that, there are two downsides to SLR cameras.

1 They're usually bulkier and heavier than compact digicams. While you can often slip a compact digicam into your pocket, an SLR camera will probably require a separate carrying case or shoulder strap. If, in all honesty, you don't see yourself carrying a big SLR camera

around, get a compact digicam. A camera does you no good if you rarely take it with you.

2 A good SLR body and lens setup can cost more than most compact digicams.

Still, SLR cameras are fantastic. They're the most appropriate choice for people who want to learn more about the artistic side of photography. Most professional photographers use this kind of camera because it so successfully balances versatility and ease of use. Your decision ultimately comes down to deciding whether you want a compact, simple, and somewhat limited camera or a bigger, more expensive, and expandable camera.

Once you have a sense of which kind of digital camera sounds most appealing to you, the next step is to consider a few of the most important features, such as megapixels, lens options, creative controls, and burst rates.

MEGAPIXELS—WHAT DOES IT ALL MEAN?

Especially if you're going to be printing your images, you'll want to get as much resolution as you can afford. Resolution is often expressed in megapixels (MPs), or as a figure such as 1024×768. Either way, the higher the numbers, the better. Unfortunately, this aspect is the one most closely tied to the price of your camera because it is tied to the high costs of expensive electronic chips.

If you're only going to use your camera for Web site imaging, e-mailing, or other screen-output applications, you can relax when it comes to comparing megapixels. Most digital cameras on the market today will offer more resolution than you will ever need.

File size is just another way of measuring the resolution of the camera's output. If the camera can capture more information, hence generating bigger file sizes, your resolution is higher, too.

It's important to find out if the resolution of a digital camera is *optical* or *interpolated*. If you see that interpolation is used to attain a pixel resolution, ignore this interpolated resolution spec. Learn what the camera's optical resolution is, and use that figure exclusively when comparing digital cameras.

Resolution, however, is not the only factor to consider. In order to make outstanding images, you need great lens options, a decent burst rate, and creative exposure controls.

LENSES: FIXED, ZOOMS, OR INTERCHANGEABLES

Lenses play a crucial part when it comes to getting great pictures. These pieces of glass most directly affect image quality and sharpness. As mentioned earlier, compact digicams usually have a fixed or a zoom lens incorporated into the camera itself; SLR units are connected to detachable lenses to allow an even wider range of options than even the best of compact digicams.

Focal length indicates the magnifying power of a lens. Lenses that fall within certain magnifying distance ranges are classified either as *normal*, *telephoto*, or *wide-angle* lenses.

Zoom lenses allow you to quickly magnify or reduce your subject, going from a wide-angle to a telephoto with a simple movement of your fingers. Many compact digicams have a built-in zoom lens that lets you get a little closer to, or further from, the subject.

Even though compact digicams with zooms cost more than those without, this feature is worth every penny; the ability to recompose your photo on the fly and fill the frame with your subject makes these cameras worth the extra cost.

SLR camera users have many more choices when it comes to zoom lenses. They can buy ones that range all the way from 35–200mm and beyond, or they can get zoom lenses that hover around one area. For example, a 16–35mm wide-angle zoom allows shooters to get both slightly and extremely wide-angle images.

Macro modes and lenses let you get much closer to your subject than a typical lens so that you can take interesting close-up photos. They're great for photographing insects, the insides of flowers, and other small objects.

> **TIP:** GET AN SLR CAMERA THAT LETS YOU SWITCH LENSES
>
> Some SLR cameras have a single lens permanently attached to the camera body. This defeats one of the main advantages of using an SLR camera—the ability to use a variety of lenses. If you do decide to purchase a digital SLR camera, get one that lets you change lenses.

BURST RATE

This specification refers to how fast a camera can capture images. Slow burst rates can be a problem in digital SLR cameras but are even more likely to slow you down when using a compact point-and-shoot digital camera. A slow burst rate can cause you to miss the shot. Although burst rates vary from camera type to camera type, an example of a fast burst rate might be 8.5 frames per second, and a slow burst rate might be 1 frame per second.

Burst rate becomes especially crucial in sports, fashion, and wildlife photography for which a fast recycle time (the amount of downtime a camera needs between exposures) is essential. Since a digital camera has to actually "write" the image file every time you take a picture, you want this writing time to be as brief as possible so that you can get back to shooting.

A Dozen Quick Questions to Ask Yourself
When Buying a Digital Camera

The following questions are designed to help you narrow down the choices. Answering them before you visit the camera store will let you make the wisest, most independent decision.

1 What kinds of digital cameras have you used in the past?

Considering the kinds of cameras that you've used in the past (both film and digital) can help you pick the best camera for your future photographic endeavors. What did you think of your past cameras? If you were happy with them, you might enjoy buying a similar kind of camera. If you were unsatisfied or are now ready for more, you might like to upgrade to a digital SLR camera. This question is applicable whether your previous cameras were film or digital. If you enjoyed a film SLR camera in the past, for example, you will likely enjoy a digital SLR camera. (Additionally, if you stick with the same manufacturer, you may be able to continue using all of your old lenses.)

2 How would you describe yourself?

Do you consider yourself artistic or pragmatic, adventurous or careful? The answers to these questions can point you in the right direction. Parents and travelers who just want to get decent pictures of the family, for example, will likely be satisfied with a compact digicam. Someone looking for a serious hobby or even a career in photography might get more mileage out of a digital SLR camera.

3 What are you going to use the camera for?

Whether you plan to primarily photograph kids, animals, portraits, travel shots, architecture, sports, or concerts, considering the specific needs of the types of photography you intend to do will also help you identify the camera features you require. Photographers who like to shoot architectural interiors, for example, will want a wide-angle lens and will be especially happy with one that doesn't distort the subject. A sports photographer will need a camera that takes the photograph immediately upon pressing the shutter button, without any delay, and will therefore want a camera that can take many pictures, one after the other, with the utmost speed.

4 How will you be using your images?

Do you envision yourself placing your photos in a scrapbook or framing your favorites and hanging them on the wall? A 4- or 5-megapixel compact digicam should be enough if you mainly see yourself getting prints that are smaller than 5 × 7 inches. If you see yourself exclusively publishing your images on the Web or e-mailing them to friends, you can get by with an even smaller megapixel count. On the other hand, if you dream about having your images published, don't settle for anything less than a 6-megapixel camera; a camera with 8 or more megapixels would be even better.

5 Will you be printing images yourself at large sizes?

If you'll be printing big images at home, look for a camera with high resolution. Buy a camera with the highest megapixel number that you can afford.

6 Would you rather have flexibility with occasional frustration, or simplicity with less control?

In regard to file formats, you can choose to either have more options or greater simplicity. If you would rather have options—even if it means having to roll up your shirt sleeves from time to time, digging in and working hard to overcome frustrating problems—get a camera with the option to shoot raw files. If you shy away from technical complications and prefer simplicity, you may be okay with a camera that records every photo in the JPEG file format.

7 Will you be traveling with your digital camera?

If yes, then you'll want to buy as much memory storage as you can afford. This means getting memory cards with the highest MB number. Also, if you won't be bringing a laptop along with you, be sure to bring another device (such as an iPod or a FlashTrax) onto which you can download your images whenever your cards get filled up. Get a camera with rechargeable lithium-ion batteries and a good battery charger, or a similar solution that allows you to easily stay on top of battery consumption.

8 How far will you be from your subject?

If you're planning to shoot kids or wildlife, you'll probably need a strong zoom. A compact digicam's zoom (usually with an upper limit of around 135mm to 160mm) may not satisfactorily do the job. You'll need at least 300mm for birds and small animals. Parents restricted to the sidelines, unable to get any closer to their kid playing sports, will also appreciate the benefits of a strong zoom. Get a digital camera with a good telephoto zoom lens. If you will be exclusively photographing scenic landscapes, you might find that a camera with better wide-angle options gives you more satisfaction in the long run. Likewise, if you're a traveler planning to visit lots of museums and interiors, you will likely appreciate more options when it comes to the wide-angle end of the spectrum. Look for a zoom that goes down to 16mm or less. Note also that most digital SLR cameras magnify the lens, making extreme wide angles more difficult or altogether impossible to achieve.

9 How close will you be to your subject?

Will you be taking pictures of small items, like stamps, coins, bugs, flowers, and other tiny objects? If so, be sure to look for a digital camera with macro options, such as a macro mode, or with the ability to attach and use a specialized macro lens (i.e., a digital SLR camera).

10 Does the size of the camera matter to you?

It's important to determine if you're likely to bring the camera along with you even when it doesn't fit into your pocket or purse. If you don't mind the extra effort involved in lugging around a big camera, go for a digital SLR. If you're less likely to carry around such a bulky camera, look into buying a compact digicam.

11 Will you be photographing fast moving targets in low light?

Do you foresee shooting at night, at concerts, indoors, or in other low-light situations? Then you'll want to get a camera with flexible ISO settings. Do you foresee photographing kids, animals, athletes, models, or anything else that moves quickly? Then get a camera with a fast burst rate and a large buffer.

12 What is your price range?

Keep your answers to the above questions in mind as you consider price. Also keep in mind that this camera is going to be with you for some time, and its quality will have an effect on the quality of your pictures. An extra $100 can go a long way when it comes to buying your camera; the additional features and better quality lenses cost more but generally help you get clearer, more satisfying results. Since prices change all the time and could be inaccurate by the time you are reading this, visit BetterPhoto.com and other Internet resources to get more specific and up-to-date information on the various cameras and price ranges.

ONE FINAL NOTE: BetterPhoto.com features a "Digital Camera Calculator" that you may find especially helpful. Answer a few questions or select from a series of photos to indicate which kind of pictures you'll be taking. Within seconds, BetterPhoto will give you a list of cameras and features that will best meet your needs.

CREATIVE CONTROLS: APERTURE, SHUTTER SPEED, AND ISO

A camera with ISO settings such as 100, 200, 400, 800, 1600, and 3200 will give you more flexibility when it comes to shooting in low-light conditions than a camera without these ISO options. However, having ISO choices is only one-third of the battle. To have a camera with the most creative choices, you'll want to be sure to look for the ability to directly control aperture and shutter speed, as well. A camera with options such as aperture priority and shutter priority will give you the most options when it comes to creatively capturing beautiful digital photographs.

While many compact digicams offer these kinds of controls, some make it unnecessarily difficult to change these settings. Instead of using a knob or other easy control, they often use a series of complex menus to set aperture and shutter speed. It's a good idea to try changing such exposure controls on a camera before you purchase it. That way, you'll know exactly how easy or difficult it is to manipulate these important settings.

TEST-DRIVING A DIGITAL CAMERA

Once you're looking in the right direction, you can further define your preferences by trying out a camera or two. At this point in the buying process, the best way to know which particular models you most prefer is to hold them in your hands and see how each feels. Go to a camera store and pick up each camera to feel its weight. Do you like how heavy or light it is and how it feels in your hands? Does it seem too bulky?

Fiddle with the buttons and attachments. Are they easy to read and move? Are they too small for your fingers to work? Do the locations of the main buttons and dials make sense to you? Is looking through the viewfinder intuitive? Do you often fumble around, catching yourself looking on the wrong side of the camera for a particular button or dial? If you're getting a camera with a zoom, is it slow and noisy or fast and quiet?

Better yet, actually try shooting a few pictures with your potential camera. Ask the salesperson if you can take it for a test drive. In order to do this, you'll want to bring in your own memory card, take a few pictures, and then use a card reader back at home to transfer them to your computer.

Alternatively, you can look for a pro camera shop in your area that rents digital cameras. The cost of a rental is a small price to pay for knowing firsthand how much you like or dislike actually using the camera. Far too many people rush through the purchase only to put their new digital camera in a drawer after a few frustrating experiences. By trying it out ahead of time, you are less likely to be surprised by things you don't like.

Now you know what kinds of cameras there are to choose from and what features to look for. All that's left for you to do is see how your own personal needs direct your choice. Answer the twelve questions on the previous two pages to apply this Digital Camera Buyer's Guide to your own personal needs.

TIP: GET TO KNOW YOUR NEW CAMERA

Try not to buy a camera right before heading out on a trip without first using it for awhile. Give yourself a little time to get to know the camera before you travel. Try to shoot at least once or twice before leaving. Then, be sure to pull up the images on your computer to see how they look. Ideally, print off a picture or two. By practicing with your camera in this way, you won't make needless mistakes on your trip just because you haven't yet practiced enough with your new camera.

LAST BUT NOT LEAST: A FEW ACCESSORIES

In The Short Answer (page 206), I mentioned a few accessories you might need. Let's look more in depth at a few of the most essential accessories.

TRIPOD. Ask any professional and they will tell you that a tripod is a must. It is important that you not only get a tripod, but that you get the right one. To be truly useful, your tripod needs to be easy to use. And, the most important factors in a tripod are (a) that it is sturdy, and (b) that is lightweight enough that you don't mind carrying it around. In addition, look for a tripod with quick-release options—both for attaching the camera to the tripod and for locking and unlocking the telescoping legs. These are essential features. You don't want to be wasting time screwing the tripod into the tripod socket on your camera or trying to open or close up the legs.

TRIPOD

REMOTE SHUTTER RELEASE. As soon as you get a tripod, also purchase a remote shutter release for your camera, if one is available. For low-light photography with a tripod, a remote helps you create sharp photos by keeping your hands off the camera during the moment of exposure. By triggering the shutter remotely—just as a film photographer might with a cable release—you ensure that you don't accidentally move the tripod while shooting. If your camera doesn't have such an accessory, use the self-timer option each time you shoot with long, slow shutter speeds.

MEMORY CARD. The most important thing to consider when buying a memory cards is its size—how many megabytes it features and, thus, how many photos it will hold. Treat yourself when it comes to getting memory. Purchase the largest card you can afford; a 2 or 4 GB card may cost more, but it sure is nice when you can continue shooting without having to worry about filling up your card. That last thing you want is to be desperately transferring images off your memory card (or worse, deleting some) while something exciting is happening, in the hopes that you will free up enough space for one more picture.

TIP: GET A 512 MB CARD FOR BURNING TO CD-ROM

If you like to archive your digital photos onto CD-ROMs, you might consider getting 512 MB memory cards. This way, you can simply off-load each card and immediately burn the contents. While it's convenient to use larger 1, 2, or 4 GB cards, you will have to shuffle image files around until you can fit them onto a 650 MB or 700 MB CD-ROM. This can be a bit of a hassle. Using the smaller 512 MB card will make archiving easier.

When purchasing memory cards, pay attention to the speed of the card. Try to stick with memory cards that write 3.6 images per second or faster—especially when you photograph wildlife, people in action, and similar fast-moving subjects. For situations in which you are in continuous shooting mode and taking pictures like crazy, you can quickly fill up your buffer (the place where images are stored until the camera has time to write them to memory). If your buffer gets filled up, then you'll have to wait for the camera and card to catch up. Although the camera's burst rate plays an important role in this, using a memory card with a fast writing speed can help keep your camera in action.

On the other hand, if you rarely shoot in the continuous shooting mode, you may never have this problem. If you haven't experienced this frustration, you might be fine not worrying about the speed of your memory card. You really have to be shooting a lot of images sequentially, without interruption, to overwhelm your card and camera buffer.

EXTERNAL FLASH. An on-camera, pop-up flash might help you in some low-light situations. However, it will, all too often, fail, either providing too little light (causing the scene to look dark and obscure) or too much light (blasting your subject to a washed out, ghostlike figure). You may also find that too much of the time it produces the dreaded red-eye effect. If you find this to be the case and have a camera with a *hot shoe* (a place where you can attach an external, accessory flash), consider adding this tool to your arsenal. An external, accessory flash will provide you with many more options and a much higher quality of artificial light.

HARDWARE AND SOFTWARE. It goes without saying that you need a good computer. If you travel a lot, a laptop might be a good choice.

However, you might find a good desktop computer with a large, high-quality monitor much more useful in the long run. These desktop systems are usually much better for doing precise manipulations in programs like Photoshop.

As far as software is concerned, you may be able to get by with the software that comes with your camera. However, I highly recommend

LAPTOP COMPUTER

CARD READER

LAPTOP IN USE IN THE FIELD

Photoshop Elements. If you find that you really enjoy working with Elements, you might consider buying the full version of Photoshop (the expensive one). Either way, you may want to take an online course to learn how to use it.

CARD READER. This will greatly speed up and facilitate the transfer of images from camera to computer. Instead of using the cable to connect your camera to your computer, inserting your memory card into a card reader will make the process both easier and faster.

CD OR DVD BURNER. Getting a CD or DVD burner will make the process of archiving your photos much easier. You may be able to get by for a time storing your images on your hard drive. If you shoot a lot, though, you will eventually fill up the hard drive on your computer. To keep that from happening, use a CD or DVD burner to periodically move your image files from your computer to these off-line disks.

BATTERY CHARGER AND CAR ADAPTER. If you like to travel and use rechargeable batteries, get both an AC charger and a car charger for your batteries. Develop a routine of charging your main battery and a spare each night. When I photograph on the road, I use a universal adapter that plugs into the car cigarette lighter and turns it into a standard, three-prong plug. With this one device I can recharge my laptop, cell phone, and camera batteries—without having to lug around individual car adapters for each item.

The Very Least You Need to Know about Software

WHETHER YOU'RE PRIMARILY interested in e-mailing your pictures to friends and family, entering online photo contests, getting photos critiqued, or printing your images and hanging them on the wall, there are just a few things you need to know about software.

SAVING AS

If you have previous experience working in software word processing programs, like Microsoft Word, you likely already know the value of saving your work. If you fail to save a document and the power cuts out, your computer crashes, or something else goes awry, all of your work can be easily lost in an instant. It only takes one such loss to train most people to save often.

The same holds true when working with image files. When you come across an image that you like, be sure to first choose the Save As option in the File menu. Why *Save As* instead of just *Save*, you ask? The Save As option makes it easier for you to control the location and file format.

When you save an image file, note three things: (1) what file format you choose, (2) what you name it, and (3) where you save it. When shooting JPEG files, I generally save my favorites in the TIFF or PSD (Photoshop Document) file format. This takes me out of the JPEG compression process and lets me rest assured that I won't overly compress my images. You usually select the file format via a pull-down menu under the place where you type in the file name, all in the Save As dialog box.

I try to give my images descriptive file names that mean something to me, that help me remember what the images are. In my mind, "00098-b.jpg" is not a good file name; "MtLionKittenOnLogInMorningLight.jpg," although long, is a good descriptive file name. I also like to keep the image number (the number that was originally assigned to the photo by the camera) somewhere in the title. This makes it easier for me to track down my archived original if something goes wrong or I need to return to the source copy for any reason. Avoid spaces and weird characters, like "$," "?," "/," and "#"—you should even avoid periods, except for the one right before the extension.

Assign an extension after your file name—for example, "filename.tif" or "filename.jpg"—unless the program you use already does this for you. This doesn't have any effect on the file format used when saving the image. It simply makes it easier for various programs to know how to open the image. While Macs don't require an extension, PC Windows machines often do. Be nice to Windows users, and put an extension at the end of your file names.

Keeping these tips in mind, save your images often, especially when you do a lot of work on a file. One thing you're bound to do right away is resize your image. If you do, be sure to first do a Save As on the unaltered file so that you have the original source file on hand. Then do your

> **TIP:** SAVE JPEGS IN THE HIGHEST QUALITY SETTING
>
> If you ever need to save a photo as a JPEG, save it in the upper, highest quality (lowest compression) level. If you plan to make changes to an image, first save a backup master TIFF or PSD file that will remain your unaltered original.

Baseline Standard, Optimized, or Progressive?

There are three options when saving a JPEG in Photoshop. If you have been puzzling over these options, wondering which one is best for your photos, the short answer is this: Just go with Baseline Standard. The Optimized version produces a slightly smaller file. The Progressive version makes an image that displays progressively (one horizontal line at a time) in some Web browsers. Both of these latter options, however, are not supported on all browsers. So, just stick with the default—Baseline Standard.

resizing and choose Save As again, this time renaming the file as something different to indicate that it is a smaller or larger version.

RESIZING

Resizing is when you change an image's size without changing the pixels. This may sound confusing at first, but it's actually simple. You can change the image's resolution (say, from 300 pixels per inch to 72 pixels per inch), for example, without changing the file size. In this case, you wouldn't be changing your file; you would just be shuffling things around within your file. You would be causing your image to spread and cover much more real estate. You would resize an image if, for example, you want to print an image and then at some other time you want to e-mail that same image to someone or display it on the Web.

In Photoshop, you go about resizing the image by using the Image Size command. Select this option from the Image pull-down menu and a dialog box will pop up in which you can change anything you want about the image's size and resolution.

Just note one thing before experimenting in the Image Size dialog box: If you intend to resize the image in the way I mention above—changing the

resolution without affecting the overall file size—be sure to keep the Resample checkbox *unchecked*. This will allow you to make changes without any possibility of damaging your photos.

If you need to make the file size smaller (to e-mail to a friend, for example), then you will likely need to check the Resample checkbox. With this checked, you can reduce the overall pixel dimensions to an e-mail–friendly size, such as 400 pixels wide. If you do this, be sure to use that Save As option right away so that you can save the resized image with a different name and, thus, avoid overwriting your larger source file.

CROPPING, ROTATING PHOTOS, AND LEVELING HORIZONS

Once you learn how to use it, the Crop tool in Photoshop may be the one tool to which you turn the most. You can fix countless photographs that you might otherwise throw away with a simple application of the Crop tool. If you have photos with distracting elements on the edges or if you feel that your photo would have had more impact if you had moved in closer, the Crop tool enables you to fix these problems after the fact.

Using the Crop tool is as simple as finding it among the tool choices, selecting it, and then clicking and dragging the mouse along your photo to create a Crop box. This box represents what you will keep when you hit the Enter key. Once you get the hang of it, you'll wonder how you lived without this simple tool.

Rotating photos comes in handy when you have a vertically oriented image that appears on its side on the computer screen.

For fixing horizon lines that are not perfectly level, go to the handy Crop tool again. In Photoshop or Photoshop Elements, you can correct slightly askew horizons by clicking on the Curved Arrow cursor just outside of each corner of your Crop box. I use this method all the time as a quick and easy way to fix slanted horizons.

SHARPENING FILTERS

Not to be confused with camera filters (the kind you place in front of your camera lens), software filters are functions that are designed to create certain effects in your images. Of these filters, the most important one is the Unsharp Mark filter. This filter is the most effective way to make your images as crisp as they can be. You'll find yourself saving many slightly soft images and making them really stand out by learning how to use the Unsharp Mask filter.

You might wonder why this filter is called Unsharp Mask, rather than something simpler, like Sharpener. This is because you are, literally, *masking out* the "unsharpness" in the image. By changing the brightness and contrast values in certain areas of your image, this filter makes objects appear sharper.

If you use Photoshop or Photoshop Elements, all you have to do to apply this filter is go to the Filter pull-down menu, select Sharpen, and then choose Unsharp Mask. Everybody disagrees about which settings are best, so you may have to experiment. I usually prefer to keep Amount below 50%, Radius below 1.4, and Threshold at 0.

PRINTING: HOME PRINTER VS. PHOTO LAB OR KIOSK

Printing at home can be surprisingly difficult and complicated. But unless you're solely interested in e-mailing or uploading your photos to a Web site, you are going to need a way to get your images printed.

If the computer end of things frustrates you or feels uncomfortable in any way, you have an easy way out: Simply take your memory card or camera to a local photo lab, and see if they can print the images for you. Often these labs (as well as many wholesale stores and markets) have ways to accommodate your digital-to-print needs. Some have self-serve kiosks, and others will take your images and do the printing for you.

ASSIGNMENT **Print an Image**

Okay, here's one final assignment for you: Print a favorite image on your home printer, or take your memory card in to a photo lab and have them print it out for you. Regardless of which path you take, go through the entire process until at least one of your favorite images sees the light of day.

Resources

ARTICLES, COURSES, CAMERA REVIEWS, AND CONTESTS (Online)

BetterPhoto.com

Get direct feedback with an online photography course; showcase your photos on the Web with a deluxe Web site; enter your best photos into our monthly photo contest; read buyer's guides and digital camera reviews; sign up for free e-mail and newsletters—full of answers, tips, and photo critiques.

DigitalPhotoContest.com

Thaine Norris has created an excellent contest site that is famous among online digital photographers. Unlike BetterPhoto.com, the voting here is done by peers. There is also a good article on photography and interesting statistics about who's entering photos in the contest.

Luminous-Landscape.com

Michael Reichmann and friends have compiled many helpful articles, essays, and tutorials on this extensive Web site. Some of the articles are more advanced than others. This is a good resource for digital SLR photographers.

ShortCourses.com

Read helpful guidebooks that focus specifically on your particular digital camera. Author Dennis Curtin has published a staggering amount of these helpful guides. His site is an excellent resource on how to get great digital pictures.

Steves-Digicams.com

One of the best when it comes to digital camera news and reviews. Steve and his staff give prospective buyers a good look at cameras, printers, and accessories—before they take the financial plunge.

CAMERA AND GEAR MANUFACTURERS

Canon

consumer.usa.canon.com

This is the brand of digital SLR that I use. Visit Canon's Web site to learn everything you ever wanted to know about their EOS, Powershot, and Digital Elph camera lines.

Nikon

www.nikonusa.com

Just like Canon, Nikon's Web site will tell you all you ever wanted to know about their excellent digital SLRs and Coolpix cameras. (Note: If you love Nikon, also visit www.nikonians.org—a great resource for Nikon shooters.)

Sony

www.sony.com

This mega-worldwide site is a portal to everything Sony. Once you get to the home page, choose Electronics > Consumer > Digital Cameras > Learning Center from the upper navigational menu for a slick introduction to their camera choices.

CAMERA AND GEAR RETAILERS

Amazon.com Camera & Photo

www.amazon.com

Everybody knows about Amazon.com's bookstore, but fewer people know about its online camera store. Turn to this comprehensive site for great deals on digital cameras, memory cards, and accessories. (Amazon is also a great source for photography books.)

B&H Photo
420 Ninth Avenue
New York, NY 10001
ph: 800-947-9927
www.bhphoto.com
www.bhphotovideo.com
This camera superstore in New York offers extremely low prices. Way back when I first started my photography career, I found the salespeople a bit curt and gruff. However, either I or they have changed—I now find them to be the most helpful staff of all the stores on the east coast.

MyDigitalDiscount
www.mydigitaldiscount.com
This online reseller offers incredible deals on memory cards, adapters, and card readers. I go here first when I need to add to my library of memory cards.

Note: *Don't forget your local camera store. Open up your Yellow Pages and see if you can find a well-respected professional camera store in your area. If you live near a major city, this should not be a problem. Buying local may cost a bit more at first, but the payoff is that it's possible to get far better customer support if and when something goes wrong with your camera in the future; many of these stores employ a digital guru who you'll want to be your best friend.*

DVDS

Digital Photography Unleashed: Capturing Wildly Great Pictures by Jim Miotke (Tonal Vision LLC)

Photographing Your Kids by Jim Miotke (Tonal Vision LLC)

Mastering Camera Raw by Ben Willmore (DigitalMastery.com)

SOFTWARE

Adobe Photoshop and Photoshop Elements
Adobe Systems, Inc.
ph: 800-833-6687 or 800-724-4508
www.adobe.com
www.adobe.com/products
Photoshop and its little brother, Photoshop Elements, set the standard for image-editing software. Elements costs about 1/6 the price of the full version and has everything the beginning digital photographer could ask for. I highly recommend it as a great place to start. Advanced photographers and computer geeks might like to invest in the full program—a few additional features come in handy when you want to do serious photo enhancing.

Exif Reader
Ryuuji Yoshimoto
www.takenet.or.jp/~ryuuji/minisoft/exifread/english/
This is the most popular EXIF-reading program. If you don't have Photoshop (which also displays EXIF information, or metadata), this free software will tell you all the details about each photo you have created—including the shutter speed, aperture, ISO, white balance, and more.

MISCELLANEOUS

Shutterbug Radio with Jack Warren
www.shutterbugradio.com
Tune in each week for a fun and informative talk on photography. Jack has a wonderful ability to attract some fantastic guests. Past shows have featured the likes of Jeff Bridges, George Schaub, Tony Sweet, and Jim Zuckerman. At the end of each show, Jack and I sum up the main points and share several tips on how you can put what you've learned to use, creating great pictures yourself.

Further Reading

BOOKS

Creative Techniques for Photographing Children
by Vik Orenstein (Writer's Digest Books)
Vik's photos of her clients' kids capture what every parent wants—natural, unique, and fun expressions. Follow her guidelines if you want to take pictures that show off the charming, adorable side of the children you photograph.

Edge of the Earth, Corner of the Sky by Art Wolfe, forewords by Robert Redford and John H. Adams, essays by Art Davidson (Wildlands Press)
As you improve your photographic skill over the years, you'll find that it takes more and more to impress you. This is the book that causes even the most advanced master photographers to hold their breath. Be sure you're sitting down when you look at this incredibly beautiful coffee table–style collection of Art's artwork.

Examples: The Making of 40 Photographs by Ansel Adams (Bulfinch Press)
One of my favorites from the master. In this work, Ansel shares stories that illustrate his technique, philosophy, and experiences as he photographed. A great read.

Eye to Eye by Frans Lanting (Taschen)
Big, beautiful, mind-blowing . . . these are the words I use to describe Frans Lanting's amazing collection of wildlife photographs in his book Eye to Eye. Frans has a way of getting intimate close-ups and exciting environmental portraits with every subject he photographs. With amazing imagery, well-printed in a gorgeous coffee-table book, this work will not fail to inspire you.

Fine Art Nature Photography: Advanced Techniques and the Creative Process and *Fine Art Flower Photography* both by Tony Sweet (Stackpole Books)
These two books deliver more punch per square inch than any other I've come across. If natural landscapes or flowers are your thing, these two books must find their way to your bookshelf.

How to Wow: Photoshop for Photography by Ben Willmore and Jack Davis (Peachpit Press)
This book is a gold mine of Photoshop techniques. If you have ever wondered "How did they do that?" read this book. It contains a plethora of recipes—step-by-step instructions on how to create certain effects in Photoshop.

John Shaw's Closeups in Nature by John Shaw (Amphoto Books)
John's books played a huge role in my development as a photographer. His photography is awe-inspiring, and his writing is excellent. Who could ask for more?

The Joy of Digital Photography by Jeff Wignall (A Lark Photography Book)
This big, beautiful book is a jam-packed introduction to digital photography. Jeff explores the reasons we love shooting digitally and shares expert techniques on light, design, working with various subjects, and more.

Learning to See Creatively: Design, Color & Composition in Photography, Revised Edition by Bryan Peterson (Amphoto Books)
This is the book to read if you want to learn how to be more artistic (yes, artistic talent can be learned). The first edition has been a best-seller for over a decade. This revised edition brings everything up to date and shows you how to find your own creative vision.

Mastering Digital Photography and Imaging by Peter K. Burian (Sybex, Inc.)
The term "digital photography" usually refers to the art of making digital pictures with a digital camera, while "digital imaging" envelops a wider sphere, including such topics as scanning. If you would like to learn more about both of these worlds—digital shooting and scanning film—check out Peter's excellent book.

Understanding Exposure: How to Shoot Great Photographs with a Film or Digital Camera, Revised Edition by Bryan Peterson (Amphoto Books)
This is the book to read if you want to learn more about the technical side of photography. Do you feel comfortable with topics such as composition but less sure when it comes to shutter speed, aperture, and ISO? Then this is the book for you. The original edition was a classic; this revised edition is even better.

MAGAZINES

Outdoor Photographer
Werner Publishing Corporation
ph: 800-283-4410
www.outdoorphotographer.com
For many years, Outdoor Photographer has been one of the better photography magazines. Nature, landscape, and wildlife photographers enjoy the articles and columns by great photographers/writers like Frans Lanting, Bill Neill, and others. One year of this magazine can take you light-years ahead in photographic understanding. Highly recommended!

PCPhoto
Werner Publishing Corporation
ph: 800-537-4619
www.pcphotomag.com
From the publisher of Outdoor Photographer, this magazine provides a great introduction to the world of

digital imaging. This periodical makes electronic imaging seem easy, featuring comparisons, tips, reviews, step-by-step instructions, and columns by Lewis Kempner and others.

Petersen's Photographic
Primedia Magazines, Inc.
www.photographic.com
This magazine features great articles and extensive reports on what's hot in the world of photographic equipment and accessories. This is a good place for information regarding cameras, workshops, schools, contests, and seminars.

Popular Photography
Hachette Filipacchi Media U.S., Inc.
www.popphoto.com
One of the most widely read photography magazines, Popular Photography provides extensive guidance on what to buy and how to take the best possible pictures. This is a great magazine to turn to if you're wondering what kind of camera to buy.

Practical Photography
Emap Magazines
Each issue of this outstanding British magazine is a book! I have never seen so much great content poured into a print magazine. The price tag is high, but the material is so excellent that I make a habit of picking one up from the local bookstore every month.

Shutterbug
Primedia Magazines, Inc.
www.shutterbug.net
Shutterbug offers excellent in-depth equipment reviews, interviews, how-to articles, and up-to-the-minute announcements on new products. With an editor like George Schaub and writers like Peter Burian, the team at Shutterbug produces outstanding photography-related content each month.

Index